Caspar David Friedrich

Life and Work

Author: Jens Christian Jensen
Translator: Joachim Neugroschel

BARRON'S
Woodbury, N.Y.
London

All inquiries should be addressed to:
Barron's Educational Series, Inc.
113 Crossways Park Drive
Woodbury, New York 11797

Library of Congress Catalog Card No. 80-10830
International Standard Book No. 0-8120-2102-9

Library of Congress Cataloging in Publication Data
Jensen, Jens Christian.
 Caspar David Friedrich: life and work.

 Bibliography: p. 240
 Includes index.
 1. Friedrich, Caspar David, 1774–1840.
2. Painters—Germany—Biography.
ND588.F75J4613 1980 759.3 [B] 80-10830
ISBN 0-8120-2102-9

For Angelika

Contents

The color reproductions in the text are designated as "plates," while the black and white illustrations of paintings and drawings are referred to as "figures."

1 The Outer Appearance

This truly wonderful nature has taken violent hold of me, even though a great deal about him has remained obscure to me.

Ludwig Tieck, 1834

The artist would probably not have stood for someone focusing on him first before judging his paintings, his sepia works, his studies and sketches. For it was part of Friedrich's personality to step back behind his *oeuvre.*

We know rather accurately what Friedrich looked like, not only from his self-portraits (cf. Figures 4, 5, 6) and from the pictures that other artists did of him, but also from descriptions of him in contemporary autobiographies and letters.

Take Louise Seidler (1786–1866), a painter and writer, who spent the years 1810 to 1814 in Dresden, studying painting and drawing with Friedrich's friend, the painter Franz Gerhard von Kügelgen (1772–1820). She then got her final polish in Munich, Rome, and Paris. Regarding her acquaintanceship with Friedrich, she writes: "In his appearance, Friedrich, with his ash-blond hair and beard, blue eyes and powerful, expressive face, completely resembled an ancient Teuton; his pure, lovely, pious, childlike mind, the almost feminine delicacy of his unaffectedly sentimental soul, did, of course, contrast oddly with his rough-hewn trunk and his whiskers; but anyone who gazed just once into his pure eyes could not help tasting the sweet kernel through the often bitter shell of his deeds and creations."

Frau Seidler (grannyish quite early on, promoted by Goethe and hence a drawing teacher in Weimar as of 1823 for the princesses of the Weimar dynasty, but of mediocre talent) recorded two conspicuous features of the painter in her sketch: his powerful "Germanic" stature and his "delicacy of the mind," which today we would call sensitivity.

Wilhelm von Kügelgen (1802–1867), the son of Franz Gerhard and likewise a painter, saw Friedrich more clearly in his autobiography *An Old Man's Memories of His Youth* (which came out in 1870 and went through countless editions; it was an unfailing basic book in the library of every educated bourgeois German until about 1930). Kügelgen recalls:

> *Friedrich was a very striking man. With his enormous Cossack beard and big, somber eyes, he was an excellent model for a painting my father did of King Saul with the evil spirit of the Lord coming over him. Yet actually, in him lived a spirit that could not harm a fly, much less be willing to kill the pious harpist David; a very delicate, childlike sensibility, which children and childlike natures easily recognized, and whom he thus gladly and familiarly frequented. In general, he was shy and retiring and yielded to solitude, which more and more became his confidante, and whose charms he tried to glorify in his paintings. Such paintings had never existed earlier and will scarcely come again, for Friedrich was absolutely singular in his fashion, like all true geniuses.*

This characterization may not be enough for us. Once again, the delicate soul in the rough-hewn shape, recorded in the nomenclature of the Biedermeier period. The phrase "childlike sensibility" was a popular and frequent formula for describing people during the Romantic period. It refers to something like love of truth, which was felt to be naive and childlike then as now. If it weren't for the recurrence of that formula in those times, we would have a false impression of the character of this man, a character that had its sharp corners, its relentless aspects, and that was dominated by the determination to be true to itself in an age that only briefly sensed the greatness of his art and then gave in to other fads and fashions.

Thus, in the course of his description, Wilhelm von Kügelgen characterizes the nature of this man:

> *Our Friedrich too was the son of a soap boiler in Greifswald; and of the characteristics of his forebears, only the inner values of a brave love of truth, a proud sense of freedom, and a high moral independence had come down to him. Otherwise, he was as poor as Kepler* [the famous astronomer Johannes Kepler, 1571-1630], *of whom the poet sings: "He only knew how to delight the minds,/That's why the bodies left him without bread."*

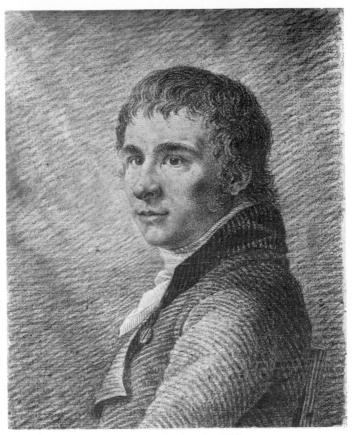

1 *Christian Friedrich, The Painter's Brother.* Ca. 1798

Friedrich too never came out of his straitened circumstances because he was shy and impractical, perhaps too good for this world. Especially after my father's death [F.G. von Kügelgen was killed while taking a walk, in 1820, outside the gates of Dresden], *Friedrich's life became more and more dismal; but the nobility of his soul remained unbroken. The rocky summit peering out of the fog towards the sun, that was his picture.*

Kügelgen is describing a trait of Friedrich's that was rooted in fact. Since the early 1820s, there were more and more critics who had no understanding of Friedrich's art or who condemned it. Like everywhere else in Germany, Dresden, where the painter had been living since the fall of 1798, was experiencing a new fashion in art. The Romantic view had been replaced by realism, whose theme was everyday life — thoroughly profane, middle-class narrow-mindedness, depicted with the detail and precision of a still life. The so-called early Victorian style (*Biedermeier*) replaced the highly intellectual, tension-fraught, and symbol-laden style of Romanticism.

By 1820, this shift was reflected in the critics' judgment of Friedrich's art: "From year to year, Friedrich is plunging deeper into the dense fog of mysticism; nothing is nebulous or bizarre enough for him; he broods and struggles to tense the mind to the utmost. Some of his paintings are no longer works of art." These lines appeared in Ludwig Schorn's art gazette, which was published in Tübingen and distributed throughout the educated strata of Germany. From 1830 on, the majority of voices condemned Friedrich's art: "It is unfortunate that a true talent, which Friedrich's was after all, had to perish in isolation." These words, as laconic as a conclusion, appeared in the *Morning Gazette for the Educated Classes* of December 1830.

At the same time, Friedrich's closest friends turned away from him, e.g., the physician and painter Carl Gustav Carus (1789-1869). In 1829, Carus wrote to a friend: "For once, I have to write about Friedrich in greater detail. For years now, a thick, gloomy cloud of mentally unclear conditions has been hanging over him, causing him to act gruffly unfair towards those who are near and dear to him and causing me, who openly spoke my mind about it to him, to detach myself from him altogether."

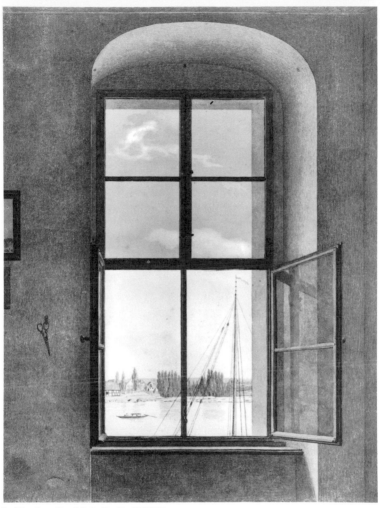

2 *View from the Artist's Studio.* 1805/06

Carus was a fine gynecologist and physiologist, who, as a painter, owed Friedrich a great debt. In 1831, two years after the above letter; Carus deprecated Hans August Marschner's (1795-1861) insignificant opera *Templar and Jewess* in respect to Mozart's music: "There is, to be sure, a strange relationship between this kind of music and Mozart's. It is like the relationship between a good painting by Friedrich and that of a Claude or a Ruysdael! [Claude Lorrain, 1600-1682, and Jacob Isaack van Ruysdael, ca. 1628-1682, were the most esteemed landscape painters of the earlier age in Carus' lifetime.] Modernity always has a certain quirk, a touch of disease, and yet, in his peculiar way, he can be highly intelligent . . . capable, and stimulating." One almost suspects that Carus, who admired Goethe and had dedicated a much-respected tribute to the poet, knew Goethe's statement (noted in 1829): "I call the classical the healthy, and the romantic the unhealthy."

One basic reason why the physician and painter turned away from Friedrich was that the artist Carus had surrendered to the new realistic conception. His *Gedenkschrift, Caspar David Friedrich the Landscape Painter, in memoriam, together with fragments from his posthumous papers,* came out in 1841, a year after the painter's death. A basis of Friedrich scholarship even today, it shows, despite the above comments, that Carus ultimately realized the greatness of the man who finally passed into solitude and madness.

Thus it was not in Friedrich's character to be "shy and impractical" in such a thoroughly altered time. However, his intellectual, artistic, and social isolation may be traced back to the uncompromising and unconditional nature of his actions and thoughts. Once he acknowledged something as true for himself and his art, once he realized what his task was, he stuck fast to it until the end of his life, exemplary in his refusal to conform. He admitted: "I am far from working against the demands of this age unless they are mere fashion, or swimming against the current; on the contrary, I really live with the hope that this age will destroy its own birth, and very soon at that. But even less am I so weak as to pay homage to the demands of this age against my conviction. I spin myself into a cocoon — may others do the same — and I leave it up to time to see what will come out of the cocoon, a gaudy butterfly or a mite."

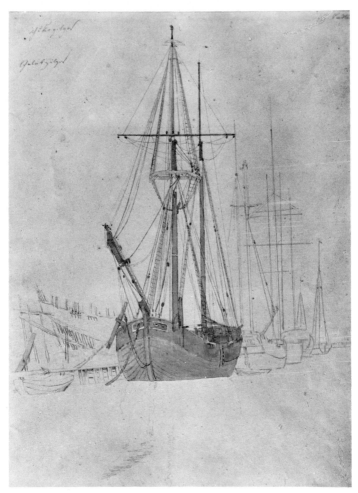

3 *Brigantine in the Harbor.* 1815

Let us establish the following: from our present-day standpoint, Friedrich seems like an exemplary figure of the artist whom his time ultimately fails to understand and passes over in silence. Wilhelm von Kügelgen was not so wrong when he compared Friedrich to the "rocky summit peering out of the fog towards the sun" (cf. Plate 2) — as banal as this may sound.

Thus it comes as no surprise that Friedrich had a rough hand, "more like a plowman or a carpenter." This was observed by the writer Friedrich de la Motte-Fouqué (1777-1843) when he visited the painter in 1822. Nor are we astonished that, as Carus wrote after Friedrich's death, he was a bad housemate during the last ten years before his death: "Distrustful as he was, he tormented himself and those near and dear to him with fancies about his wife's infidelity, notions that were sheer fabrications....Nor were harsh, rough attacks against his loved ones wanting." It all fits in with our image of the painter — this surliness, brutality and violence that contemporaries discerned in him. He preserved his childlike nature behind a wall of morose defensiveness, a wall that rose higher with the years.

In his memoirs, Wilhelm von Kügelgen also describes the time when Friedrich built a tower of stones in the middle of a brook with the help of children — and it was he who got the children to do it: "Friedrich, in a kind of fisherman's outfit, standing in the stream like a long-legged heron, arranged them [the stones] into a pyramid or column, which soon rose out of the water as tall as a man." Then the edifice was bombarded "with ineffable pleasure, for destruction is a great creative delight for everyone" — until it collapsed.

This little sketch reveals not only Friedrich's immediate rapport with children and his own joy in playing, but also a certain cryptic significance: the painter of the great symbols of ephemeralness realized himself in this game. And thus we may trace Friedrich's "very delicate, childlike sensibility" to a basic experience of ephemeralness and certainty of death. It was covered over with gentleness, until the dark depth of being and living virtually smashed through towards the end of his life, effacing all that was gentle, delicate, and childlike.

2 The Self-Portrait of 1810

The painter was thirty-five or thirty-six years old when he drew his
self-portrait in black pastel on a sheet of paper two hands wide. It is
Friedrich's most revealing picture of himself. And together with a
profile drawing that he must have done with the help of two
mirrors around 1810, it was the last portrait he ever drew. There is
hardly a book on the painter that does not include this likeness, and
the present volume includes it as well. There is a good reason for
this.

All of Friedrich's other self-portraits belong to earlier years and
show the artist before the age of thirty. However, this drawing, in
the State Museums of Berlin, depicts the painter in the fullness of
his strength, at a point when his art was finally affecting people,
even arousing enthusiastic approval. The controversies surrounding
his first great religious landscape painting, the so-called Tetschen
Altar (Plate 1), were behind him. The uncommonly positive
response to the 1810 exhibit at Berlin's Academy is in the
background of the self-portrait. Two landscapes, *The Monk by the
Sea* (Plate 4) and *Abbey in the Oak Forest* (Plate 3), had been
purchased by the king of Prussia. The painter had been elected to
the Berlin Academy by a vote of 5 to 4. Goethe and the younger
generation of literary Romanticism, Heinrich von Kleist and
Achim von Arnim, Clemens Brentano and Theodor Körner, had
understood both canvases and celebrated them in reviews, sonnets,
and bulletins as extraordinary works of art filled with the Romantic
spirit. Friedrich never found deeper understanding at any other
point in his life. Honorable purchases and similar acclaim came
only once more, in the year 1816.

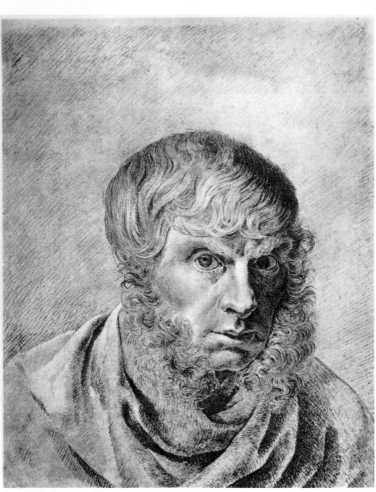

4 *Self-Portrait.* Ca. 1810

Gotthilf Heinrich von Schubert, a theologian, physician, and philosopher (1780-1860), described Friedrich's face as follows, around 1809:

> *For a countenance such as his was one that I had then and have since viewed seldom or never in another human being. It was by no means the sort that one calls handsome, it was rather pale and thin; but every single muscle, even when he was not moving, represented a powerful trait of character, which, because of the consistent frame of his mind, had become a set cast. The melancholy earnestness manifest in the features of the forehead was softened by the childlike, artless gaze of the blue eyes; a light touch of humor hovered over the mouth.*

The description generally fits the self-portrait of 1810 (Figure 4). However, the "childlike, artless gaze" is not to be found here. After all, the likeness is ruled by the eyes, whose gaze, composed yet unsettling, has nothing that we might today call "childlike." Anyone viewing the portrait for a long time, most likely remembers it well because of that look in the eyes. Today it is hard to judge whether this face was as extraordinary at first sight as Schubert claimed. Some things would speak against it. For instance, the Russian writer Vassily Andreievitch Shukowski (1783-after 1852) reported to his patroness in St. Petersburg about meeting Friedrich in June 1821: "Anyone who knows Friedrich's fog pictures and, on the basis of these paintings, imagines him as a reflective melancholic with a pale face and poetic brooding in his eyes is mistaken. Friedrich's face will not surprise anyone who meets him in a crowd."

In the roughly ten years between Schubert's account and this one, the painter could scarcely have changed very much. Alert, skeptical, dissatisfied — that is what might be said about the expression at first sight. Not conspicuous, not marked by any outstanding features. But the form of the portrait is bizarre: the head and shoulders fill approximately the lower two-thirds, while the upper third remains free. The crosshatched background, which is lighter up towards the head, is peculiarly empty; the crosshatching is denser in the head and clothing; the distribution of light and shadow is richly nuanced and striking. The figure gives an impression of compactness, which has something squeezed about

it, something pressed by the lower edge. This makes it seem as if the painter were looking up at the observer, which is actually not the case.

The painter's right eye is almost at the center of the portrait; all forms seem to be arranged around this point. If we focus on this eye, we notice that the face consists of two vertical halves divided by the bridge of the nose; the right half in the light, and the left half in the shadow. This gives the face a somewhat dichotomous, schizoid character. On the right, it is in the light — gentle, calm, rather clear; on the left, the eye menaces eerily from the shade, peering out of isolation. This brokenness deprives the portrait of anything smooth or apparent; and after longer viewing, we have to agree with Schubert: it is peculiar and unusual.

Here we have a portrait of an artist with certain parallels in Romantic drawings, for example the self-portraits of the Hamburg painter Philipp Otto Runge (1777-1810), whom Friedrich met in Greifswald, or Franz Pforr's (1788-1812) self-portrait (also from 1810, in Frankfurt's Städel-Museum), to which the drawing's severe silhouette can be related, or Carl Philipp Fohrs (1795-1818), or the self-portrait of the Heidelberg man who drowned in 1818 — or so many other portraits of artists in that time. They are all without affectation, vanity, or marks of social standing (how the painters of the seventeenth and eighteenth century loved to depict themselves as princes of art!). All of them isolated, very much alone, all of them avowals to themselves and their own brokenness. Friedrich's self-portrait arouses a sense of definitiveness. Everything seems anticipated here — the somber paranoia of his final years, and the strength of his tenacity. It is no coincidence that this likeness terminates the series of Friedrich's self-portraits.

Some people have thought that the painter depicted himself as a monk here, that his garment is a monastic robe. Certainly, the painter's figure has an ascetic touch, but he is not wearing a cowl. Wilhelm von Kügelgen remarked: "As different as their work-rooms were the appearances of the two workers themselves. My father, with brown hair and a clean-shaven chin, was always very neatly dressed; while Friedrich, light blond and sporting a Cossack's beard, was satisfied with wearing a long, gray traveling coat, which left it doubtful whether he had anything else on underneath; and anyone acquainted with him knew that this was not the case."

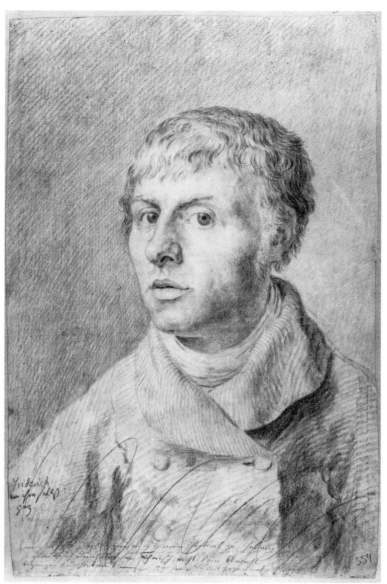

5 *Self-Portrait*. Ca. 1800

The painter has drawn himself here in this coat; for Kersting, who shows Friedrich wearing a topcoat and trousers in his studio pictures, is lying (frontispiece). This traveling coat probably struck him as too out of the ordinary, too eccentric and incomprehensible, for his contemporaries. If we imagine Friedrich wearing this costume at his easel, we realize how pompous Kersting's green studio rooms must have seemed. Kersting naturalized his friend, the painter, integrated him in society, and robbed his appearance of what made it so different from others, as his self-portrait shows us: its extraordinary quality, which was not due to interesting externals or conspicuous mimicry, but was comprehensible only to those who knew *whom* they were encountering.

We find nothing of the quick self-confidence of the successful man in this self-portrait. No triumph, only a solidity that takes later sufferings into account.

The seer's gaze which one would like to read into this portrait is not so obvious; there is something of the "Nordic seer," but it does not appear as the main theme of this face, it resonates without determining the whole. The simplicity in the self-depiction admits neither ebullient self-awareness nor prophetic illumination. This anything but vain self-questioning stamps not only this portrait, but all of Friedrich's life and thought. In this way, the drawing has none of the self-stylizing that suggests itself in self-portraits, and to which artists have so often fallen prey.

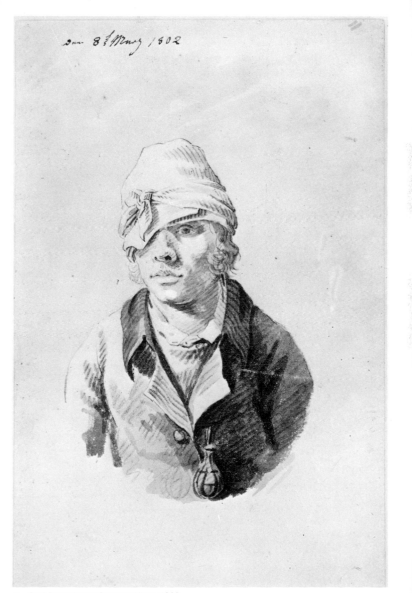

6 *Self-Portrait with Cap and Visor.* 1802

3 Friedrich's Studio

His manner was often somewhat stiff, but it contained the basic features of a great fidelity to nature and a fine observation, carried by a simplicity in the conception which often verged on meticulousness or emptiness.

Johan Christian Clausen Dahl, after 1840

We know what Friedrich's studio looked like, for his friend and companion of many wanderings, Georg Friedrich Kersting (1785-1847), painted four versions of it. These paintings, two of which are variants of the other two, were done around 1811. In one, Friedrich is holding a brush in his right hand, the palette in his left hand, along with a sheaf of brushes and the long stick that gives the painter a sure hold on the brush. He is leaning forward slightly over the back of a chair and gazing at the easel painting in front of him. The other painting shows the artist in the same room (cf. frontispiece). To the left, the window, its lower part covered with wooden shutters; next to it, on the wall, again the two palettes, T-square, triangle, and ruler. The right-hand window is totally sealed with broad planks. A table with bottles and a paint box has been added. But now Friedrich is sitting on the chair in front of his easel. He is painting a picture in which one can discern a waterfall cascading from a cliff. (This is probably the lost painting *Landscape with Waterfall,* done the same year as the studio picture, 1811.) The space is bare and strikingly sober. Contemporaries had the impression that this studio was ruled by "tremendous simplicity," as commented in a letter by the sister of the poet Theodor Körner (1791-1814), the singer and hero of the Wars of Liberation.

From his years in Dresden (1806-1809), Gotthilf Heinrich von Schubert has left us the following description of the studio:

Friedrich was living out in the suburb of Pirna, near the Elbe, in a house that, like most of the houses in the neighborhood, belonged to people of lesser means. The furnishings in his room fitted in quite well with this neighborhood; there was nothing to be seen but a wooden chair and a table,

16

on which tools of his trade were lying. If he had any visitor whom he wished to seat, then an old, wooden chair was brought in from the chamber, and if two people came, then a wooden bench from out on the landing by the staircase. For, aside from the old chair, the chamber likewise had nothing but an equal-ranking table and a bed, on which a woolen blanket was spread.

Wilhelm von Kügelgen, in his memoirs of his youth, describes the studio around 1813. He compares it to the "chaotic workroom" of his father, Franz Gerhard von Kügelgen.

Friedrich's studio, in contrast, was so absolutely empty, that Jean Paul [1763-1825, a popular German novelist] *might have likened it to the eviscerated corpse of a dead prince. There was nothing in it but the easel, a chair, and a table, above which a lonesome T-square hung as the sole ornament of the wall, and no one could grasp why it had been paid this honor. Even the highly justified paint box, together with bottles of oil and paint rags, was expelled to the next room, for Friedrich was of the opinion that all external objects disturb the interior of the pictorial world.*

Let us quote a third description from the year 1834. David d'Angers (1788-1856), a French Classicistic sculptor, was visiting Carl Gustav Carus in Dresden:

This evening we called upon the painter Friedrich. He himself opened the door for us. He is tall and haggard. His eyes, overshadowed by dense brows, have deep circles. He took us into his studio: A small table, a bed that looks more like a bier, an empty easel — that was all. The walls, covered with greenish distemper, were completely bare and unadorned; the eye vainly sought a painting or drawing. It was only after our long pleading that Friedrich dug out a few works for us....Friedrich's gift lies in the simplicity of his feeling and his line; his pencil has something of the laconic restriction of a great orator.

If we read these three descriptions together, we can draw a few conclusions about the artist's personality. From 1806-9 (Schubert), 1813 (Kügelgen), and the first versions of Kersting's painting around that time, until 1834 (d'Angers), the studio did not change. It remained the bare, sober space which contained only painting implements. Friedrich stayed true to himself for over

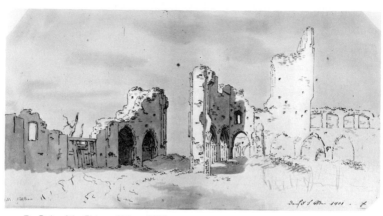

7 *Ruin of the Eldena Abbey.* 1801

thirty years in his views, his work methods, and the space he needed for his work.

Wilhelm von Kügelgen's father may have loved ingenious disorder in his work room, thus demonstrating a view of art molded by the notion of genius in the *Sturm und Drang*. But Friedrich's frugal studio offered not just an external contrast. It was ruled by a different artistic will, a different thinking, a different attitude towards art. Friedrich's friend von Kügelgen felt that "all imagination must waste away amid empty walls and in orderly rooms." But Friedrich would have been bothered by any superfluous furniture or equipment. Nothing was to insert itself between the imagination and the painting. The artist's studio evinces a will to concentrate. Which is why this room has something of a monastic cell about it. It is a place for meditation, in which thinking, looking, and creating become one.

And that is how Friedrich himself drew his studio around 1805. The drawing of his studio window (Figure 2) has the same economy of means, a rigorous directness, which, with almost terrifying harshness, shows nothing but the window view of the Elbe, just barely a piece of wall left and right, a pair of scissors, a bit of a picture frame, and, above it, a portion of a mirror. The viewer

gazes through the open window, undiverted by anything, just as the painter must have often peered through it himself: we step into the painter's place. This is also made obvious by Friedrich's self-portrait in the mirror. The forehead and the eyes suggestively compel us to participate in the artist's imagination. We gaze from bareness and narrowness into the rich outside.

The 1822 painting *Woman at the Window* (Plate 16) shows the studio in the apartment that the painter had rented since 1820. He had moved only a few houses away. His studio window again opens out on the Elbe, the row of poplars is visible, and whatever we see of the room is, aside from the window, similar to the drawing of 1805/06. This canvas of a meditation room and workroom stamps the impression of a cell onto our minds. It also shows the tension-fraught relationship between inside and outside, between confinement and immeasurable vastness.

"We are happy when the head and heart and hand keep an even pace with one another." And: "The only true source of art is our hearts, the language of pure, childlike feeling. Any work of art that has not sprung from this well can only be artificial. Every genuine work of art is conceived in a hallowed moment and born in a happy moment, often, unknown to the artist, from an inner urge of the heart." These are the painter's thoughts.

His studio reflects this attitude. This is where the work of art is conceived and born, this is where the "hallowed moment" takes place. The impulses for the work of art do not come from outside. No stimulating, sparkling atmosphere puts the painter in the right mood. The impetus really comes from an "inner urge of the heart." That is why there is something consistently matter-of-fact about the studio. Any necessary tools are within reach — nothing else. Even the spittoon was faithfully noted by Kersting in his picture (frontispiece). No studio could be emptier, more banal, more impersonal. And yet it is a mirror of the man, the painter and thinker Friedrich. For it is his personality that fills the studio. Without his personality, this is just any bare room that contains painting instruments as though they had been forgotten there. It is not the workshop itself that is holy or some kind of ascetic temple. Taken by itself, it is nothing. Only the artist gives meaning to the studio by working there, being touched by a good moment there, tarrying and brooding in front of his painting there.

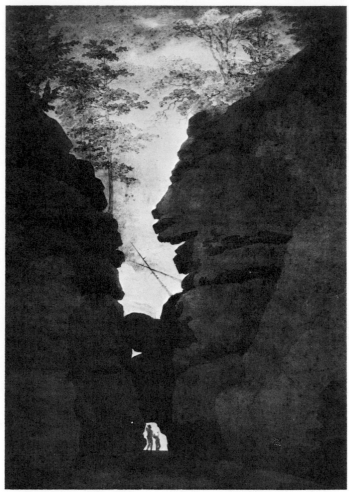

8 *Uttewald Abyss*. Ca. 1801

This conception of art is the basis of the whole subjectivity of Romanticism, which makes the individual's feeling and thinking absolute. "Many have received few things, few have received many things: the spirit of nature reveals itself differently to each man; hence no one must burden someone else with his rules and teachings as an infallible law. No one is a standard for all, everyone is a standard only for himself and for minds that are more or less akin to his." In this avowal, Friedrich dissociates himself from all traditions that are taken for granted — indeed, in a way, he distances himself from his time.

And he goes on: "Thus, man is not meant to be an absolute model for man; his goal is the divine, the infinite. Art and not the artist is what he should strive for! Art is infinite, the wisdom and talent of all artists are finite." Romantic subjectivity thus does not mean a glorification of the artist. Actually, he is the one who is given the power to set standards in his art for himself and for minds akin to his. Not because of his own perfection of power, but because he serves art, which is part of the divine. And because he knows and observes the limits of his "wisdom and talent." The studio is the limited room — demarcation lines could scarcely be drawn more sharply between inside and outside. It is a rigorously finite space, which admits the light and the sky: infinity is graspable only in the finite. The crux is not the artist and his studio, but art. The artist serves art exactly as the tools and the workshop willingly obey him.

4 A Harbor Painting

One of Friedrich's main themes is the sea: the view of the water from the shore (Plate 19) or of the coast from the sea (Figure 18), the unending surface of the ocean (Figure 63), the arrival of a boat in the harbor, the departure, the harbor itself.

This harbor painting (Plate 8), together with a now lost architectural painting, was shown in 1816 at Dresden's Academy Exhibition. It brought Friedrich an honorary membership in this art school and the accompanying annual stipend of 150 talers. That same year, both pictures were shown in Berlin, where King Friedrich Wilhelm III purchased them. The crown prince, later Friedrich Wilhelm IV, the "Romantic on the royal throne," received them from his father on his birthday.

Caspar David Friedrich spent August and September of 1815 in his home town of Greifswld, Pomerania. He went on hikes and revisited the island of Rügen, whose landscape had inspired and marked so many of his works. From these excursions he brought back drawings, which contain an unusual number of studies and sketches of boats. The drawing in Mannheim's *Kunsthalle* (Figure 3) is one example. Along with other sketches, it was used as a preliminary study for the harbor painting. The big topsail schooner on the left clearly goes back to the Mannheim study. Friedrich did the painting after his return to Dresden.

Obviously, Friedrich's homeland directly prompted the set of themes in his paintings — ocean, coast, harbor. We will continue to point out the artist's emotional dependence on the experiences and impressions of his childhood and youth and the Pomeranian landscape — things that he kept refreshing and deepening through long and — until 1818 — regular visits.

9 *Landscape with Meadows and Forest.* 1806

But not only Friedrich's themes were determined by the coastal region on the Baltic Sea. The painter received his pictorial form, space, and structure there, taking them to his Dresden studio as his suitable pictorial conception.

The *View of a Harbor* (Plate 8) is under the direct dictate of a new encounter with this landscape, with the ocean. However this does not imply that Friedrich based the painting on a specific, concrete situation. That is true of very few of his works. What it does mean is that his pictorial imagination received new but clear impulses from this journey. They are as much "pictorial material" as the ship sketches he did in front of the various objects. Thus, this harbor picture may be based on a certain visual impression, which, however, cannot be considered too complex — the experience of a special mood, a vision aroused by the eye. This painting is not a likeness of reality.

View of a Harbor is an evening picture. Between the masts of the two big ships in the middle ground, we see the thin, white sickle of the waxing moon at the level of the schooner's yard. The moon divides the powerful heavens — which rise from the low horizon and occupy almost four-fifths of the picture surface — into two

zones of opposite illumination. Beneath the sickle, the sky darkens, at first cloudy, then in stripelike thin layers of paint, from lightest yellow, to orange, flaming red, and finally a dull, dense brownish gray. Above the sickle, the area lightens into transparent silvery blue, with gray clouds reaching in and ultimately obscuring the sky toward the upper edge of the painting. In the brightest zone, which divides the cloudy gray from the yellow-red illumination below, the moon floats along, yet distinctly remains the center of the picture even though it is shifted to slightly above the midpoint.

The colors of the sky rule the entire painting: the brownish gray turns solid in the boats. It becomes a "material," richly nuanced brown in the hulls, masts, and rigging. The yellow-red is mirrored in the water, which is as stripelike and immobile as the sky over the horizon. Even the red Danish flag, the Danebrog, on the mast of the rowboat articulates this color tone just once more — as if in conclusion — with special emphasis. This colorfulness will be recognized by anyone who has spent evenings by the water. Yet it still has something unreal about it: the sickle moon hovers in the southeast over the reflection of the setting sun.

10 *Moon and Clouds.* 1806

The ships are virtually embedded in this color plane. They open the space into the depth or float — better: they hover — from the depths to the front, gradually becoming larger. They leave a passageway in the middle, directing the eye to the two vessels on the horizon, with the sickle moon above them. On the right and the left, the passageway is marked by the two large anchored ships. They loom from the watery surface and stand out significantly against the sky. The forest of masts, closer together behind them, finds its last degree of intensity in their masts and ropes. These two sailing vessels seem to symbolize the theme of departure and arrival.

The ship on the left has its prow toward the beholder; the ship beyond it is coming in; its sails are brailed up. The ship on the right, a brigantine, has its stern towards us, as do, apparently, the ships behind it. The schooner far in the background on the central axis of the picture (the axis runs along the mainmast) is seen from the side. It is performing a heave maneuver towards the left, aport. It is as if the stationary ships were forming a kind of horseshoe diagonally to the right, into the picture space, starting right, ending left, and opening out to the front.

In front of the opening of this arc, we see the boat with the rowing men, a silent shape. The two oars sweeping out on each side and the pole (which the man standing in the prow holds vertically, like a measuring rod) almost make this silent shape look as if it were at the crossing point of two coordinates.

The masts strike rigid verticals against the horizontal stripes of the sky and against the water. The highest masts loom into the diagonally torn clouds, which form a transition between the graphically vivid order of the pictorial surface and a lighter, more dynamic area.

The harbor painting gives the viewer an impression of vast stillness, which resides formally in the picture's symmetry. This symmetry arranges each object in its fixed place: the large ship on the left corresponds to the one on the right; one forest of masts balances the other. These are not rigid correspondences, but lively variations of similar groups of forms.

The foreground is occupied by the empty surface of the water — the two large ships just barely belong there. Everything receding into the distance lies further back. The beholder's viewpoint is low. We might be standing on a bridge protruding into the water.

25

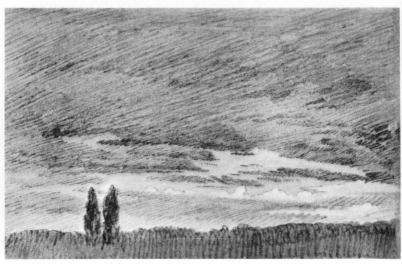

11 *Landscape with Two Poplars*. 1806

The red-flagged boat in the foreground is rowing from the lower edge of the canvas, from the shore, into the background. It is pushing the ships, the horizon, and the sky mutely and motionlessly away from us into an ultimately hazy distance.

People have thought that Friedrich saw a symbol of death, the terminal station of all life, in the harbor. In contrast to this token of death, the heavens may spell promise, the waxing moon may signify hope.

Critics have tried to make this reading of the picture more concrete (moon=Christ). But we must not forget that such an interpretation takes only one aspect into account. For not everything is silent here. A sailor is climbing through the yards, men are repairing the hull of the ship at the left, two figures can be discerned in a boat at the left-hand edge of the canvas. Granted, the rowers in the boat in the foreground are pausing, for they have lifted the oars out of the water. But in another instant, they will keep on rowing. So we are not dealing with the total muteness of

death. The picture remains a depiction of a harbor, in which the active life of departure is also breathing. The symbolism is a thin veil upon this picture; it does not suffocate everything, but rather, it pays its due to the visual truth of the painting.

We cannot tell whether this picture shows the harbor of Greifswald, for we do not see the characteristic silhouette that Friedrich often painted. As a matter of fact, we really perceive nothing of a harbor. The limits of the canvas on the right and left are chosen in such a way as to make it appear that the anchored ships are safe and snug in a harbor. Where else could all these ships and boats be gathered?

However, it is more than probable that this painting has a direct kinship to the harbor in Friedrich's home town. The image of this harbor must have impressed itself upon his mind from childhood on. Here, it is purified, ordered, filled with meaning, and preserved in the work of art.

5 Greifswald

Friedrich, the landscapist of a totally Nordic, Ossian-like nature, raised in its icy air and on the Baltic Sea's chalk cliffs, which are lapped at by dark waves; everything that he is, [he is] through himself and through an attentive study of his cherished homeland.

Rühle von Lilienstern, 1809

Caspar David Friedrich was born in Greifswald on September 5, 1774. His father, Adolph Gottlieb Friedrich (1730-1809) was a soap boiler and candlemaker, who had been living in this Pomeranian university town since 1763. Like the painter's mother, he originally came from the town of Neubrandenburg in the province of Mecklenburg. Thus his background was by no means that "of an old dynasty of counts, which had been expelled ages ago because of its Evangelical creed, from its old ancestral seat of Friedrichsdorf in Silesia, and had moved to Pomerania." This is a legend recounted in Wilhelm von Kügelgen's memoirs. But one thing *is* correct: Friedrich grew up in a pious home molded by Protestantism. His thinking was determined for all time by that religion.

Caspar David was the sixth of ten children. Three of his siblings died in childhood. His mother died in 1781. After that, a housekeeper ran the household and brought up the children — "Mother Heide," with whom the children had a loving relationship. A tutor instructed the children, which would make it appear that the family enjoyed a certain petty-bourgeois prosperity.

The painter's childhood was shaped by his father. This man was an upright moralist, as the saying goes: strict and just. At any rate, his children, even as adults, had a trusting relationship with one another. The extant letters, especially those to and from the painter, testify to that fact. A younger brother, Christian (1779-1843) was a carpenter and woodcarver, and he worked closely with his painter brother. It was Christian who did the woodcuts based on Caspar David's drawings (for example, Figures 21 and 22).

Their hometown of Greifswald had been under Swedish control since the Thirty Years' War. During Friedrich's youth it was a

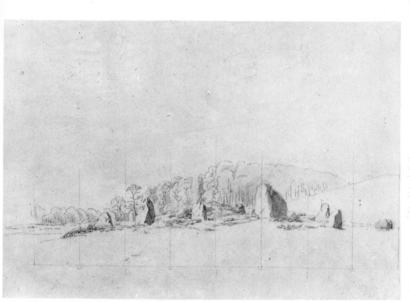

12 *Rock Formation at Nobbin.* Ca. 1806

small town where time stood still. Trade was meager; there were no major commercial or business enterprises. Not even the university brought much life to the poor streets, whose housing had scarcely changed in two or three hundred years. It was a town on the border of Prussia, a Swedish outpost on the mainland, losing more and more political significance. In 1815, this anachronism was ended. Greifswald became Prussian.

Intellectual stimuli were scarce; the existing ones must have affected Friedrich all the more. His first teacher was Johann Gottfried Quistorp (1755-1835). A drawing instructor at the university of Heidelberg (like Ferdinand Rottmann, 1768-1816), he had educated three early Romantic painters: Carl Fohr, Ernst Fries, and his own son, Carl Rottmann. It was with Quistorp that Friedrich mastered the elements of drawing. He was most likely taught according to a system that was generally part of academic training. Friedrich had to do object drawings of copper engravings or books, both figures and landscapes.

Thus, early on, he got to know the Baroque concept of the figure and the pictorial inventions of the landscape painters who were considered the acme of landscape art during the late eighteenth century. These included the Netherlanders Jacob van Ruysdael, Aert van der Neer, Jan van Goyen, and the famous French landscapist, Claude Lorrain. Copying was supposed to "train the hand" and school the eye. It transmitted the art of older painting to the pupil and taught him to employ certain formulas correctly in a picture, for instance, the leafwork of trees, cross-hatching, the arrangement of light and shadow. It also showed him how to achieve a good pictorial effect. As a teacher, Quistorp, who was actually an architect, must have valued precision and careful execution. He owned a vast collection of prints and paintings, which contained the material he showed to his students.

Nevertheless, it has been established that Friedrich did not excel in any special accomplishments when he entered the Academy of Copenhagen in 1794. His drawing lessons with Quistorp evidently inhibited Friedrich more than they helped him. The extant graphics from this time demonstrate Friedrich's insecurity. Studies in and of the reality of nature appear to have been exceptions.

Crucial to his views was, above all, Gotthard Ludwig Kosegarten (1758-1818), a writer who was highly renowned in Pomerania at that time. This theologian had been administering a parish in nearby Wolgast since 1785. In 1792, he became a provost in Altenkirchen, Rügen. Kosegarten was a friend of Quistorp's. Thus, both directly and indirectly, he had some impact on young Friedrich's opinion. It is certain that by 1805 he already owned "three or four sepias" by the painter, and that he was one of the first to recognize Friedrich's importance as an artist. Kosegarten also strongly influenced another founder of German art: Philipp Otto Runge, who came from Wolgast.

Kosegarten exposed Friedrich to the intellectual world of *Sturm und Drang* and German classicism. Just a few years later, Friedrich tried to get Goethe's attention, and it may be assumed that this wish had already burgeoned in Greifswald and was stirred up by Kosegarten.

The poet and theologian preached the emotional piety of the Enlightenment. He venerated the poet Friedrich Gottlieb Klopstock (1724-1803) and was familiar with English religious

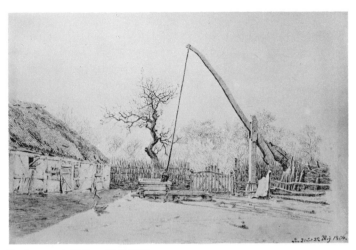

13 *Farmyard with Draw Well.* 1806

literature of the eighteenth century. The heroic epic *Ossian,* a series of cantos, was supposedly by an ancient Scottish bard; it was only decades later that it was recognized as a brilliant work by Macpherson, written in the ancient style. *Ossian* filled Kosegarten's thoughts and verses, just as it cast a spell on so many other minds of that era. Thus Kosegarten celebrated primordial Nordic nature and linked theologically dogmatic rationalism to an emotional mysticism of nature. In Rügen, he had found Ossian's landscape, and he propagated its fame in his writings. Friedrich was consequently following in Kosegarten's footsteps when he first visited Rügen in 1801 and discovered this landscape for himself.

Friedrich, through Kosegarten, may have made an early acquaintance with ideas that, since 1797, had been the basis of an esthetics of literary Romanticism by the poets and philosophers Tieck, Novalis, Schelling, and the Schlegel brothers. We could mention Johann Gottfried Herder's (1744-1803) statement about the symbolism of natural phenomena, or Johann Georg Hamann's (1730-1788) conviction that God reveals Himself equally in Scriptures and in Nature. Kosegarten gave "shoreside sermons,"

31

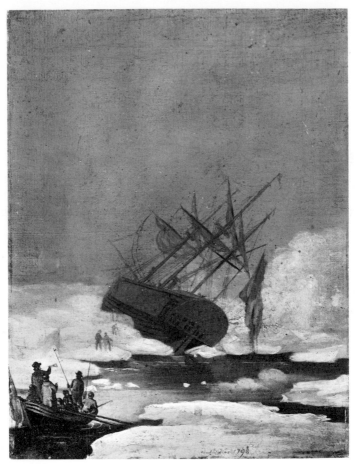

14 *Wreck in the Polar Sea.* 1798

which made quite a sensation. In these sermons, he linked rigid theological principles to a subjective sense of nature, mixing Enlightenment theology with irrational pantheism. He also advocated the view that primal beauty, like the divine, is revealed in Nature itself, that the experience of Nature is a divine workshop leading directly to the experience of God. Primal beauty, however, he said, is also present in the work of art, and thus the devout contemplation of art can likewise be religiously edifying. For it is the task of art to mediate between God and man. These ideas must have had a profound effect on Friedrich, who, in his work, made a vast attempt to create a new form of religious painting with the methods of landscape art.

Friedrich's pantheism was presumably also stimulated by the poet, philosopher, and historian Thomas Thorild (1759-1808). The latter became a professor and university librarian at Greifswald in 1795. His ideas were rooted in Leibniz, Spinoza, and Shaftesbury. An ardent pantheist, he believed that the divine is operative in each single individual, and that the knowledge of divine omnipotence comes about in the soul of each human being: "One can find only what one can feel." Later, in his aphorisms, Friedrich said: "Painters practice inventing, composing — whatever they call it, is this not another way of saying that they practice mending and patching? A painting must be felt, and not invented." Friedrich had obviously taken over a few of Thorild's ideas here.

As of 1803, when Friedrich was doing his first important pieces in the sepia technique, he saw the work of art as "depicting — free of rules — an inner pictorial world" (Sumowski). Nature, for him, was imbued with divine forces; God revealed himself in nature, the individual human being could take part in this revelation with his "head, heart, and hand," the "hand" pertaining especially for the artist.

Thus the years in Greifswald were rich with impressions for Friedrich. They were in no way confined by any provincial dullness, as one might think. We can be sure that the "seeds" grew slowly in Friedrich. It was only after 1800 that these impressions took shape in his art, but they remained one of the determining coordinates in his *oeuvre*.

6 Three Portraits

Friedrich began achieving independence as an artist around 1800. Quistorp's lessons had resulted only in the general things that a pupil produces: Friedrich's drawings from his period at the Copenhagen Academy were overshadowed by his teachers, and they are also strangely dilettantish. The surviving sketches and studies from around that time free themselves only hesitantly from the things he had learned or else gleaned from other artists — important as these works may have been for his art in the coming years. This process is evident in his early portraits.

The picture of his brother Christian Friedrich (Figure 1) was done after the painter left Copenhagen in 1798, returning to his parental home in Greifswald for a few weeks (before going on to Dresden in October). At home, he drew not only his brother, but also his father, the housekeeper Mother Heide, his sister Catharina Dorothea, and a friend of the family's, the vicar and writer Ernst Theodor Johann Brückner. These portraits were done in soft black chalk and in a hatchwork technique that was obviously fashioned after the works of French engravers of the late eighteenth century. This training could have taken place only at the Academy in Copenhagen. The so-called crayon manner imitated the crumbly, transparent stroke of chalk in the technique of drypoint. The drawing was engraved on the etching ground and then mechanically gone over with a small hammer, whose striking surface was studded with punctuated elevations. This technique reflected upon the technique of drawing, at least in the academies, which had their students copy engravings for drawing practice. Around 1800, these parallel chalk strokes could be found in young artists everywhere, especially academy students.

Friedrich's portrait of his brother shows a conventional sureness. With its clear stroke (on rough paper, which has turned slightly yellowish), the conception may be called late Baroque. The evenly worked background — which lightens only around the facial contour of the subject, thus creating space for the head — is an element of academic training. The subject's expression, friendly but detached, is a late Baroque convention. The leftward turn of the upper body and the semi-profile of the head, are also in that same tradition. These devices are supposed to give room to the body on the surface of the drawing. Friedrich evidently developed into a fair drawer of portraits at the Academy, as shown by the portraits of his other relatives as well. The almost routine treatment of the portrait problem and a vast outlook contrast strikingly with the unsureness of Friedrich's works using landscape or figure motifs during his Copenhagen years.

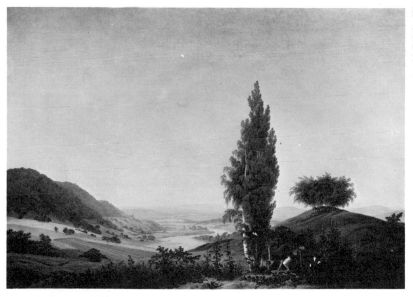

15 *Summer*. 1807

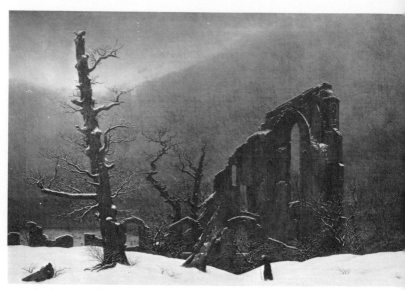

16 *Winter.* 1808

The self-portrait from around 1800 (Figure 5) was given to Friedrich's fellow student at the Academy, the Danish painter Johann Ludwig Gebhard Lund (1777-1867). Lund, who subsequently joined the group of German Nazarenes in Rome, visited Friedrich in Dresden in 1799/1800 and corresponded with him until the 1820s. During his sojourn in the Saxony, Lund did a "big" portrait of his apartment-mate Friedrich. And Friedrich sent him his portrait in exchange, since he had painted Lund's picture over. Hence the caption in Friedrich's hand: "If you were serious about having my portrait, I feel I have not acted unfairly with this exchange."

Friedrich once more used black chalk here, but the lines, again parallel fields of strokes, are finer now. The drawing is altogether less rough, it is gentler and more transparent. The artist's attention is concentrated in the face. Its plastic presence is brought out so to speak from the background to the foreground by the distribution of

hatchwork shadows and untouched light areas. The head is turned left from the frontal view into a half profile, thereby resembling the posture of Friedrich's brother Christian. However, the torso, which is drawn far more hastily and seems sophomorically rigid, is shown almost from the front.

The overall conception has changed. This may be partially due to the presence in Dresden of one of the most famous portrait masters of the late eighteenth century, the painter Anton Graff (1736-1813). However, there is a new expression captured here, recalling the self-portraits of Philipp Otto Runge. It is the seriousness, the open, self-revealing gaze, which betrays doubt and yet also an uncertain strength of young self-assurance, which capture the viewer. This portrait has something of a mood of departure about it.

The drawing technique, which operates with parallel strokes, remained intrinsic to Friedrich. It became progressively more precise (cf. the tree studies of 1809, Figure 20); at first it was treated freely and loosely (cf. the sailship study of 1818, Figure 17); it became sharpened and used deliberately as a constructive element (cf. *Eldena Ruin,* 1825/28, Figure 38). Its descent from the old crayon manner remains obvious, even in Friedrich's late drawings. This refinement and animation of the lines was possible because after 1800 Friedrich drew normally with a pencil and rarely with chalk.

The third portrait (Figure 6) is once again a self-depiction. It is dated March 8, 1802, by the artist and drawn in a technique that Friedrich developed in those years and kept using until the end of his creativity. Over a pencil drawing, a wash drawing in brown sepia ink is applied with a brush, adding fields of shadow and light — that is, painterly components — to the lines.

It is the picture of the artist at work. Hence, on the one hand, it has nothing of Romanticism's narcissistic self-depictions devoted to the artist scrutinizing his own image in a mirror; it has nothing of Friedrich's portraits from 1800 (Figure 5) and 1810 (Figure 4). On the other hand, it exhibits the self-confidence of a man who is in the midst of utterly absorbing work, in which every step opens up a whole new realm. The portrait exudes the self-assurance that comes from the successful conquest of an independent plan of work. Here, an artist has found himself.

17 *View over the Prow of a Sailing Ship.* 1818

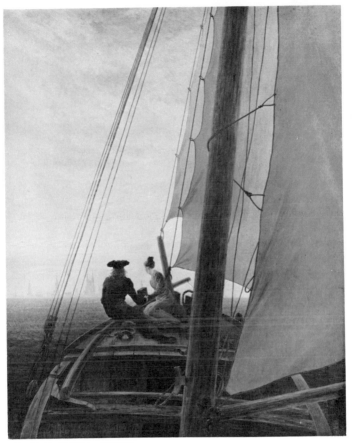

18 *On the Sail Ship*. 1818/19

The visor flap over the right eye, the bottle of sepia ink buttoned to the jacket, the self-possessed, almost defiantly raffish expression on the face — they show an artist in full command of his strength, making one forget the old-fashioned approach determined by tradition. The very brush wash has added plastic, painterly values in a way an artist would have used them in the late eighteenth century. If we compare this wash with that of later drawings (cf. Figures 17 and 39), the difference is obvious. Later, Friedrich used the wash to shade the planes. He no longer focused on demonstrating volume or achieving a loose painterly spontaneity. He simply wanted to clarify graphic structures. The wash no longer had its intrinsic value.

A year after this self-portrait, in 1803, the breakthrough came. Friedrich produced a number of sepia works in a large format. From year to year, they improved so greatly in form, technique, and content that Friedrich finally dared to pick up a brush. In 1807, he did his first oil paintings.

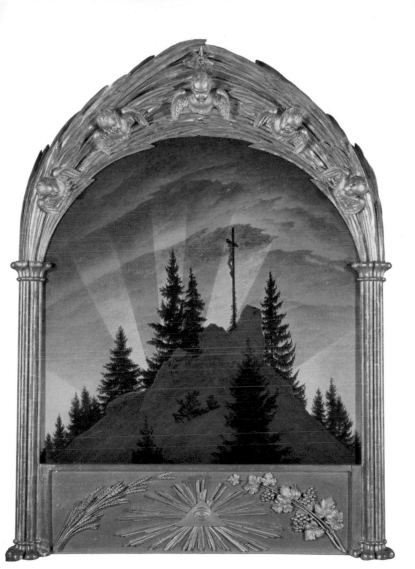

1 *The Cross on the Mountain* (The Tetschen Altar). 1807/08

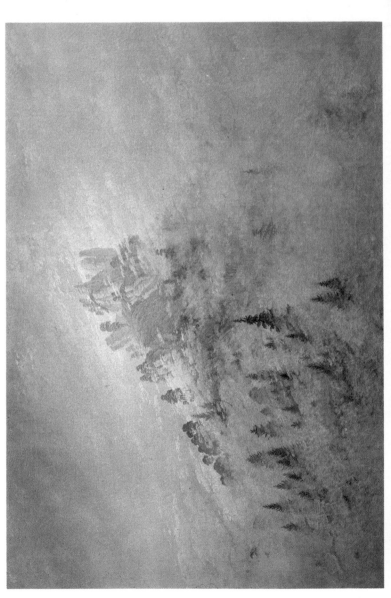

2 *Morning Fog in the Mountains.* 1808

3 *Abbey in the Oak Forest.* 1809/10 ▷

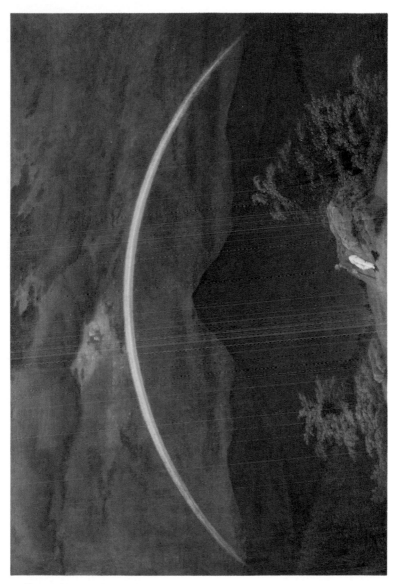

5 *Mountain Landscape with Rainbow*. Ca. 1810

◁ 4 *Monk by the Sea*. 1808/10

6 *Garden Terrace.* 1811/12

7 *Morning in the Giant Mountains.* 1811 ▷

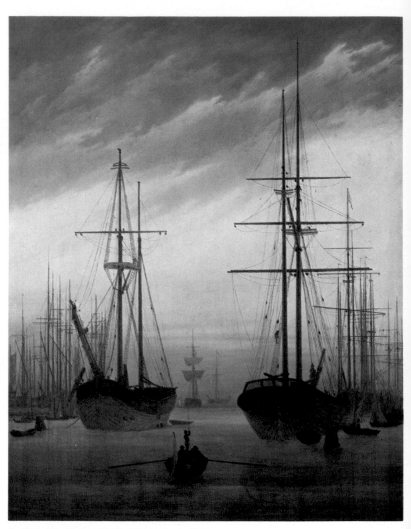

8 *View of a Harbor* (Greifswald Harbor). 1815

7 The Academy

I have also said that...in our time, the academies struck me as merely satisfying the vanity of the rulers to whose royal households they belonged, and who thought they had done everything if they spent huge sums maintaining academies...so that one should wish that this tyranny, which cripples genius in the cradle and deprives the state of so many useful citizens, would some day come to an end.

Asmus Jacob Carstens, 1795

Friedrich was twenty years old in 1794 when, recommended by Quistorp, he traveled to Copenhagan to study at the Academy of Art. For the towns along the Baltic Sea, the Danish capital was a natural partner or opponent — in any event a constant in every political or economic reckoning. Denmark's cultural importance, centered in Copenhagen, also exerted a fascination on her neighboring countries, especially during the eighteenth century, when the cultural strength of the old Hanseatic towns was either moribund or not yet restored. It was thus not by chance that Friedrich went to Copenhagen like Asmus Jacob Carstens before him (1754-1798, in Copenhagen 1776-1783), or like Philipp Otto Runge after him (Runge, who was born in Wolgast near Greifswald, spent the years 1799-1801 in Copenhagen).

For Scandinavians, like Friedrich's later housemate and friend, the Norwegian Johan Christian Clausen Dahl (1788-1857, in Copenhagen 1811-1818), the Danish Academy was taken for granted as the first station of their training in art, particularly since tuition was free for both natives and foreigners.

The Danish art school had a good reputation. The faculty included artists whose works and personalities were by no means provincial, but occupied a prestigious rank on a European scale. Friedrich studied with two of the most important of these men: Nicolai Abraham Abildgaard (1743-1809) and Jens Juel (1745-1802). Both integrated the ideas of the "Nordic Renaissance" into their works. However, their artistic ambitions aimed elsewhere.

Abildgaard was essentially a figure painter indebted to the rules of classical form, which he combined with the painting legacy derived from the Baroque. This approach was characteristic during

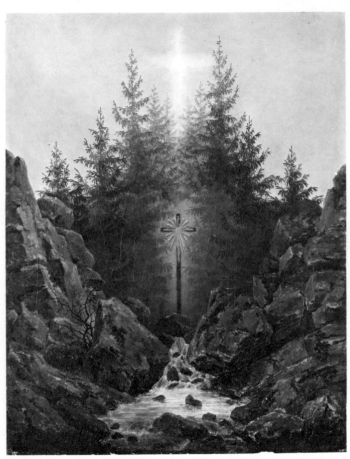

19 *Cross in the Forest*. Ca. 1835

the decades after 1770. But he virtually tore it apart with the daring proportions of his overly slender, stretched-out figures and his tremendous, impressive pictorial layouts, which were transmitted to him by the Swiss painter Johann Heinrich Füssli (1741-1825). Füssli had been working in England since 1778, and the two painters had met while studying in Rome.

In Abildgaard, Kosegarten's ideas found a kind of pendant in the field of plastic art. Abildgaard too was deeply impressed by Ossian's fantastic northland vision. Pictorial themes from this realm of heroic myth and legend were important for his work, as were Shakespeare's writings, which had a profound effect on the art and literature of German Romanticism at that time.

Jens Juel was a portraitist, indeed the most important Danish portraitist of his time. As a landscapist, he had developed his approach from Dutch landscape art of the seventeenth century (A. van der Neer). Not an untalented epigone, but rather a typical representative of the late eighteenth century, Juel reanimated the old pictorial formulas with an intense study of nature, thus finding his way to a personal style. His landscapes, which do not add up to a large number, form a parallel to works of German landscapists like Johann Christian Klengel (1751-1824) in Dresden or Ferdinand Kobell (1740-1799) in Mannheim. What Juel shared with them was a powerful realism of immediate freshness. Indeed, as an excellent colorist, he outdid both German painters in the modernity of his pictorial language. Atmospheric values and a precisely calculated, spare structure were essential to his art.

We should also mention Christian August Lorentzen (1749-1828), a painter of so-called Sentimentalism, whose training under Jean Baptiste Greuze (1725-1805) in Paris is apparent throughout his works. But he not only painted portraits and historical and genre pictures, he also did landscapes close to Ruysdael's and Everdingen's pictorial approaches. Along with simple, down-to-earth views, there are highly emotional, theatrical "tempestuous" landscapes. The study of reality had left scant impact on Lorentzen's work. Next to Abildgaard and Juel, he appears traditional, schematic, and unoriginal.

The influence of these teachers upon Friedrich can be clearly demonstrated, and it kept resurging until around 1815. Abildgaard probably first impressed the young man in Copenha-

gen. Perhaps it was the example of his Danish teacher that led Friedrich to feel he was a historical painter: as late as 1801, in Dresden, he exhibited a composition inspired by Friedrich von Schiller's drama *The Brigands*. After all, in the academic hierarchy, which was also valid in Copenhagen, historical painting was regarded as the highest level to which a painter could aspire. Portraits and landscapes were considered less difficult and hence less serious or glorious.

Abildgaard in particular, as a major exponent of the ideas of the "Nordic Renaissance," must have had an effect on Friedrich. This Renaissance notion describes a phenomenon in intellectual history. Strongly influenced by the development in England, this Renaissance occurred in Scandinavia, especially Denmark, during the second half of the eighteenth century. It was not just Ossian that captivated artists' minds, but the entire old Nordic world. Not only were the ancient heroic sagas and lays discovered — like the Icelandic Edda poems or Saxo's chronicle, but the monuments to the past in the country itself — the Germanic rune stones, graves, and cult sites as well. This new world of motifs and figures was played out against the tradition of classical Antiquity that had operated until that point. People drew the tapestries of Bayeux and copied from writings on English and Scottish antiquities. They tried in this way to open up new wellsprings for art, to infuse rigid, venerable conventions with a breath of fresh air. They found new symbols and a new mythological field of reference that could be used as a bearer of religious concepts.

Copenhagen was the center of this movement, and Abildgaard, within the framework of the Academy, was one of its spokesmen. When Friedrich opted for landscapes, the formal model of his teacher faded, but the intellectual stamp remained effective. As of 1800, Friedrich took ruins, graves, and rock formations into his pictorial world, which also indicates that his sojourn in Copenhagen had left a powerful impact on him.

Of all the teachers at the Copenhagen Academy, Jens Juel, who also instructed Friedrich, must have had the most lasting influence on the draftsman and painter. His love of optical effects and everyday motifs, like the northern bays, farms, and villages, which he treated with a sense of down-to-earth simplicity, were important for Friedrich.

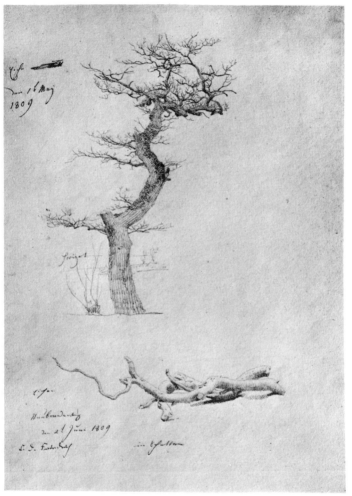

20 *Tree Studies.* 1809

The young man from Greifswald had gone through the academic training with no sign of bad grace, but also with no outstanding accomplishments. On the other hand, Juel's Romanticism directly influenced Friedrich's work, but became truly relevant for Friedrich only after 1800, when he finally decided upon landscape painting. We have to conclude that the road leading to a new awareness took Friedrich an unusually long time. He was a late bloomer. The very fact that he did not begin his academic training until the age of twenty was exceptional in his time.

It seems as if Friedrich subsequently blamed his slow development on his academic schooling. His attacks against the academies would speak for that assumption. They are linked to the resistance the Romantics showed to the onesided teaching methods of the art school, methods that were tailored to the average mind. This protest was also aimed at the conception of art that was transmitted at the academies. "Not having been instructed is often a boon for intellectually gifted men. All the teaching and instructing, as we have said, all too easily kill the spiritual in men and raise something like wretchedness to mediocrity. The damage is greater than the possible gain." These words, written by Friedrich around 1830, condemn his period in Copenhagen, to which, when viewed objectively, he owed a great deal. Across the decades, his ideas coincided with those of Asmus Jacob Carstens, the first declared adversary of academic training in German art history.

8 *The Great Pasture*

This painting (Plate 23) was done during the artist's final creative period. He completed it around 1832, eight years before his death. The landscape it shows lies before the gates of Dresden; the river that has flooded the adjacent meadows is the Elbe. The countryside is deserted; only the barge with the hoisted drift-sail indicates the presence of human beings.

We observers stand above the landscape as though on a high pulpit. The flooded meadows begin below us. Thus the landscape builds up in thrusts of form, across the severely articulated clumps of trees, to the horizon, above which the vaulting sky covers more than half the pictorial surface. The whole thing virtually floats away beneath our feet towards a point in the center of the picture, marked more or less by the middle clump of trees in the background. More precisely: the central axis of the painting runs along the right-hand contour of the single tree standing isolated to the left of this group. Here, the shape of the picture is bound together; here, earth and heaven seem closest together: from this point, the bank of clouds fans out left and right; from here, the lines of the landscape glide out to the lower left and more gently to the right.

At first glance, one gets the feeling that the vast clarity of this picture is due to its strict orderliness. For it is obvious that two main lines determine the painting: the binding together in the middle produces the form of a hyperbola, which is marked above by the gray cloud bank over the horizon and below by the river embankments and the dead river arms: two curves, whose vertices meet, one from below, from the earth, the other from the zenith. Other lines converge toward these two main lines as though being

sucked into them: the outlines of the water puddles; the shoreline of the Elbe, running from the right as though from far away and then sweeping out towards the lower left; the narrow strips of cloud, moving away from the main line in the sky as if thin threads were pulling out of a powerful trajectory.

If we take a closer look, everything grows more complicated. The hyperbola loses its simplicity. It obviously spreads apart more strongly towards the left. These two movements — the flood area moving away from the lower edge of the picture and floating into the background, and the yellow reflection from the setting sun overhead — are joined by a third. This third movement, enveloping the two others and drawing them away, is the slow, inexorable motion from right to left, distorting the hyperbola shape toward the left.

Between the two curves stand the rows of trees, gradating in two parallel lines from left to right toward the horizon. Each shift diminishes the size of the trees, as though a kind of staircase were leading into the distance. The perspectives change. Deep vistas are opened and blocked. The actual depth of the picture, the final stratum of space, remains in uncertainty. The painting offers an apparent vista of endless space, which draws the observer into it, but simultaneously moves away, far and near at once; just as the form of the picture is simple and clear on the one hand, yet complex and intricate on the other. This network of contrasts gives the painting its tenacious tension. Thus the underlying structure of *The Great Pasture* is not stable, with all its forms and lines in motion. Yet the structure is so distinct that it could be detached as an abstract form from the painting — if it were not linked by the sensory power of the imagination to the objectiveness of the landscape picture.

The first impression of total orderliness includes the cool, rich colorfulness of the painting. It is ruled by three tones: earthy green, which lightens into milky olive; the steel blue of the strips of cloud over the horizon; and the yellow of the sunlight, which melts into watery-bright gray towards the zenith. The sickle of the waxing moon floats through it. The yellow shimmer of the sky is reflected in the pools of water. Endless color nuances of great precision make the picture a miracle of color wealth. Here too, we see that its

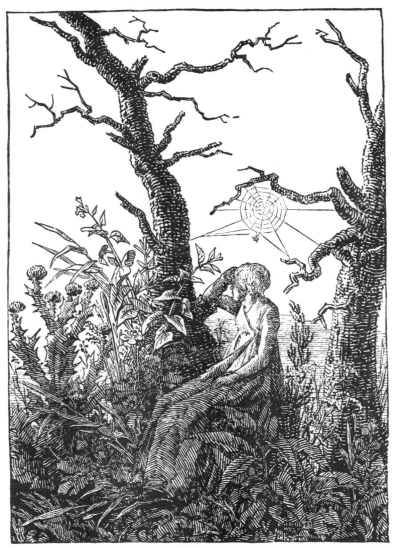

21 *Woman with Cobweb between Bare Trees* (Melancholy). 1801/17

initial clarity is lost in an inexhaustible, mysterious ambiguity. The paint is thin, with the brilliance of enamel.

The harmony of the colors is extraordinary. It almost appears to be fixed only for an instant before passing on like the barge that slowly drifts by. The barge moves in utter silence, like a ship of the dead, leftward through the painting, following the overall stream of the forms.

Strangely, we see only a fragment of the Elbe. It emerges from high embankments on the right parallel to the lower edge of the canvas; on the left, the river vanishes again in a ravine that bends downward, as though drawn by an abyss.

This is an autumn picture, at evening; the night is already pressing in from below. "This highpoint of beauty is not portrayed for itself or for the sake of artistic virtuosity, but rather as a symbol of Christian dying." That is how Helmut Börsch-Supan interprets this painting. He may have hit the nail on the head, but he is really just summing up the emotions that everyone has upon viewing this work. Yearning for death and promise — that is the statement of this painting. If one tries to hunt down and name this statement in all the details of the picture, the whole thing disappears in a mental construction. Friedrich reveals himself here as a painter of the highest sensibility. Sensory enchantment and religious conviction have become one. Who would want to pull them apart?

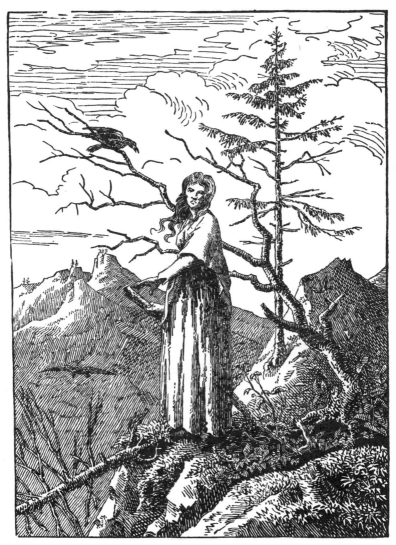

22 *Woman with Raven at the Abyss.* 1801/17

9 Dresden

In Dresden, he always kept himself very isolated, not attaching himself to any of the professors, and thus gradually developing his own deeply poetic, though also somewhat dark and rugged landscape style....He was almost never seen in the company of others....

Carl Gustav Carus, 1865

Friedrich lived in Dresden as of October 1798. He died there on May 7, 1840, after suffering a stroke in 1835, which made oil painting almost impossible for him. In 1805, he lived at number 27 On the Elbe, at the gates of the suburb of Pirna. From 1820 until the end of his life, he lived at number 33 On the Elbe.

The painter must have had definite reasons for settling in the capital of Saxony. Of all the German academies around 1800, the one in Dresden (founded in 1764) was the most important. The one in Düsseldorf (founded in 1774) was a regional art school, which gave no inkling whatsoever of its subsequent brilliance. The academies of Munich (1808) and Karlsruhe (1854) did not yet exist. Friedrich evidently realized that he still required systematic training; and aside from Dresden, only Vienna (1725) or Berlin (1696) was worth considering. It was by way of Berlin that he traveled to Saxony, and he must have looked about in the Prussian metropolis. Was the city too big for him, or too cold and prosaic? Did the flat landscape of Brandenburg fail to appeal to him? Evidently, he didn't care for the Berlin academy either. And Vienna? One need only imagine the native Pomeranian in the capital of the Austrian empire to instantly discard this idea. Friedrich in Vienna — that seems truly impossible.

Thus, he was almost compelled to choose Dresden. It had the portraitists Anton Graff (1736-1813, academy professor since 1766) and Josef Grassi (ca. 1758-1838, academy professor since 1800). It had the then progressive landscapists Adrian Zingg (1743-1816, academy professor since 1766) and Johann Christian Klengel (1751-1824, academy professor since 1773). Likewise,

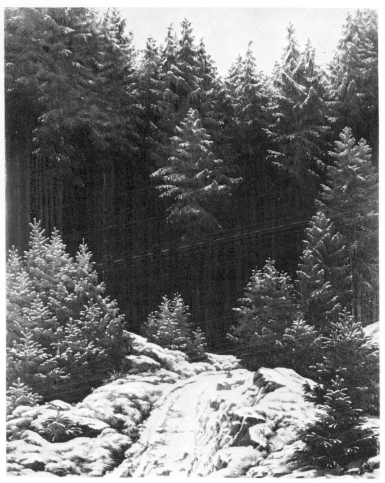

23 *Early Snow.* Ca. 1828

Jacob Wilhelm Mechau (1745-1808) lived in Dresden (after long stays in Rome, where he became friends with Philipp Hackert) from 1798 until his death. There were also fine genre and historical painters, like the urbane and liberal Johann Eleazar Schenau (1737-1806, academy professor since 1774). At the time that Friedrich came to Dresden, Schenau was co-director of the Academy together with the historical painter C.J.J. Seydelmann (1750-1829, academy professor since 1796). Hence Friedrich, who at first practiced drawing nudes at Dresden's art school, was probably not attracted exclusively by the landscapists. Plainly, he first tried to realize in figural works the things that he wanted to express.

One major feature that attracted him was the countryside, the rich "Saxon Switzerland" around Dresden. But also, the town itself, the splendid buildings, the harmony of an international level of art (what treasures were in the Dresden Gallery alone!) and provincial security. Dresden must have reminded him a bit of the Nordic town of Copenhagen. Later, the painter summed up his reasons in favor of Dresden: he wanted to continue working there "in the vicinity of wonderful art treasures and surrounded by a beautiful nature," in a city "that should justifiably be known as the German Florence."

Just a few months after arriving, Friedrich, probably stimulated by the landscapists in Dresden, began an intensive study of nature. This is borne out by sketchbooks of 1799 and 1800. In these often unsure, sometimes sophomoric works, Friedrich made up for what he had neglected. He gradually liberated his drawing style from any dependence on others and practiced the precise viewing and exact depiction of the reality of nature. The painter was thus going through the ABCs of his art, and it was not mere chance that he went back to this material even in later years. This period brought forth a series of drypoint landscapes, with lines clearly reminiscent of Klengel and Mechau, and yet conspicuous because of their untraditional empty spaces. Here trees, paths, or rocks are already the only subject matter. Friedrich first tested the instruments of his allegorical landscape art here. We may assume that his shift towards landscape depictions, which came around 1801/02, was emphatically prepared for in these drypoints.

Although he registered at the Academy very soon after coming

to Dresden, Friedrich essentially kept training himself outside the art school. However, he did make occasional use of its facilities, for instance drawing from nude models. He must have eagerly drawn in the Dresden Gallery, copying paintings of the masters, who had been pointed out to him by Quistorp in Greifswald and by his teachers in Copenhagen. Once again, it was works by Ruysdael, Berchem, Waterloo, Everdingen, and others that interested him. He primarily noted the figures and not the landscapes. This took place in the years 1798-1800. As of 1799, there are landscape pictures by Friedrich's hand, not just after works of the seventeenth century, but especially after Dresden masters such as Zingg. If, however, we compare Friedrich's early Dresden drawings with Zingg's carefully thought out pictures (Friedrich knew the painter personally), the copies look almost dilettantish. It was only around 1800 that Friedrich's drawing style took on more and more of a

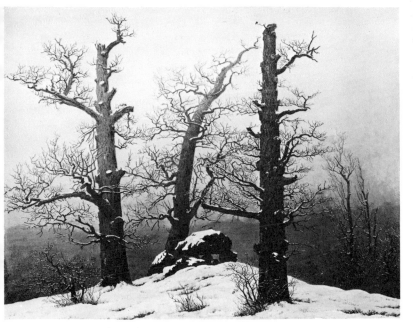

24 *Dolmen in the Snow.* Ca. 1807

profile. And as of 1803, he did large sepia works, which, to be sure, betray nothing more of these uncertainties. This surprising progess within four years indicates that Friedrich pursued his training with energy and tenacity. In Dresden, he probably also saw coastal paintings by the then renowned Frenchman Claude-Joseph Vernet (1714-1789), and they obviously had a strong impact on him.

During his first few years in Dresden, the painter managed to get by on odd jobs. It was only in 1803 that he could sell his own works. Presumably, he colored engravings and taught drawing to children "of higher ranks." Sometimes, he accompanied out-of-towners on their trips through Saxony. By this time, he was already living a secluded life, but he was certainly not unsociable, as Carus describes him. On the contrary, letters from these early Dresden years reveal that he could be cheerful and frolicsome. Beginning in 1805, as his name gradually came to be known, he found a small circle of friends. These included: the painters Franz Gerhard von Kügelgen and Christian Ferdinand Hartmann (1774-1842, academy professor since 1810); Kügelgen's pupils Caroline Bardua (1781-1864) and Louise Seidler; and the above-mentioned philosopher and naturalist Gotthilf Heinrich von Schubert. Art lovers passing through the city now visited the painter in his studio.

Crucial to Friedrich's conception of art was his acquaintanceship with Philipp Otto Runge. Both pursued the same artistic goals. When they met in Greifswald in 1801, Friedrich may have encouraged the Hamburg painter in his wish to move to Dresden, where he then continued his studies within the framework of the Academy from June 1801 to April 1804. Although the two most important German Romantic painters lived in the same city during those three years, they were not on close terms. Yet both of them managed to clarify their attitudes, partly by meeting the poet Ludwig Tieck (1773-1853), by getting to know Romantic literature (especially Novalis, the pseudonym for Friedrich von Harden-berg, 1772-1801) and Romantic philosophy (Schelling, the Schlegel brothers). Here, at the same time, they both found their pictorial language, which from then on filled and molded their work. Both, in parallel fashion, developed their allegorical or, as

Runge writes, their hieroglyphic pictorial style: Runge in figures and arabesques, Friedrich in landscapes.

In those years, both of them realized the high calling of the artist, which they accepted as their future model and strove to substantiate. In March 1802, Runge wrote to his brother Daniel: "You can only sense God behind these golden mountains, but you are certain of yourself, and what you have felt in your eternal soul, that is eternal too — what you have drawn from your eternal soul, that is immortal; this is where art must originate if it is to be eternal." These lines also voice Friedrich's conviction. And in December 1802, Runge wrote to the poet Ludwig Tieck: "Hence, this art cannot possibly be understood in any other way than from the deepest mysticism of religion, for that is where it must come from, and that must be the solid ground for art, otherwise it will collapse like a house built on sand."

Friedrich would have agreed with these lines as well. Later, in his aphorisms, *On Art and the Spirit of Art* (which were found among

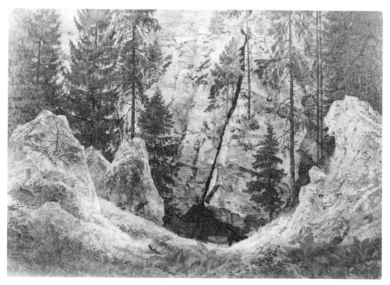

25 *Cave with Tomb.* 1813/14

the posthumous papers of the painter J. C. C. Dahl), he made a similar remark. Briefer and less Protestantly dogmatic, terser and less lively, Friedrich's statement sums up the two passages from Runge's correspondence:

> *Thou shalt obey God more than men. Each man carries the law of right and wrong inside himself; his conscience tells him to do one thing and not do another. The sacred Ten Commandments are the pure, unvarnished pronouncement of all our knowledge of truth and goodness. Everyone acknowledges them unconditionally as the voice of his inner being, no one can rise up against them. So if you wish to devote yourself to art, if you feel a calling to consecrate your life to art, oh, then heed the voice of your inner being carefully, for that is art within us.*

With a persistent will, Friedrich pursued his art from 1798 to 1803 and then on to his first great religious painting, the Tetschen Altar of 1807/08 (Plate 1). As his artistic drive shows, these thoughts were alive in him quite early, certainly since his large sepia works of around 1803, and perhaps already with the early etchings. Friedrich's first eight or nine years in Dresden brought about the decisions that governed his work until the end of his life.

10 Preparation for Painting

It is a bit daring, and an oversimplification, to regard Friedrich's works until 1807, when he really began to produce oil paintings, as a mere preparation. After all, his large sepia works were meant as self-contained works of art and do not point ahead to paintings. But if we strike the word "mere," then the title of this chapter can stand as is.

Noticeably, during the first eight or nine years after arriving in Dresden, Friedrich persistently developed his pictorial language and learned how to use it. Of course, there are gouaches and water colors from this period; but essentially, his work from this period consists of pencil drawings and sepias. In the first few years, pen and ink drawings are frequent, but then the pencil clearly dominates. That is to say, Friedrich limited himself in his technical means, with a conspicuous sense of the rational use of his capabilities, an "economical" mustering of his energy. This also applies to his pictorial style, his subjects, and his clear-cut use of studies in his pictures.

Friedrich trained himself as a precise draftsman and a painter who had fully mastered the technique of sepia painting. The brown sepia ink, applied with a brush, generally adds values of light and shadow in a pen and ink drawing to produce a brown monochrome picture. By thinning and concentrating it, the artist has to make this one hue so sensitive that a living work results, created exclusively by the nuancing of various degrees of light or darkness. Starting in Italy during the 1770s, this technique became the favorite form of painting until 1810. The artistic conception of Classicism, oriented towards the alleged colorlessness of ancient

26 *Design for Warrior Monument with Multicolored Flags.* 1814/15

sculpture and the red figures of Greek vase painting, rejected colors. Hence it promoted the sepia technique, practically monopolizing it.

The pigment was extracted from the glandular fluid of the *sepia,* the cuttlefish. J. C. C. Seydelmann, the historical painter and academy professor, was one of the first to paint in sepia ink. He was even regarded as the inventor of this technique.

Adrian Zingg also worked almost exclusively in this technique, achieving a complete mastery of it. Friedrich was no doubt strongly impressed by the older academy professor and his sepia technique. Sepia painting systematically schooled and refined Friedrich's

capabilities as a painter. This can be seen in his paintings, whose sensory effect relies on the most delicate color modulations.

But it was not only drawing and sepia technique that Friedrich learned to master in order to use them in paintings. At the same time, the themes of his art were expanded. He also brought together his allegorical arsenal, from which he then erected the symbolism of his paintings as though with architectural members. Here too, Friedrich's systematic procedure is astonishing.

One of the earliest drawings of the Eldena ruin is dated May 5, 1801, by Friedrich (Figure 7). He saw the tumble-down Cistercian abbey near Greifswald when he left Dresden for his first visit home (four months), on which occasion he also visited Neubrandenburg, his native town, and Rügen. The ruin would be a leitmotif haunting the painter's entire *oeuvre*.

The drawing is done in a traditional technique. The wash of the sepia brush is dabbed across the pen and ink lines. We see clearly that the brown tone establishes the shaded areas, its light dabs supplementing the pen strokes, which mark the mortar spaces between the rows of bricks. The relaxed use of the brush is old-fashioned, as are the brittle lines of the pen, which carry with them the light of the eighteenth century. The approach recalls Friedrich's self-portrait of 1802 (Figure 6). In contrast, the sobriety of the depiction is new. This was no moody sketch, but an objective rendering of facts.

The frontal studio window (Figure 2), on the other hand, shows the drawing style that Friedrich would use in the future: the sepia is applied flatly with the brush over thin lines constructed with the help of the T-square. The sepia modulates the gentle passage from shadow to light in the window jamb; and it clarifies the reflection in the open window — in "painterly" terms, the richest part of the work. All looseness has vanished; coolness and rigor dominate. The only lively element in this really naked depiction is the outside scene in the window. It has dabbed-in lightness, and there is a drifting motion in the clouds.

This drawing is important for the development of the two-stratum pictorial structure that became a pillar of Friedrich's style. More than fifteen years later, the painter literally made this view from the window fruitful for his 1822 painting *Woman in the Window* (Plate 16).

The picture of the natural bridge over the abyss of Uttewald (Figure 8) was chronologically right after the Eldena study. It goes back to a drawing that Friedrich did from nature on August 28, 1800, and was probably executed one or two years later. The large format stands out (70.5 x 50.3 cm). It points ahead to the sepias *Pilgrimage at Sunrise* and *Fisherman on the Sea* (both 40.5 x 62 cm), that the painter sent to Goethe in Weimar in 1805, when the poet announced his fifth and last competition. Friedrich received half the prize money for the two sepias — most likely at Goethe's express wish. This was Friedrich's first public recognition. It also made a large public aware of him. The "judgment of the submitted works," by Heinrich Meyer praises the "skill, purity, and industry of the treatment" in these works. And indeed, their technique and cunningly careful execution puts them on a level with Zingg's landscape views. They reveal an artist with a masterful command of sepia painting.

By comparison, the sepia of the Uttewald Abyss (Figure 8) seems rough and old-fashioned. The painter comes to terms only coarsely with the shadowy rocks, in which all possibilities of the only color, brown, could be gradated from a powerful tone to the blackest dark-brown. The loosely inked trees on the ridges of the cliffs point to the eighteenth century, as do the spotted inner tones in the rock. Rigor and precision are to be found in the whole rather than in the details. The overall shape of the picture has not yet been worked out evenly. Still, inspiration wins out despite the work's flaws. The dark and light zones are strikingly simple. The brightness has entered the rocky gap in the shape of a funnel. The contours of the stony chasm emerge bizarrely. This funnel of light seems to be projecting the layout of the funnel-shaped exit from the depth perspective into the flat plane. The uncompromising strength of this pictorial structure would be intensified and maintained by Friedrich's art until the end of his life, in paintings like *Monk by the Sea* (Plate 4) or *Polar Sea* (Plate 22).

The content of this picture is also characteristic of Friedrich's thinking in terms of allegories: the human couple steps into the light from the dark, stony cave as though passing through the gateway of death into eternal life.

The preliminary drawing for the large sepia picture of the Uttewald Abyss belongs to the "Mannheim sketchbook" (so-called

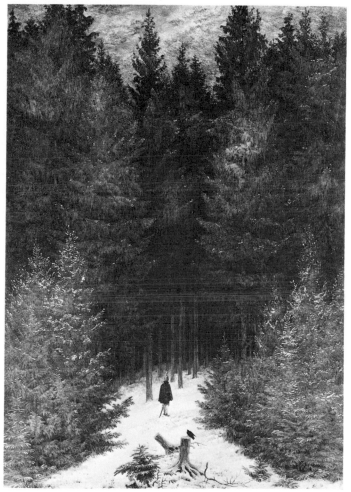

27 *Chasseur in the Forest.* 1814

because it is kept in *Städtische Kunsthalle*). Friedrich later used these studies for his paintings. A similar function was served by the drawings in a sketchbook owned by the National Gallery in Oslo, done between 1806 and 1808. For Friedrich, these notations likewise remained a reservoir of precise views of nature, which he continually fell back upon in later years.

The study of a woodland scene (Figure 9) demonstrates the shorthand style conspicuous in Friedrich's early drawings. A natural detail is distilled to purity and put on the white surface of the paper with sharply accentuating strokes. This exerts a fascination on us today. We not only sense the selective, critical eye of the painter, in whom a pictorial idea may already be in preparation; we also feel that his woodland setting, the grazing horse, the fence, even the artist's signature, are given a magical function through this process of isolation: the empty surface charges everything with significance. Reality is so concentrated that it extends into a field of meaning beyond the merely visual.

This Oslo sketchbook also has pictures of clouds and landscapes, in which the sky is the actual subject matter. *Moon and Clouds* (Figure 10) can be regarded as an example of several studies along these lines. There are also, occasionally, similar ones in the form of oil sketches. In a painter whose works give the sky an intensified meaning, such pieces do not come as a surprise. In 1816, Friedrich, through Louise Seidler, received an assignment from Goethe to do studies of clouds. But he turned the offer down because, as Louise Seidler wrote, "he saw an overthrow of landscape painting in this system." The great German poet, studying the atmospheric research done by the English meteorologist and chemist Luke Howard (b. 1772), wanted to investigate the laws of the genesis of clouds. He was hoping to gain a concept of the "primal conditions" underlying all natural phenomena.

For Friedrich, however, it was impossible to regard nature with scientific eyes, no matter how precisely he may have observed it. He was afraid that art might be taken over by science, thereby losing its elementary spiritual force of expression. The painter had no sympathy for the universal interest of the aging Goethe, who did not see nature as a mystical power surrounding mankind, but wanted to grasp it in its true essence, in terms of its laws. Friedrich remained trapped in his emotional subjectivity, negating any

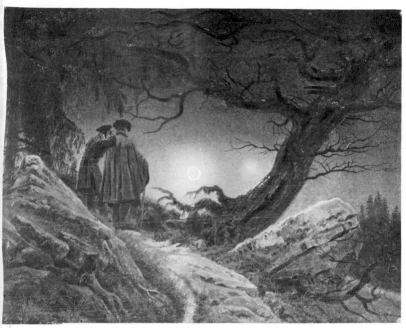

28 *Two Men Gazing at the Moon.* 1819

objective connection. A cloud, a sky, a moon, an optical effect were bearers of meaningful moods for him. In the empirical experience of Being, Goethe appears as the more progressive mind here. Carl Gustav Carus took over the poet's ideas.

Nevertheless, the study of clouds with the moon breaking through (Figure 10) has a visionary expressive power, despite the imprecise rendering of the cloud forms.

The other drawing from the Oslo sketchbook, *Landscape with Two Poplars* (Figure 11), shows with what imagination Friedrich saw things. The tableau of nature is penetrated by a feeling that reshapes it into a depiction of impressive bleakness. The sky, in ragged strips, moves across the broad, dark wall of earth. Only two poplars loom into the sky, making the overall forlornness fully

obvious. This small drawing is virtually a draft for Friedrich's later paintings of the utmost revelation.

The year 1806 brought the *Rock Formations at Nobbin* (Figure 12) and the drawing *Farmyard with a Draw Well* (Figure 13). Even though the drawing shows a coherent section of a landscape, it captures only a careful choice of objects.

The empty foreground pushes into the picture in a V shape. The triangular form recurs (erect) in the rope and the crowbar of the well, and also in the roof of the shack. This world, meant to be idyllic — but hindered by the rigidly ordered pencil structures — ends at the fence. Beyond the fence lies the zone of death, indicated by the dead tree. Thus the drawing reveals the painter's attitude — it bears witness to the incessant projection of his innermost thoughts and feelings upon the reality of nature.

Now the time had come. Friedrich had developed into an extraordinarily skillful landscape draftsman. He was a master of sepia. He next proceeded to paint oils on canvas. His work as a painter began in 1806/07. He had already tried this technique in Dresden during the year 1798, painting the small-format *Wreck in the Polar Sea* (Figure 14). He had also done a number of colored graphics, using opaque paints and water colors. But it was only now that his work became real. He launched into the history of his fame and the mute tragedy of oblivion.

One of Friedrich's early paintings is *Summer,* 1807 (Figure 15). (*Winter,* Figure 16, came later, in 1808, as a pendant.) This summer picture shows lovers embracing in a bower. Two doves, billing and cooing, mirror the motif — they are embarrassingly superfluous. Friedrich's allegorical landscape art has passed fully into this painting. The landscape basks in the warm light of noon. Flowers — lilies, roses, and sunflowers — blossoms of fullness, surround the couple. Two intergrown trees, a birch and a poplar, not only add a formal accent, they also take up the theme of the embrace. The broad river in the valley represents the passing torrent of life.

In the foreground, the painter used plant studies he had drawn in 1799. This once again underscores the meaning that the master's early work had for him and for his incipient painterly *oeuvre*. With his accomplishments behind him, as though, like a medieval master, he had filled his book of samples with drawings, studies, and sketches, he was now ready to follow his true destiny: painting.

74

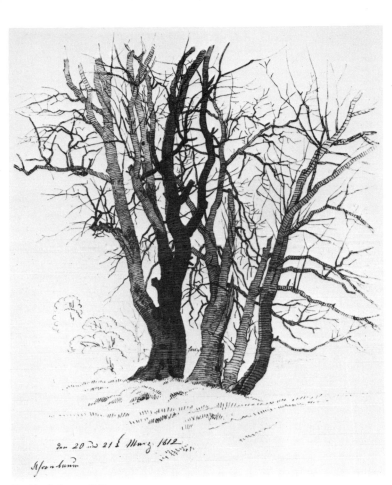

29 *Maple Trees.* 1812

11 At Work

Do you really find me so uniform? People say I cannot paint anything but moonlight, sunset glow, the ocean, the beach, snowy landscapes, church-yards, bleak moors, forest torrents, rocky valleys and the like. How do you feel about this? — Friedrich asked and received the following answer from the poet Friedrich de la Motte-Fouqué: *I think that one paints an immense amount into such subjects when one thinks and paints as you do!*

De la Motte-Fouqué: *Diary*, 1822

As a painter, Friedrich worked slowly and carefully. In his travel memoirs (written in 1849), the Swedish poet Per Daniel Amadeus Atterbom (1790-1855), described his sojourn in Dresden in 1817. In these memoirs, he calls Friedrich "the mystic with the brush." However, the "mystic" proceeded quite rationally and according to a rather set plan. In a letter to his wife, dated July 12, 1822, he poked fun at his own deliberate way of working: "Yesterday and today, I stoutly sicced my brush on my big picture."

No one instructed Friedrich in oil painting. But we may assume that he was informed about its possibilites and technical prerequisites by his friends Von Kügelgen and Hartmann, and others. Basically, he was self-taught, and not from necessity or lack of opportunity (after all, the Academy was available), but from conviction. A systematic schooling in the art of painting struck him as irrelevant and even harmful: "Learning to paint pictures the way you learn to stand on one leg or walk a tightrope (that is to say: to keep training one's hand the way *they* train their feet, until you finally know how) is certainly not the right way to go about it; or else artists of the brush and artists of the tightrope are on the same level. I admit that this is true in general, alas, but I maintain that it should not be true."

To keep from overestimating this — one might almost say — contemplative method of working, it is important to know that Friedrich, with an *oeuvre* of more than three hundred paintings, is by no means less prolific than other artists. This number testifies to Friedrich's unrelenting industry.

Carl Gustav Carus has described Friedrich's working method as follows:

30 *Firs at the Forest Edge.* 1812

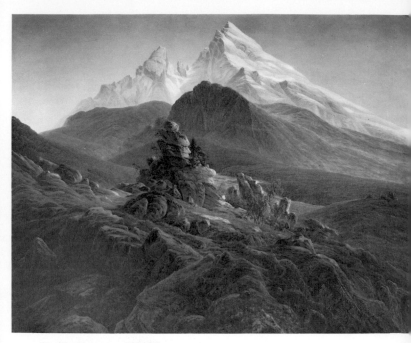

31 *The Watzmann.* 1824/25

> *It was of the utmost importance to me to get to know Friedrich's procedure in*
> *planning his paintings. He never made sketches, cartoons, or color drafts,*
> *for he claimed (and certainly not wrongly) that the imagination always*
> *cools a bit with such auxiliary devices. He did not begin the painting until*
> *it loomed alive before his soul; then he drew the whole thing on the*
> *immaculate mounted canvas, first sketchily with chalk and pencil, then*
> *neatly and fully with the reed pen and India ink, and he soon launched into*
> *the priming. Hence, at every stage of their genesis, his paintings always*
> *looked definite and orderly and always imparted his peculiarity and the*
> *mood in which they had first appeared to his mind's eye.*

Thus, Friedrich's approach to painting was almost the same as
the sepia technique. To begin with, he arranged the picture as a
large drawing with chalk and pencil, first sketching, then execut-

ing it precisely. The priming, which was in brown tones, actually looks like a huge sepia painting. Then, over this brown painting, the oil pigments were applied in thin, glazelike layers. Carus was amazed that the painting looked "definite and orderly" at every stage. This can actually be demonstrated in Friedrich's unfinished canvases, such as *Graveyard Entrance* of 1825 (Plate 21), which remained in this state until the painter's death. The brown priming is totally untouched in the lower third of the painting; but elsewhere, the artist had begun to apply the first layers of oil pigments. The sky seems to be almost completed. But otherwise only an initial oil glaze, in bright silvery blue, has been painted over the brown patches of fog, plus black in the figures and green in the wreath of leaves over the entranceway. The expressive power of the canvas is none the weaker; in fact, it comes out even more clearly. This observation tells us that there is no point at which Friedrich's canvases were necessarily finished. The painter himself decided when the painting was done. However, this is something that Friedrich's art shares with all glaze painting.

Evidently, the painter had to see the picture in all of its phases not only "alive before his soul," but before his eyes. It could thereby be checked over at any time and revised. This was what happened with *Monk by the Sea* (Plate 4). At an early stage, it had two sailing ships on the surface of the water; but Friedrich painted them over when putting the final touches on the work.

However, there was probably a further reason for this approach. This time-consuming, almost pedantic course of action required holding the imagination fast over long periods and arousing it again. The pictorial shape, evident in all stages, gave the artist the possibility of literally being in the picture at all points and going on with his work.

However, this gradual procedure must have had a further significance for the painter. As the inscription on a study of fir trees (1807) notes, he could spend "3½ hours" drawing a single fir with the utmost concentration. Thus Friedrich certainly needed a working method that not only permitted, but even stimulated contemplation. Carus, who didn't quite understand this drive for absorption, viewed it as follows: "Incidentally, he almost continuously brooded over his artistic creations in his darkly shadowed room."

32 *Temple of Juno at Agrigento.* 1828/30

Friedrich always scorned quick, easy painting, which he called "shaking art with the brush." He avowed: "Just as only a pure, undimmed mirror can reflect a pure image, so too a true work of art can emerge only from a pure soul." This striving to get feelings and spiritual processes as directly as possible into the painting could succeed only with meditative intensity.

Today, we can no longer be as unshakably positive as Carus was when he stated that Friedrich never did "sketches, cartoons, or color drafts for his paintings." To be sure, there are no cartoons or color drafts. Yet we can demonstrate for nearly every work that the painter did indeed incorporate sketches, from nature directly into his canvases. One example is the ship study (Figure 3), which he worked into his *View of a Harbor,* 1815 (Plate 8). Another is the sketch of a *View over the Prow of a Sailing Ship* (Figure 17), which passed into the painting *On the Sail Ship,* 1818/19 (Figure 18).

There are also certain drawings that not only were used as preliminary works for parts of paintings, but actually contain the

33 *Greifswald in the Moonlight.* 1816/17

entire idea of the canvas and served as the model for the pictorial
form. For instance, a hurried sketch in the Oslo sketchbook of
1818: the pictorial layout recurs in the painting *Garden Bower.* It
has also been speculated that the four pieces in the cycle of the
times of the day in Hanover (Plates 11–14) are direct renderings of
nature studies. Likewise, *Eldena Ruin,* ca. 1825 (Figure 37)
evidently derives directly from a nature study.

Of course for sepias there are actual preliminary drawings, which
the artist traced out in order to paint the sepia picture over the
tracing.

But on the whole we would have to agree with Carus. Friedrich
created his paintings right at the easel. The first outlines in pencil
or chalk could be easily erased or revised. Thus, normally, the
painting emerged without preliminary stages, gradually becoming
denser and more concrete, in the manner described by Carus.

Wilhelm von Kügelgen was surprised that, in Friedrich's
studio, "a lonesome T-square hung...on the wall, and no one could

grasp why it had been paid this honor" (cf. chapter 3). Kersting's paintings (frontispiece) also show a triangle and a ruler next to the T-square on the painter's studio wall.

Critics have often pointed out Friedrich's "architectural thinking." One need only view a canvas like *Cathedral*, ca. 1818 (Figure 48), to know what they mean. Friedrich's designs for Sankt Marien in Stralsund (cf. Figure 49) prove that he expressly did construction drawings of architecture.

It clearly follows from these indications that Friedrich's paintings are based on a rigorous structure: symmetries, series, parallel shifts, geometric figures like triangles and angles, hyperbolas and diagonals, the distinct vertical and horizontal emphases. These abstract schemes were constructed with a ruler, a square, and a T-square.

The abstract basis of Friedrich's canvases fulfills a demand made by Philipp Otto Runge, who, on February 13, 1803, wrote from Dresden to his brother Daniel: "I've also written to you once that I certainly believe that strict regularity is at its most crucial in artworks springing directly from the imagination and mysticism of the soul, with no external matter or history. . . . This procedure requires something solid of us, otherwise we would perish or have to begin lying. . . ."

Thus the artist Friedrich subjected his imagination to severe discipline. He controlled the "inner sense of symmetry" that he required from the artist by subordinating the picture he saw inside himself to a structural order, a "regularity," which purified his pictorial idea like a filter, forcing it to become solid matter and holding it fast as in a grid.

If we looked at this 1808 painting by Caspar David Friedrich (Plate 2) with the eyes of an eighteenth-century connoisseur of art, we would be outraged. Why?

The eighteenth century loved landscapes in which the pictorial space developed in clear steps from the usually dark foreground, through a detailed middleground, to the bright, slightly *sfumato* background. Most of these canvases, which recalled the stage sets of the period, had a gold frame plus a clear framing within the picture: to the left or right, at the edge of the painting, a tree stretched its twigs, as distinct silhouettes, into the bright sky. A road, a river, or a valley, normally starting broadly on one side of the canvas, moved diagonally into the pictorial space, opening up the representation, so that the eyes of the art lover could stroll through the painting. The viewer looked for "variety" and "harmony" in the forms and colors, which had to be lined up behind one another as scenes and strata.

"How pleasantly the eye glides," in these paintings, "from one plane to the next, how it is strained by this straight line, stretched by that winding line, invited to hop by a third, mixed line....This is the lovely shape of the depths, the cavities of the surface, or, if you prefer, the lovely shape of the perspective of the planes and lines!" Such was the delighted exclamation of the *amateur d'art* at such landscapes, which were theatrical and remote from reality — in the best sense — even though the painters enriched their paintings with things they carefully observed in nature. Inspired by the Netherlandish artists of the seventeenth century, they relied less and less on a pretty composition, and looked around at the

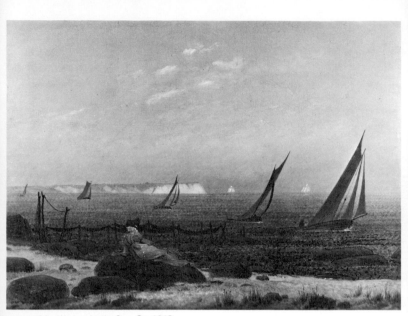

34 *Woman by the Sea.* Ca. 1818

world instead. The props they obtained by studying nature were pushed theatrically into their stage settings.

In pictures by these painters, the color was atuned to a specific tone that was remote from nature: "Landscape painting fully reproduces the harmonious effect that the black mirror or the reflection of nature produces in water, with every local color offering something of the main color of the surface, on which the mass of multicolored objects is depicted."

We can thus sum up what an eighteenth-century art lover expected from a landscape portrayal: "The lovely shape of the linear perspective is utterly intrinsic to the landscape; as are the charm of the overall tone of the painting and the aerial perspective in color and light; and only the landscape has at its disposal the most enticing optical effects in the open air."

If there were also single figures or groups enlivening the landscape scene, whose proportions made the individual depth strata more obvious, then the painting had an "effect." It was a tour de force, combining surprising and highly emotional objects, and thus virtually in an artificial concentration offering the surrounding nature a parklike order or theatrical drama.

Friedrich's mountain picture (Plate 2) contrasts as drastically as possible with such a "taste in art" (the term back then). It must have been a slap in the face for any lover of stage landscapes. After all, this canvas had nothing but a mountain peak in morning fog, with pines and spruces rooted in the bleak ridge. A particularly disconcerting element was the thin cross looming up high on the bare, deserted rock, surrounded by a small wreath of clouds. One can discern it only after long scrutiny (and barely make it out in a small reproduction). The peak stretches immediately into the painting, provokingly compact. The viewer, accustomed to seeing a painting like a stage set, as a clearly self-contained unit in front of him, establishing his place outside the picture and, so to speak, tailored to him, must have been deeply irritated. He saw the peak from a point on the same level as the peak itself, like a bird in flight, heading toward the mountain from somewhere. Also, he must have felt that the mountain actually blocked the painting, for there are no vanishing lines into the depths — on the contrary, they are virtually buried by the mountain.

Could a picture showing nothing but a mountain be really called a work of art? No landscape scene could be more boring or more uninteresting. What about the crucifix? Could the painting possibly have some hidden meaning? That might explain the monotony of the depiction. But why was the cross so concealed? Why was the overall significance so hard to decipher? What kind of viewer did the painter have in mind? Since very little was offered to the eye, it would have to be poets, theologians, or philosophers, and not merely visual people, who could ferret out the meaning.

It was with the eyes of such a tradition-bound art lover that the Dresden chamberlain Friedrich Wilhelm Basilius von Ramdohr (1757-1822) viewed Friedrich's landscapes. The passages quoted here come from his pamphlet against Friedrich's painting *Cross in the Mountain,* the so-called Tetschen Altar (Plate 1), which was also done in 1808.

Indeed, with his painting *Morning Fog in the Mountains* (Plate 2), Friedrich meant to depict more than a mountain top. The peak with the cross rises from the fog into the circle of clear blueness. The crucifix on the rock of faith promises the fog-covered earth the light of salvation from all gloominess. The fir trees, looming out of the white haze, symbolize the faithful souls who are already participating in the certainty of deliverance.

Our description of traditional viewing habits among the artist's contemporaries shows that such an uninteresting, actually empty painting would simply have to elicit questions as to the real meaning of these portrayals. Friedrich was counting on a viewer who would not be satisfied with hasty answers or with losing interest quickly.

Perhaps he also had the kind of thoughts that Runge had when writing to his father in 1803: "What I call art is such that if it were just simply stated to people, no one would understand it, and they would declare me mad, crazy, or silly."

Friedrich too veils the meaning of his picture. It was and is grasped only by someone having thoughts similar to the artist's or refusing to avert his eyes until he has comprehended the meaning of the entire work.

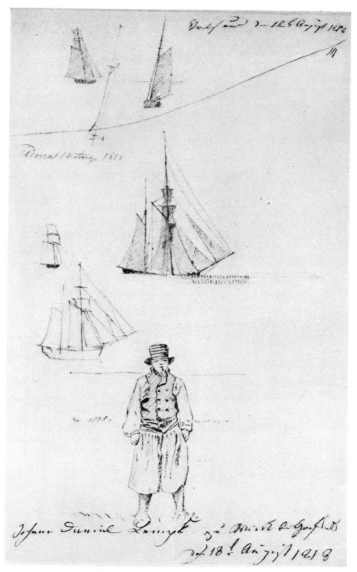

35 *Six Sail Ships and Skipper*. 1818

13 Controversy over a Painting

I, for my part, demand an elevation of the mind from a work of art and —
if not only and exclusively — religious exaltation.

<div align="right">

Caspar David Friedrich, ca. 1830

</div>

During the Christmas season of 1808, Caspar David Friedrich exhibited his painting *The Cross on the Mountain* (Plate 1) at his studio. It was commissioned by Count von Thun-Hohenstein, who wanted it for his private chapel, at his wife's request. This work is generally regarded as the painter's masterpiece, not because its artistic importance is greater than that of most of the works, but because, for the first time, it plainly and programmatically embodies Friedrich's new conception: the religious landscape.

Contemporaries recognized what was new in this depiction. It kindled a controversy between the opponents of such art and Friedrich's friends, and the argument went on for over two years in newspapers and magazines. The spokesman of the traditional majority was Chamberlain von Ramdohr. The vehemence of the critics is obvious from the fact that no less than three of Friedrich's friends took his part: the painters Ferdinand Hartmann and Franz Gerhard von Kügelgen and the Prussian general, art collector, and painter Johann J. O. A. Rühle von Lilienstern (1780-1847). They were joined by the theologian and library secretary Christian August Semler (1767-1825), whose article in the *Journal des Luxus und der Moden (Journal of Luxury and Fashion)*, 1809, was penned by Friedrich himself and merely edited by Semler. This article offers a brief description and an interpretation of the painting:

> *Description of the picture: On the peak of the rock stands the cross, erected high, surrounded by evergreen firs; evergreen ivy winds around the base of the cross. The sun is setting, radiant, and the Savior on the cross shines in the purple of the evening glow.*
>
> *Description of the frame: The frame was made by the sculptor Kühn at Herr Friedrich's directions. At the side, the frame forms two Gothic*

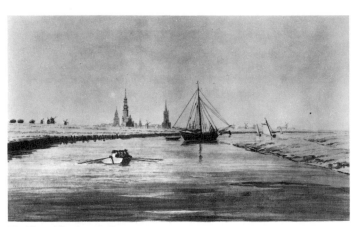

36 *View of Greifswald.* Ca. 1818

columns, with palms rising out of them and arching over the painting. In the palm fronds are five angel heads, all gazing down in adoration at the cross. Over the middle angel, the evening star hangs in the purest silvery glow. Below, filling out the length, is the all-seeing eye of God, enclosed in the holy trinity and surrounded by rays. Wheat sheaves and vine tendrils bow on either side towards the all-seeing eye and indicate the flesh and blood of He who is nailed to the cross.

Interpretation of the painting: Jesus Christ, nailed to the cross, faces the setting sun as the image of the eternally all-animating Father. An old world died with Jesus' teachings, the age when God the Father walked upon the earth. This sun sank, and the earth could no longer grasp the departing light. But the Savior on the cross shines with purest metal in the gold of sunset glow and thus reflects a milder brilliance on earth. The cross stands erect on a rock, as unshakably solid as our faith in Jesus Christ. Evergreen through all times, the fir trees stand around the cross, just as the hope of mankind is set upon Him, the Crucified Savior.

This description and interpretation are extremely crucial to Friedrich's art, for the artist seldom made such concrete statements about his works. Conspicuously, Friedrich does not follow Protestant theology, as Runge does; instead, he offers a completely subjective symbolization of Protestant doctrine in this painting.

89

Jesus' death has destroyed the "old world...where God the Father walked upon the earth." God, the sun, is sinking, the crucifix shines in the glow, just as Christ's teaching is an echo of God's promise. One might think that in some of his works, Friedrich may have been trying to depict the "old world, the age when God the Father walked upon the earth." Such an idea would make us basically skeptical about any attempt to interpret Friedrich's art in theologically concrete iconographical terms.

Friedrich creates a religious landscape by relying on his own particular feeling. He does not paint Protestant theology, but rather his own subjective exegesis of the Christian faith, the image he bears within himself.

It has been correctly pointed out that this religious subjectivism was preached by the most influential theologian of the Romantic epoch, Daniel Friedrich Schleiermacher (1768-1834). Theology, he said, is a depiction of individual emotion: all dogmatism must be rejected; a yearning for the infinite is the foundation of all

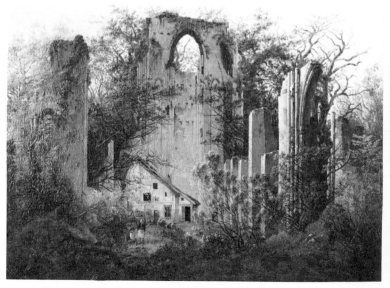

37 *Eldena Ruin.* Ca. 1825

religions. Feelings, however, in order to know God, require intuitive contemplation. "Intuitive contemplation of the universe — please become friendly with this notion; it is the pivot of everything I say, it is the highest and most universal formula of religion." God, however, is not in nature, but beyond it; He is the universe itself.

Friedrich seems to have been familiar with this theology. In his painting, God is beyond nature. Nature only lies in His gaze as in the beams of the setting sun. Thus, for all his pantheistic religious sense, the painter was no nature mystic. Nature is merely a simile, not a religious incarnation: "Evergreen...the fir trees stand around the cross, like the hope of mankind...." Hence, the firs do not signify the faithful, they are an allegorical formula for the "hope of mankind."

Ramdohr, whose attitude towards art was rooted in the eighteenth century (cf. chapter 12), realized this clearly:

> Let us put the emblematic significance [of the frame] together with the allegory of the painting and consider the tendency of the whole work, with a sacrifice of truth and taste, an admittedly honorable, comforting, but in no way esthetic idea of our religion: to symbolize the mysterious effects of the eucharist; how is it possible, then, to ignore the influence that a now prevailing system has exerted on Herr Friedrich's composition! That mysticism that now creeps in everywhere, wafting towards us from art as from science, from philosophy as from religion, like a narcotic vapor! That mysticism that passes off symbols and fantasies as painterly and poetic images, trying to replace classical Antiquity with Gothic carvings, stiff Little Masters, and legends!

This attack was aimed at the entire Romantic movement. The chamberlain, who had himself authored books on art, would not allow Friedrich the right to employ the landscape as a bearer of religious metaphor. "Indeed, it is truly presumptuous of landscape painting to try to sneak into church and creep up on altars." Ramdohr felt that Friedrich was putting excessive demands on landscapes by attempting to use them in creating a new type of religious painting. Why, he asked, does Friedrich not follow the historical painting that, for centuries now, has depicted biblical events and religious truths in figurative pictures?

91

Ramdohr's objection must be taken seriously. He merely overlooks the fact that there could be no valid church art after the French Revolution. Religion had become interiorized and was absorbed by an apparently modern subjectivism. There was no longer any valid picture of God the Father, Christ, or the events of the Salvation. Throughout the nineteenth century, and in a certain sense even today, there have been attempts at achieving universally understood pictorial contents in the area of figurative painting. But none of these attempts could restore the lost concordance. The subjectifying and spiritualizing of the Christian religion made all older church art look naive. Any concrete depiction of the substance of faith in figures seemed shallow. It was only the younger Romantics, the so-called Nazarenes, closely following medieval art and, characteristically, Catholic dogma, who tried once again to found a religious figurative art.

Friedrich's painting, like the intuitive contemplation of the early Romantics, is focused on an "inner image" of religion. Free of all confinement, it seeks to name the unnamable. In its ambivalence and its allegories, it is a model of self-oriented religious contemplation. Ramdohr recognized the retreat of this art from its public sphere of activity, but he completely failed to see its unavoidable problematics.

That was why he condemned Friedrich's "deliberate tendency" to arouse a "pathological emotion" in order to have the viewer recognize the religious parable concealed in his landscape picture. This tendency, according to Ramdohr, overstrains the legitimate and possible "esthetic emotion" evoked by a work of art. The man who wants to be pathologically moved, i.e., shaken in his being, and whose "heart, mind, and soul would like to be asked to show love, gratitude, and admiration for the Creator," should turn to nature itself and see the true "brilliance of the sun, the height of the mountains, the vastness of space." Ramdohr goes on: "It is ridiculous to expect such truly pathological emotions from a painting."

Ramdohr's opinion cannot be simply dismissed as backward. There is no doubt that Friedrich often overstrained the structure of a picture in order to bring out a religious allegory. He did not always succeed in fusing the natural picture of the landscape with the emotions and the allegorical religious meaning.

In the so-called Tetschen Altar, the frame sums up the religious content and communicates it unmistakably. For — as Ramdohr also saw — "the allegorical interpretation of the landscape must therefore always be sought outside the painting," because the meaning of the allegorical natural objects (firs, mountain, fog, moon, sun, river) cannot be clearly derived from the objects themselves. One has to know Friedrich's allegory if one wishes to grasp the contents of the landscapes. The painting *Morning Fog in the Mountains* (Plate 2) would be incomprehensible in its religious susbstance if one were not familiar with Friedrich's other crucifix landscapes — especially *Cross on the Mountain,* which concentrates the idea expressed in *Morning Fog.*

This devotional painting was revolutionary in its time. It set a full stop: objective Christian iconography was finished. It set a new start: in the future, the artist would have to find his own symbolic language for his intuitive contemplation. Friedrich was well aware of this. Looking back at the controversy over his *Cross on the Mountain,* he wrote: "Had Friedrich taken the beaten path, where every donkey carries its sack, where dogs and cats walk for safety's sake, because the famous artists of earlier times have been set up here as models and paragons for thousands of years, then Chamberlain von Ramdohr would truly have held his peace."

The "cross in the landscape" as a painting theme was on Friedrich's mind at an early point. An extant pen and India ink drawing from his Copenhagen period shows a rather conventional *Rocky Forest Landscape with Cross.* A drawing in the same technique, *River Landscape with Cross,* which handles the theme more clearly and with new earnestness, is dated "the 11th of August 1802." It is followed by an India ink drawing of a Madonna statue on the peak of a rock (1804), and then a sepia drawing from just a short time later, where the crucifix in a mountain landscape appears for the first time. It also appears in several depictions, of which a sepia drawing the size of a painting, ca. 1806/07, forms an immediate preliminary stage to the Tetschen Altar.

The most important painting on this theme after this altarpiece is *Morning in the Giant Mountains,* 1811 (Plate 7). As early as 1812, when the work was shown in Berlin (and purchased by King Friedrich Wilhelm III), observers pointed out its strong similarity to Friedrich's ocean pictures. This is due to the strict two-layer

38 *Eldena Ruin.* 1825/28

construction of the space: the brown rocks in front, culminating in the cross, are separated like a solid shore from the foggy mountain crests, which come rolling in almost like waves. A plunge into bottomlessness cuts this foreground off from the movement of the mountains, which glide away into uncertainty. The crucifix is erected at the border between the two layers of space, a haven from infinity. The sun, whose final light shines upon the Corpus Christi in *Cross on the Mountain* (Plate 1), here is about to rise over the skyline. Analogously to the Tetschen Altar, we would have to conclude that the sun allegorically shows God's return, and is thus a sign of hope, of salvation.

The figures come from Friedrich's friend Kersting, and add a specific meaning to the picture. On the bare rock, a lightly dressed blond woman pulls a man towards herself and towards the base of the cross. We would have to go along with the indication that the

painter was bringing out an early Romantic idea in line with both Friedrich Schlegel (1772-1829) and Schleiermacher that the universe reveals itself in the beloved: "I do not know whether I could worship the universe with all my soul if I had never loved a woman," writes Friedrich Schlegel, Schleiermacher's friend. This is the key to the meaning of this picture. The fact that Friedrich portrayed himself in the man (confirmed by a critic as early as 1811) gives the picture the character of a confession. Walking towards the mediator Christ, the female shape is an incarnation of the eternal feminine, drawing the man from earthly prepossession to the light of this morning of salvation. The figures are quite unreal in this mountain world, which a contemporary labeled "nothing but a still life." One has the impression that Friedrich spelled out his allegorical vocabulary all too clearly here. The group of figures shifts the allegory into the realm of the sentimental. The secret of this splendid morning picture is exposed too abruptly. One might say: the viewer does not care to know it all that precisely. The form, the subject, and the allegorical meaning do not fuse into a unity; they are poles apart.

A later formulation of the crucifix landscape is the painting *Cross in the Forest* (Figure 19), which may have been completed shortly after Friedrich's stroke (1835). However, it has a powerful formal and iconographic kinship to works on the same theme that were done between 1812 and 1818.

The symmetrical structure of the painting points directly to its meaning: the cross with the radiant sun at the intersection is erected at the center and points to Christ. The source springing out at the foot of the cross symbolizes the tidings of salvation, which flow into the bleak, death-fraught abyss, bringing life. The crucifix stands at the border beween the rock and the backdrop of firs, which recall the facade of a Gothic cathedral, for the treetops stand like pinnacle towers. This border seems to form the demarcation between the compactly and concretely painted foreground — the earthly realm — and the finely articulated fir wall of the background, which seems to belong to a different sphere.

Friedrich was preoccupied with the theme of the crucifix landscape until the end of his creativity. His estate included "a large gold frame in the shape of a pointed arch, plus the beginning of a painting of a crucifix."

Nothing can be sadder or more dismal than this position in the world: the only spark of life in the vast realm of death, the lonesome midpoint in the lonesome circle. With its two or three mysterious objects, the painting lurks like the apocalypse, as though it had Young's [the English poet Edward Young, 1683-1765, whose sentimental poems were published under the title "The Complaint" or "Night Thoughts on Life, Death and Immortality"] *night thoughts; in its uniformity and endlessness it has nothing but the frame as its foreground, as though the viewer's eyelids had been cut away.*

Nevertheless, the painter has doubtless blazed a completely new trail in the field of his art, and I am convinced that his mind could depict a square league of Brandenburg sand with a barberry bush on which a lonesome crow is ruffling its feathers, and that this painting would have to have a truly Ossian-like or Kosegarten-like effect. Nay, if one painted this landscape with its own chalk and its own water, I believe it could make the wolves and foxes howl: the strongest praise that one can, without any doubt, voice for this kind of landscape painting.

These lines were penned by the writer Heinrich von Kleist (1777-1811) one year before his suicide, and appeared in the *Berliner Abendblätter* as a review of the painting *Monk by the Sea* (Plate 4). Kleist co-authored the critique with the Romantic poets Clemens Brentano (1778-1842) and Achim von Arnim (1781-1831). These three major representatives of German Romantic literature had seen the painting, together with *Abbey in the Oak Forest* (Plate 3) in 1810, at the exhibition in the Berlin Academy.

Kleist, who spent a year in Dresden in 1808 and was part of Friedrich's circle of friends, described the painting with emotional poignancy rather than dry precision. The impact of the work on Friedrich's contemporaries is clear from Kleist's statements. Its effect must have been enormous, and it is not surprising that the Prussian king made sure to purchase this peculiar phenomenon together with its pendant *Abbey in the Oak Forest* (Plate 3). Just what was it that aroused viewers at that time?

Monk by the Sea (Plate 4) turns all previous rules of landscape pictures topsy-turvy — to a far more radical extreme than the Tetschen Altar (Plate 1). After all, the Tetschen Altar had a subject, namely the crucifix on the mountain; and its content had a reference that was made visible by the frame, namely its use as a

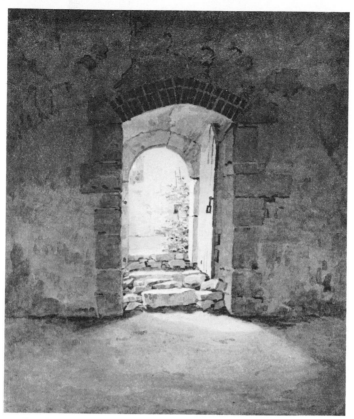

39 *Front Entrance of the Princely School in Meissen. After 1835*

devotional picture in a private chapel. Here, however, in the much larger seascape with the lonesome monk, there was nothing to see — only "uniformity" and "endlessness." This was the work of an artist who could paint "a square league of Brandenburg sand," i.e., nothing. The only thing the viewer could latch on to was the figure of the monk. And that was what Kleist did when he wrote: "...and so I myself became the Capuchin, the picture became the dune, but that which I was supposed to gaze out at yearningly, the sea, was

utterly missing. Nothing can be sadder or more dismal…" Kleist identified with the figure in the painting; and through the figure's eyes he saw the vast "realm of death," the end of the world, the apocalypse. That, incidentally, is a sensation that the picture still arouses today.

Friedrich turned artistic tradition on its head. The pictorial structure no longer has perspective depth. The narrow shore of dunes is a whitish strip, rising leftward at an obtuse angle, and then dropping leftward from the vertex, where the monk is standing — the only perpendicular object in the painting! (In the traditional landscape picture, the foreground was normally dark, with the colors lightening up only in the middleground.) The horizon, drawn abruptly as though with a ruler, is extremely low. And in between, the dark, narrow strip of water, which, as Kleist remarks, really shows nothing of the sea: for the painting consists almost exclusively of the sky, which covers five sixths of the surface. We can get our bearings up to the horizon, for there are still mutually attuned proportions, especially since the monk embodies something like a unit of measure. The background, however, cannot be grasped by measurement. On the one hand, it refers to the shoreline, for the sky lightens over the deep blue in such a way as to take up the shoreline, albeit in a mirror image. At the level of the monk's figure, the two opposite forms are constricted, so that all the "lines" in the painting radiate from this "point" out of the pictorial surface. Furthermore, the blue creates an impression of depth, an impression that is repeated and strengthened over the bright cloud edges above.

On the other hand, the horizon sharply divides the two zones, so sharply that the land/sea zone seems flat as it stretches from the horizon. The dark sea becomes a negative form, finding its positive correspondence in the sandy strip. The ocean waves virtually continue in the crests of the dune hills. Viewed in this way, the sky stands like an imaginary wall, unspatial, vastly and transparently extended. Thus the painting, which at first seems restrained with its "two or three mysterious objects" and lines, appears to be in constant motion: a movement coming from the juxtaposition of a measurable perspective and an abstract surface figure, of spatial depth and a diaphanous plane, of a summation of similar forms

(waves and clouds) and surface tones that are carefully nuanced like glazes.

Since all lines flow out of the picture, fully heedless of the confining sides, the framework seems like an arbitrary rectangle. Kleist saw this: it is "as though the viewer's eyelids had been cut away." These words accurately describe the radical, revolutionary quality of this painting. The viewer, seeing the painting from somewhere above, is confronted with a directness that is almost brutally felt. This directness forces the viewer to take a position; it points to the symbolic content.

The latter could be summed up as follows: the monk, aware of his smallness, meditates on the enormity of the universe; he is the "only spark of life in the vast realm of death." The endlessness, the immenseness make him conscious of his earthly impotence. The question of the meaning of life is asked here. What importance does Being have, surrounded by the superior force of infinity? What sense does the lifetime of man have compared to the timelessness of the universe? The monk focuses his yearning, his thoughts, on the otherworldly, which, in this painting, verges immediately on the death-fraught wasteland of earth. The gesture of leaning his head on his hands indicates absorption and humility, but certainly not grief.

Friedrich did not complete this painting at the first attempt. He revised it thoroughly four times. The new radical pictorial structure was not complete in his mind when he began; it had to be rethought and reworked over and over again. The painter was obviously aware of the new and subversive step he was taking with this painting. He sent it to the Berlin exhibit as the public place where his canvas could be seen and discussed like a programmatic declaration.

Friedrich portrayed himself in the figure of the monk. Thus the painting is an avowal not only of his conception of art, but also of his overall conception of life. Art and life, art and the artist, the painter and his work, are insolubly linked; they form a whole. One of the demands of Romanticism, to fuse life and art in a synthesis, is fulfilled here. The point at which everything falls together, from which everything receives its internal unity, is the self: "Every picture is more or less a character study of the man who painted it,

just as the inner spiritual and moral man speaks in everything we do or do not do." Having professed this, the painter demands in the most famous of his aphorisms: "The painter should paint not merely what he sees before him, but also what he sees inside himself. If, however, he sees nothing inside himself, then he should forget about painting what he sees before him. Otherwise, his paintings will be like the screen behind which one expects to find only sick or even dead people." The picture of reality is sucked up by the artist's vision. This inner visionary picture has top priority. It joins what has been separated and relates all external things to the individual's inner world.

Monk by the Sea has a pendant, which Friedrich also showed at the Berlin Academy exhibit in 1810: *Abbey in the Oak Forest* (Plate 3). Here the style is less radical. But in this picture as well, the foreground begins empty, concentrates in the ruin, and then breaks off abruptly. Behind the architectural backdrop, there is a brownish-gray wall of fog, which cancels all spatiality; overhead, there is the sky, lit up by the glow of sunset, with the waxing moon. The two pictorial strata are severely divided and do not communicate with one another. The front one is emphatically closed off by the symmetrical layout. This closure is also due to something else: the bare oak trees (which go back to studies from nature; cf. Figure 20), together with the crosses and the stone monument on the left, surround the ruin in a transverse ellipse, pegging out the foreground space like border markings. The background is unreal, a diaphanous wall. The train of monks moves away from the viewer into the pictorial depth, which funnels out in the portal with the pointed arch, yet has no measurable spatial effect.

In 1803/04, Friedrich had done a huge sepia entitled *My Funeral*. This has led some critics to assume that the pendant to *Monk by the Sea* is the funeral of the painter himself. The monks are bearing a coffin past the open grave, under the cross, toward the distant light. The oaks symbolize the pagan gods, who have been abolished. The ruin of a church indicates the futile work of the Church as an institution — above all, most likely, the dogma-bound teachings of Catholicism.

In contrast to the opinion I have previously expressed in earlier editions of this book I have come to believe that this painting takes

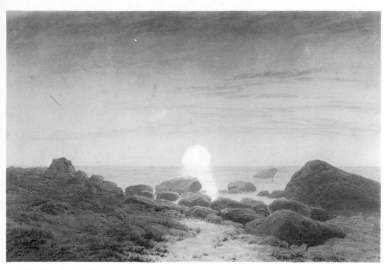

40 *Beach with Rising Moon.* 1835/37

place in the evening. The waxing moon is following the sun. Hence, this painting symbolizes mortality rather than hope for resurrection.

Theodor Körner wrote two sonnets on *Abbey in the Oak Forest.* The second ends with the lines:

> *I must not coldly admire — no, I feel,*
> *And in emotion, Art perfects itself.*

He thus clearly defined the viewer's position, exactly as the painter desired.

Around 1810, Friedrich again portrayed himself in a painting: *Mountain Landscape with Rainbow* (Plate 5). The picture is odd because it takes no heed of the reality of nature: it obviously has two sources of light. One is in back of the viewer, making the rainbow visible and illuminating the foreground and its figure; the other, over the zenith of the rainbow, is most likely a moon breaking through clouds. Presumably, the depiction was first conceived as a

101

nocturnal landscape. Subsequently, the rainbow was boldly placed across the night sky. In refusing to paint over the moon, the artist must have had a good reason, which is to be derived from the meaning of the whole work.

Once again, Friedrich is uttering a profession of faith. Like the monk by the sea, this self-portrait is fully devoted to contemplation, *Anschauung*. The rock may symbolize the unshakable conviction of faith, but it could also indicate the artist's mission in the world, a mission that gives his life solidity. Leaning against the rock, the man, bare-headed and humble, peers at the rainbow and at the dark mountains, from which he is separated by the depth of the valley. On the brink of the abyss, exposed, he experiences the miracle of nature. The rainbow, as a symbol of reconciliation between God and man, promises deliverance from the gloomy world lying in ominous shadow. Thus the man is struck by the light, which also allows the rainbow to appear. Day and night, life and death are linked; time is removed to a different sphere, one that is close to God. The moon and the sun, which medieval art assigned to Christ as signs of eternity, come together here in a similar connection of meaning.

15 Melancholy

No human being can or will feel that what I bring forth comes from this misery; for it is supposed to appear charming, and even the greatest work of art, filled with horror and terror, is soothing, because it is consistent; but this most consistent birth has sprung from the most inconsistent, most dreadful sufferings, and when it is here, no one thinks about the terror.

Philipp Otto Runge, 1802

Most of the records that friends and visitors have left about their encounters with Friedrich touch upon his melancholy. Carus was probably the one who most aptly described this melancholy and, as a physician doing research in psychology, most aptly explained it:

Born on the banks of the Baltic Sea, a quite sharply drawn North German character, with blond hair and whiskers, a significant head structure, and a gaunt, very bony body, he wore a peculiar, melancholy expression in his usually wan face, whose pair of blue eyes lay so deeply concealed under the strongly protruding orbital edge and likewise blond and bushy eyebrows that the gaze of the painter, who concentrated the effect of light to the utmost degree, was very characteristically explained. As a youth, Friedrich had the dreadful experience of seeing an especially beloved brother, with whom he was ice-skating near Greifswald, crash through the ice before his very eyes and be swallowed up by the deep. Considering, furthermore, his very high notion of art, his somber nature, and, coming from both those things, a profound dissatisfaction with his own accomplishments, one can easily understand that he was once really misled to attempt suicide. He always wrapped this in a deep secret, but one can readily feel that such an act, having been commenced, albeit prevented in time, must have had a dark and gloomy aftereffect on an individual of this kind.

The suicide attempt, which most likely took place during the artist's first few years in Dresden, must be accepted as a fact. Several obituaries dramatically embellished it:

Withdrawing to his solitary chamber, he had already cut a deep wound in his throat, when the door was flung open, and he was not merely saved, but moved by his friend's rebukes to give his word of honor never to make any

further attempt on his own life. On this occasion, I consider it my duty to dispute the suspicion of affectation, which many people felt justified in believing because of the extraordinarily hairy lower part of Friedrich's countenance; at the time, there was no thought of the later rather universal habit of sporting beards among young men, and anyone who sought embellishment in a beard was regarded as a ridiculous swaggerer...Subsequently, I learned that it was probably his closest friends who inveigled him into this, or else he himself hit upon it, because there was no other way of hiding from human eyes the uncommonly huge scar of the wound that the suicide attempt had inflicted upon him...

The stilted anonymous writer of 1843, who, like other contemporaries was evidently repelled by the painter's Cossack beard, either reported a legend here or repeated a truth — we don't know which. Carus' quasi-diagnostic explanation for the artist's melancholy, once so convincingly stated, has been constantly referred to in the critical literature. It has, no doubt, made it more difficult to approach Friedrich's art.

This difficulty came from the viewer having a shallow explanation from the very start. Shallow because the painter's pictorial world was hastily seen in terms of his character. An example of the predominant opinion of contemporaries is the passage on Friedrich in Count Raczynski's *Geschichte der neueren deutschen Kunst (History of Recent German Art)* (1840): "Friedrich paints gloomy subjects: bleak plains, ocean wastes, polar ice, fog, snow, glaciers, nighttime, churchyards, and the like. His dreary mood must have its basis in the misfortune he encountered. He was once ice-skating..." And then the story of the accident is repeated.

Thus access to the meaning of his pictures is blocked because critics first point out Friedrich's gloomy nature, and one need no longer rack one's brain about why this artist charged his landscapes with existential earnestness.

Granted, the artist's personality flowed into his art to an extent that was uncommonly intense for his era. But after the collapse of religious iconography, Friedrich's mission to create a new type of devotional painting for an educated middle-class public was dictated by the era. Hence, its nature was objective. Certainly, he was depressive from birth, and the things that happened to him in his adolescence — the deaths of his mother and his siblings —

41 *Wanderer over the Sea of Fog.* Ca. 1818

activated this tendency. But his main theme, the certainty of death and the hope for salvation, is universally human. He was the first artist to employ this theme in landscape painting. It was frightening for his era, and its radicality was inexplicable, especially in a society that did not care to think about death and that even today makes more and more of an effort to develop and apply mechanisms for suppressing death and the fear of death.

This indecent intensity in form and theme could only be attributed to facts in Friedrich's biography. It then only takes one more step to label such an artist as perverse. This led to such bombastic formulations as "the painter's brooding, melancholy imagination turns virtually into an anxiety-ridden shriek here" (E. A. Hagen, 1837). The public simply couldn't understand that an artist was making art not for the sake of beauty, but in order to communicate a statement that was about himself and hence the theme of what he painted — art as an act of self-realization, i.e., of self-liberation. Friedrich lived in and for his art, and he lived through his art. It is almost poignant to note how the majority of critics strove to translate Friedrich's revolutionary pictorial language into conventional terms. Whenever they failed to do so, they practically excused his work by citing his melancholy.

Yet this melancholy should not be overestimated. As Friedrich's letters and the many accounts of his personality testify, he was friendly despite his gruffness, cheerful and witty, full of irony and hidden humor. There are splendid bright paintings by him, with no shadows whatsoever, full of hopeful certainty and affirmation of life, such as: *Summer* (Figure 15), *Morning in the Giant Mountains* (Plate 7), *Garden Terrace* (Plate 6), *Chalk Cliffs in Rügen* (Plate 9), *Drifting Clouds in the Mountains* (Plate 15), or *The Watzmann* (Figure 31). It was only during the last decade of his life, when he was embittered by illness and by misunderstanding from the public and the critics, that his life became dark.

Hence one should not characterize Friedrich as a melancholy, onesided, gloomily obsessed artist; one should not regard him as unsophisticated and impractical. The self-willed way in which he gained acceptance for his art, which drew and still continues to draw attention, is a sign of artistic genius (always transcending the ephemeral) and of an extremely non-conformist character.

42 *Woman before the Setting Sun.* Ca. 1818

What has been precipitously called "melancholy" in Friedrich is also his living Protestantism. The earth is a "vale of tears" for him, and the old hymn "In the midst of life are we/All by death surrounded" (Martin Luther, 1524) was a religious experience for him, as he expressed in his verses and aphorisms:

> *Why — the question has often come to me —*
> *Do you pick as the subject of your painting*
> *Death so often, ephemeralness, the grave?*
> *— In order to live eternally some day,*
> *One must surrender frequently to death.*

These stanzas are — not coincidentally — reminiscent of Protestant chorales.

In the period of deep depression, 1801/02, when Friedrich may have made the attempt on his own life, he did the drawings that his

brother Christian Friedrich cut in wood in 1817: *Woman with Cobweb between Bare Trees* (Figure 21) and *Woman with Raven at the Abyss* (Figure 22). The first woodcut shows a woman peering into the distance, into the light coming from the left, from a source not visible in the picture. She is absorbed in her thoughts, and her head is supported by her hand. This is a landscape of death, in which the cobweb is spanned out, a symbol of easily destroyed life that is threatened by annihilation. The thistles enhance this symbolism of ephemeralness. Yet there is the affirmation of life in the midst of death: the cobweb is complete, a closed circle, concentrating towards the center as if with annual rings. If one has found the meaning of life and made it come true, one is invulnerable to all danger.

Woman with Raven at the Abyss (Figure 22) presents a hopeless exposure to death. The dead tree and the bird of death on the dry branch, the uncertain position of the woman on the breaking sapling right on the edge of the cliff, the serpent angrily springing from the ground, the dissheveled hair, the woman's helpless gaze out of the picture — all these things add up to an impression of despair and emptiness. The symbol of hope — the fir tree solidly rooted in the rock at the back — is not perceived by the woman. Few other works by Friedrich are ruled by such hopelessness. It was only during the last few years of his life, in his pictures of graves and cemeteries, that similar thoughts took pictorial shape (cf. Figures 61 and 62).

16 *Dolmen in Autumn*

This painting, done around 1820, is the most dramatic of all of Friedrich's depictions of megalithic graves (Plate 10). The tremendous boulder lies under a gaping sky, sealing the grave with definitive force. The smaller rocks arranged in a circle and supporting the boulder have sunk into the earth. The storm, breaking in from the left and blowing through the painting, bends the twigs of the bushes toward the right. The splintered tree trunk at the right edge of the canvas is part of this movement, which finds a counterforce in the clouds, a gray concentration breaking out of the bright zone, which arches downward. This opposing direction is repeated in the twin branches at the center of the canvas.

Friedrich once again developed the overall shape of the picture from a hyperbola. The hill cuts off the lower arch on whose vertex the dolmen rests, finding a correspondence in the sky. Thus not only is the dolmen virtually squeezed between the legs of the geometrical form (or do the rocks blast the lines of the arch apart?); but this form has two other functions:

1. It forces the two completely diverse spatial layers together on the surface of the picture: the narrow natural stage with the grave and the background layer of the sky, rising up from somewhere deep below.
2. It provides a framework within the picture for the subject, the dolmen. This framework is laterally completed by the concave shape of the trunk at the left and the dead stump at the right.

As a result, despite all the dynamic forces passing through the picture, the overall structure has something of a circling motion around the subject. The stone monument is holding out against the

storm of time. It has come down to us from a distant past.

Some critics have felt that this depiction symbolizes the "failure of a heroic, pagan outlook on life," the "futurelessness" of the pagan *Weltanschauung*. Yet one could also turn this exegesis on its head: the great signs of the past have outlasted the centuries, they have survived despite all the tempests and catastrophes brewing ominously in the heavens. The granite block resists unshakable. Does it not come from the time "when God still walked the earth?"

We may also assume that the dolmen does not actually symbolize the pagan world, but rather the glorious national past that continues into the present. That would give the painting a political significance, such as Theodor Körner expressed in his song *The Oaks:*

> *Unconcerned about all doom and fate,*
> *Time has threatened you to no avail,*
> *And I hear a call from branches' soughing:*
> *Greatness always holds its own in death!*

Hence this picture would be Friedrich's commitment to the unbroken strength of the Germans in a time of restoration, when the so-called persecutions of demagogues began.

This theme must have seemed Nordic and exotic in Dresden; yet conspicuously, the painter chose precisely this defiant painting as the obligatory work for his membership in the Academy of Art. Wasn't the picture almost a challenge? Perhaps the conclusion forcing itself upon us is not so wide of the mark: this work (which takes in studies that the painter did of the dolmen near Gützkow, Pomerania in 1809) pointed out not only Friedrich's Pomeranian background, but also his own position in time. "Oh, you dry, leathery, commonplace people, think up rules all the same! The crowd will praise you for the crutches you offer; but the man who feels his own strength will laugh you to scorn!" *Dolmen in Autumn* would therefore be a symbol of the artist's "own strength," defying the passage of time, its shocks and injuries, its perils and catastrophes.

The year 1801 marked Friedrich's first visit to Rügen. The following year, he returned there, wandering all over the island with his first teacher Quistorp. When he drew the dolmen near

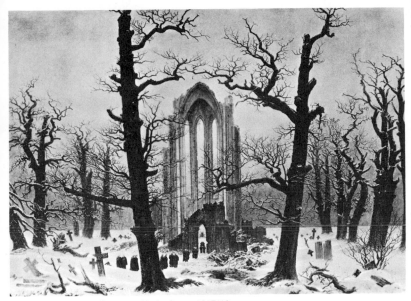

43 *Monastery Graveyard in the Snow.* 1817/19

Gützkow on March 19, 1802 (the same dolmen that appears in the above-mentioned painting, Plate 10), Quistorp lay "up on the cap rock, smoking a little pipe." Evidently, it was the teacher who had made Friedrich aware of these prehistoric monuments.

Then, in 1806, during a stay in Rügen, he did a study of the rocks near Nobbin (Figure 12), eventually using it in his large sepia *Dolmen by the Sea.* This is the picture that he sent to Weimar and that was acquired by the Duke of Weimar in 1808.

Other drawings showing the dolmen near Gützkow, but done from nature in 1806, were used for Friedrich's painting *Dolmen in Snow* around 1807 (Figure 24). The motif of the oaks around the ancient rocks is taken over from the Weimar sepia, but is more concentrated and focused here. The division between the two layers of space is maintained consistently. The grave is ringed by the three oaktrees; far behind it lies the winter sky over a brownish strip of bushes, with bare trunks looming at the right edge of the canvas.

111

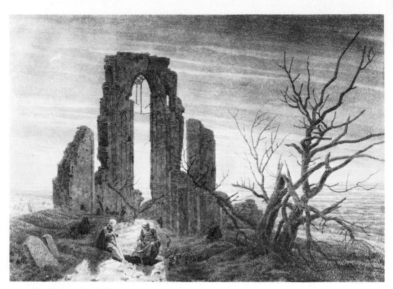

44 *Winter.* Ca. 1834

Granted, the pagan belief in gods is depicted in a wintery world of the numbness of death, a belief contrasting with the religious certitude of Christianity. The dolmen painting probably had a pendant, which combined green spruces around a bolder — hints of a Christian life — with a view of the broad valley of the Elbe.

Nevertheless, the thought of unshakable survival is also present in this dolmen picture. The indication that the heroic monument and the oaks (which even today symbolize the strength of Germans to win out against all obstacles) survive the winter unbroken — that indication must refer to political events. After the crushing defeat at Jena and Auerstedt (1806), Prussia, the last bastion against Napoleon's army, was at the mercy of the emperor. We are reminded once again of Theodor Körner's poem "The Oaks."

> *German Nation, finest of them all,*
> *All your oaks are standing, though you fall!*

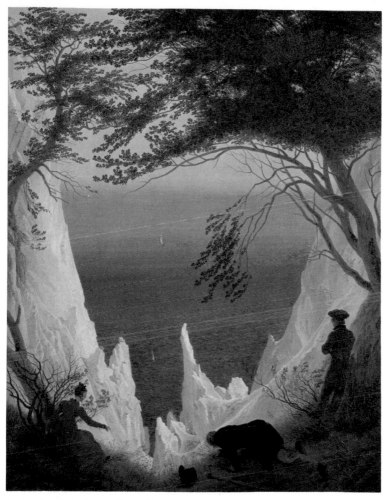

9 *Chalk Cliffs in Rügen.* Ca. 1818

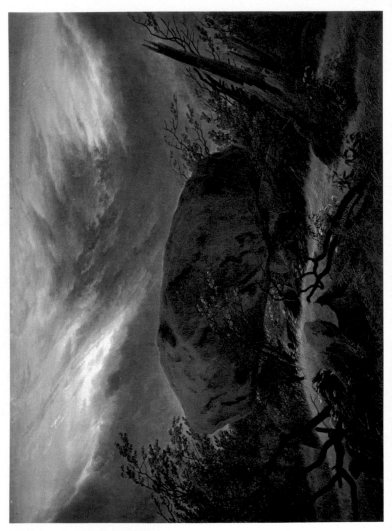

10 *Dolmen in Autumn*. Ca. 1820

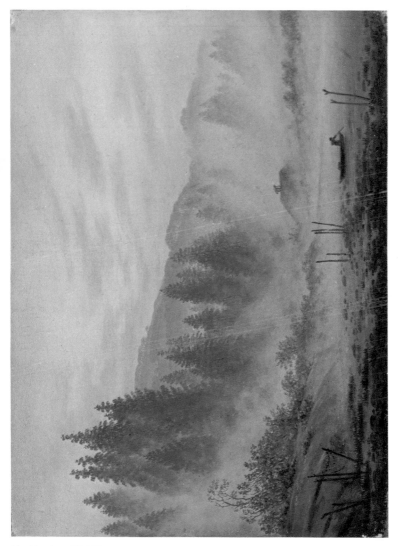

11 *Morning.* 1820/21

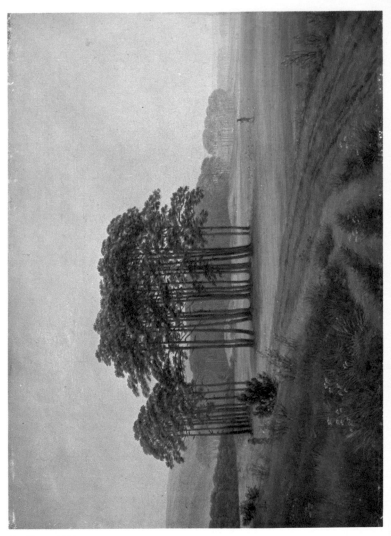

12 *Noon.* 1822

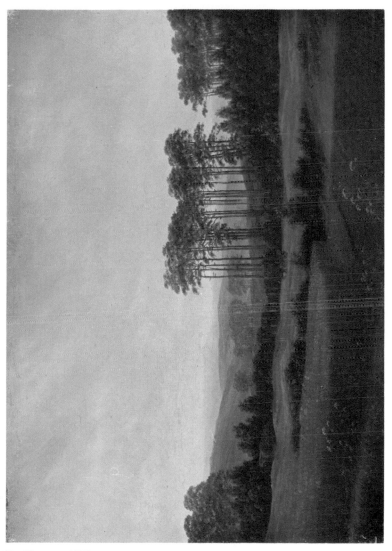

13 *Afternoon.* 1822

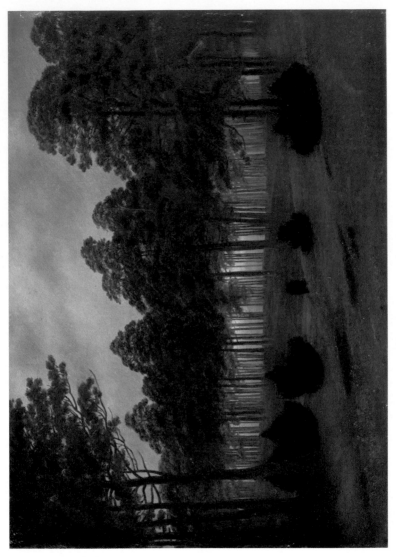

14 *Evening.* 1820/21

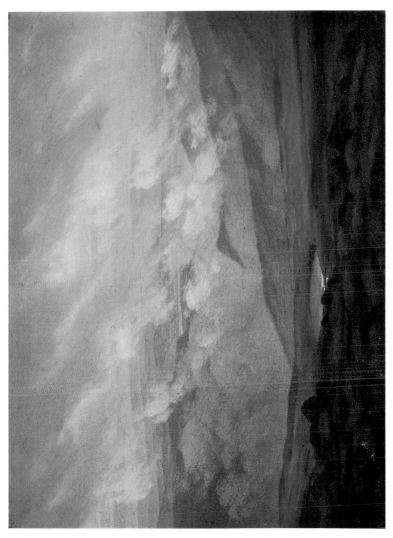

15 *Drifting Clouds in the Mountains*. 1821

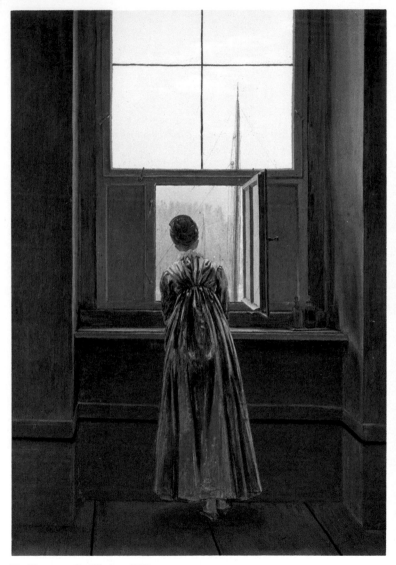

16 *Woman at the Window*. 1822

Friedrich, who never made any bones about his political stance, could readily have made such an allusion to the deathly calm of a defenseless, occupied nation. And his painting would therefore be an appeal to reflect upon the past in order to find new strength. The pendant, *View of the Elbe Valley,* would thus not have a primarily Christian substance, but would point instead to the principle of hope: if this nation awakens from its numbness, the earth will turn green again in peace, hope, and faith.

Quistorp's and Kosegarten's Ossianic and Nordic convictions are apparent in these dolmen paintings. Friedrich's encounter with the Nordic Renaissance was made fruitful (cf. Chapter 7). Nevertheless, these canvases have no trace of any sentimental nostalgia for the past. They are hard and strict. They are worthy of their subject in the consistent boldness of their pictorial structure. And they are full of what I regard as a deep political significance.

17 Germanism

As in art, thus was he in life as well; of a rigorous justness, uprightness, and seclusion — German through and through — he never so much as attempted to learn one of the modern foreign languages, he was alien to all ostentation as to all luxurious socializing.

Carl Gustav Carus, 1865

The "justness and seclusion" alien to "all ostentation" (i.e., all boasting), which Carus cites as character traits in Friedrich, may not strike us as absolutely likable today. After all, such things add provincial isolation to his art, an ingredient that still deprives him of international recognition at the present time. His emphatic support of the Germans in the struggle against Napoleon, from 1806 to 1815, contributed to this narrowing of his artistic horizon, even though his political stance coincided with that of the best German minds — just recall the thoughts and deeds of Imperial Baron vom und zum Stein (1757-1831). Of course, Friedrich had more intense relations to neo-German zealots like Ernst Moritz Arndt, who was also a native Pomeranian (b. 1769 in Schoritz, Rügen; d. 1860), or F.L. Jahn, the unsophisticated founder of gymnastics (b. 1778 in Prignitz, Brandenburg; d. 1852). Friedrich immortalized all three names on the coffin top in his painting *Ulrich von Hutten's Grave* (Plate 20), along with other names: Joseph Görres (1776-1848), the Catholic, national writer; and the Prussian general Gerhard von Scharnhorst (b. 1755), who died in 1813 of a serious wound he had suffered in the battle of Gross-Görschen (May 2, 1813).

Friedrich expressed his Germanism uncompromisingly. In 1808, he replied to a letter from his brother Christian, who had written him from Lyon: "You feel yourself that it is not right for you as a German to be in France, and that certainly consoles me a bit, for otherwise I would despair altogether of your Germanhood. Still, I resent it so much, my dear, good boy, that I must ask you *not* to write me anymore so long as you remain in France; but as soon as you have passed the French border and are in a different

country, then I urgently ask you to let me know where you are and how you are doing."

It must have been around this time that he did a now lost painting or sepia entitled *Eagle over the Fog.* Gotthilf Henrich von Schubert, who saw it in Friedrich's studio around 1807/1809, reported the painter's comment:

> *With his usual wrath towards the French, Friedrich also expressed his pain at the humiliation of Germany. But when we uttered further dismal worries and anxious fears about the distant future, he pointed to the eagle in his painting. "The German spirit will manage to work its way out of the storm and the clouds," he said, "and there are mountain peaks up here, standing solid and sunny. If the storm hadn't come, the eagle may have remained perching below, where no prey was to be seen or caught, he would have gone hungry and prowled about in search of food. The German only needs to warm up before lifting his arm; but once he lifts it, it will 'work smooth,' as we say in Pomerania."*

In the years before the outbreak of the Wars of Liberation (1813), the painter belonged to a group of like-minded people, including Schubert, the writer Heinrich von Kleist, his painter friend Friedrich Kersting, and the philosopher Adam Müller, as well as several officers. In 1813, Arndt was also living in Dresden. When Kersting heeded the appeal of the Prussian king in the spring of 1813 and joined the Prussian army (like the writers Theodor Körner and Friedrich de la Motte-Fouqué, like the painters Philipp Veit and Friedrich Olivier), Friedrich contributed to his friend's equipment. He himself felt he was too old for the military. Kersting and Körner then met in Major von Lützow's volunteer corps.

Friedrich did paintings that warned and reminded: in 1812, *Tomb of Old Heroes* or *Grave of Arminius,* which bears the inscription: ARMINIUS — G. A. F. NOBLE YOUTH / SAVIOR OF THE FATHERLAND, and THE NOBLY FALLEN / FOR / FREEDOM AND JUSTICE. T. A. K. These initials, which have not been convincingly interpreted, are most likely not for names but for mottos, such as were often used in academic circles at that time.

One year later, Friedrich did a second, denser version, *Cave with Tomb* (Figure 25), using a now lost study of the marble quarry at Hartenburg in the Harz Mountains. The picture opens like a

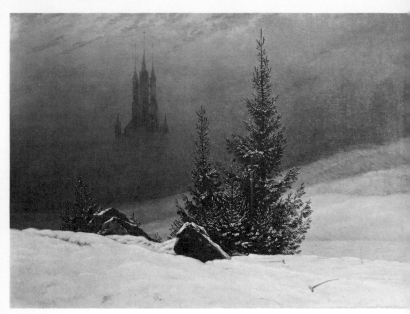

45 *Winter Landscape with Church.* 1811

funnel, leading the viewer's eyes to the dark cave with the sarcophagus. A French soldier is humbly looking down at it; he is almost crushed by the jagged wall of rock that cordons off the picture powerfully and definitively. As in a grave of Christ after the Resurrection, the cover stone does not seal the tomb; it lies obliquely against the walls, making the tomb look as if it were opening. The fir trees symbolizing hope loom up before the wall of rock, increasing the impression of strength and unyielding faith. The inscription says: MAY YOUR LOYALTY AND INVINCI-BILITY AS A WARRIOR SET AN EXAMPLE FOR US ETER-NALLY. These words do not refer to Arminius or Hermann, the Germanic commander and conqueror of the Romans; they are meant for someone who died in the Wars of Liberation.

During this period, Friedrich was preoccupied with the idea of a monument for warriors. A series of drafts contains his ideas. The

monument was to stand freely in a square, as an obelisk (Figure 26) or a pillar crowned by a helmet, or a gigantic column, plus flags, coats of arms, armed figures, lions, crossed swords, such as can be found in a different form on the coffin top in *Cave with Tomb* (Figure 25). In these sketches, Friedrich shows a talent for architecture, which comes as no surprise if we recall the rigorous construction of his pictures. The strange thing about these sketches is that the forms of the Empire style (especially its Egyptian variant) and of Classicism (the column) are united with medieval emblems: armor, swords, coats of arms, and halberds. Incidentally, one of the drafts has the name "Theodor" on it, probably referring to Theodor Körner.

In 1814, Friedrich painted a now vanished memorial picture for General Scharnhorst and asked Ernst Moritz Arndt for an inscription. He wrote:

Highly esteemed compatriot!

I have received your kind letter and the enclosed drawings. I am in no wise astonished that no monuments are being erected to designate either the cause of the Nation or the high-minded deeds of individual Germans.

As long as we remain the thralls of princes, nothing great of that nature can come about. When the people have no voice, they are not permitted to feel or honor themselves.

I am now working on a painting showing a monument in the open square of an imaginary city. I wanted this monument to be for that noble man Scharnhorst, and I would like to ask you to write an inscription. This inscription should not run to much more than twenty words, for I would then lack space. I hope that your kindness will fulfill my wish. Your compatriot, Friedrich.

This letter testifies to the painter's close relationship with Arndt and contains a political avowal that was widespread in academic circles at that time: a protest against the princes and for the people. The ranks of republican-minded students produced the founders of the *Burschenschaften,* the academic fraternities, which were founded from 1814 to 1816 in Heidelberg, Jena, Giessen, and elsewhere.

Chasseur in the Forest (1814) is no memorial (Figure 27). It depicts the events of 1813, when the Battle of Leipzig initiated Napoleon's decline. The solitary French soldier is marching towards his destiny: the German fir forest will swallow him up. Likewise, his

125

footsteps will vanish in the snow, for the springtime of freedom is coming. This is what the raven on the tree stump seems to call after him. The picture shows an opening chasm, from which there is no way out for the chasseur. We feel as if once he vanishes, the picture will close like a relentless and gentle trap.

The artist must have also done a painting of outright hatred that same year: a *Stormy Twilight Landscape with Ravens,* which originally looked different. Friedrich reports in a letter: "The structure of this painting was totally different: in the deserted sandy spot, there were poles all around, with planks tied to them, moved by the wind, each with the inscription 'Traitor to the Fatherland.' At the exact center, there was a long pole in a big hole, a wheel on the pole, a man on the wheel, his hands tied to a tablet saying 'Traitor to the Fatherland.' I thought of certain beasts in this connection, but the painting became too disgusting for me, and I was incapable of carrying it out." The picture, painted over, has not survived.

For a long time, Friedrich still toyed with the idea of a memorial to those who had died in the War of Liberation. In 1818, he painted *Cross in the Forest in the Evening,* which has not as yet come to light. According to an eyewitness, it showed a "majestic forest landscape, in which, amid the loftiest mountain tops, high over tremendous pines and dark lower zones, the point of a colossal sword is thrust into the rocky ground, greeting the viewer as a radiant cross in the golden shimmer of the sun." One might think that Friedrich knew verses from Friedrich Rückert's (1788-1866) *Geharnischte Sonette (Armored Sonnets)* of 1814:

> Tear the crosses from the earth,
> Crosses must be made to swords.

The liberation struggle against Napoleon was no ordinary war, but, according to Arndt and his friends, a Holy War. Körner, in his "Appeal," wrote:

> This is no war of which the crowns now know;
> It's a crusade, it is a holy war!

Hence it is only consistent of Friedrich to connect religious and profane military symbolism (crossed swords, etc.) in paintings on this theme.

In 1820, Friedrich was working on a *Memorial Painting for a Soldier Fallen in the Wars of Liberation.* A "hill like a destroyed dolmen" constituted the foreground. 1823/24 brought *Ulrich von Hutten's Grave* (Plate 20), which was yet another clear commitment by the painter to the ideals of 1813/14 — and in a time when these lofty, subversive notions were about to be utterly destroyed.

The memorial painting for the humanist and knight Hutten, who had to leave his homeland, is both a warning and a portrayal of the political situation after the writer Kotzebue was assassinated by the fraternity student Sand in 1819. The inscriptions sound defiant: JAHN 1813, ARNDT 1813, STEIN 1813. Then: GÖRRES 1821 (that year, Görres had to flee the police agents and find refuge in Switzerland), SCHARNHORST. Here, in memory of the German Hutten, all the strugglers against state restoration are united. The man in the uniform of Lützow's volunteers, leaning on his sword and peering absorbedly into the open tomb as though he were praying, sums up in a single figure the recollection of the time of the liberation movement. (Some observers have thought that Görres himself is depicted here.) The man has returned to the ruin, which most likely does not primarily symbolize medieval religiousness, but indicates the waning of strong faith in freedom. After all, the Fides figure holding the cross is also mangled; its head is missing. The pious ardor of the Wars of Liberation has been destroyed. Green shrubs and the protective spruce grow only around the altar, which is crowned by a helmeted bust in the chancel of the church. The greenery is a sign that the idea of freedom has not perished fully; it is renewed and strengthened in the memory of the war dead, even if the dry branches in the right half of the canvas augur a bad future. A butterfly rises from the black crack of the tomb, indicating the immortal soul, which is present for those who do not forget the dead.

Solemnly, the chancel wall surrounds the altar and the man. Solemnly, the narrow pointed arches open, admitting the heavens, which, as an imaginary second framework, envelop the pictorial space. Religious sentiment and the memory of freedom are one in this painting, which virtually offers a mental outline of the political situation around 1823.

Thus in his architectural drafts and in his paintings, Friedrich followed the demand made by his friends and politically like-

minded people for powerful monuments for the freedom fighters. After the Battle of Aspern (1809), in which the Austrians first stood up to Napoleon's armies, Theodor Körner had given utterance to that demand in his poem "On the Battlefield of Aspern." The concluding stanza goes:

> *Hence, my Nation, hear thou the appeal:*
> *Austria! Thou shalt venerate thy dead!*
> *He who calls himself a German now —*
> *Let him proudly, joyously give his gift,*
> *And upon their grave let it be built:*
> *Their heroic grandeur's monument,*
> *So that all the centuries may say*
> *When our age has sunk into the whirlpool:*
> *Twas the German Nation who fought this battle,*
> *This stone is the German Nation's thanks!*

Friedrich obeyed this appeal as persistently as if he considered this idea his personal obligation.

Until his very last paintings (cf. Plate 24), Friedrich kept up the memory of the Wars of Liberation and his political enthusiasm for the plans for greater justice in the social structure and for the realization of a democratic, republican political system. He did this in his figures, and more precisely in their costumes. In 1814, Ernst Moritz Arndt had propagated a German costume for men and women in his work *On Custom, Fashion and Clothing.* The male outfit consisted of a gray or black coat buttoned up to the collar, with a broad shirt collar spreading out over it. The hair, worn down to the shoulders, was topped by a black velvet cap. A black cloak completed the picture. The Lützow volunteers took over this look, albeit in a simplified form — without the shirt collar. This costume, like the woman's long, dark dress, with a high waist, long sleeves, and high, closed collars (cf. Plate 24), was worn by the figures in Friedrich's paintings.

Two Men Gazing at the Moon of 1819 (Figure 28) is an example of the artist's adherence to Arndt's clothing style, which contains a political avowal. The two men, an older one in the German costume at the right, a younger one, fashionably dressed, at the left, peer intently into the depth of the picture, at the waxing moon. The older man may be Friedrich himself, the younger one

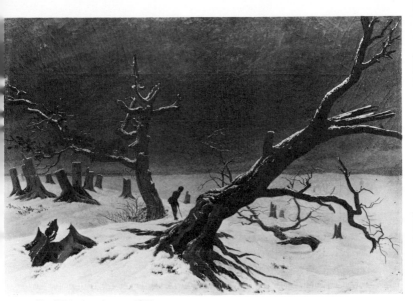

46 *Winter Landscape.* 1811

his pupil August Heinrich. The younger man is leaning on the shoulder of the other, who seems to be initiating him into contemplating the moon, which glows as a token of meager hope in imaginary immensity. The two men are standing on a ledge, in a rugged, impassable, rocky landscape, under the evergreen spruce tree, the sign of permanence: they are holding fast to the ideals of freedom. At the right, the dead, uprooted oak, which seems to be toppling, characterizes the condition of Germany during the Restoration period.

The validity of this interpretation is borne out by Friedrich himself. In 1820, when talking to Karl Förster and Peter Cornelius (cf. Chapter 23) in front of this painting, he employed a striking, revealing irony: " 'They're involved in demagogical machinations,' said Friedrich ironically, as though by way of explanation." This account is by Förster. After Kotzebue's assassination, the student fraternities and all those who were unable to come to terms with the Restoration were persecuted as "demagogues." The German

costume was decried and in part prohibited. The first expulsion of intellectual political groups from Germany occurred during these years, from 1819 to 1823. It was repeated after the so-called Sentry Storm of Frankfurt in 1833 and on a large scale after the abortive revolution of 1849. These persecutions led to an overall loss of democratic substance in Germany, which in turn had a disastrous effect on the country's future.

Friedrich then resigned himself politically. His letter to his brothers in Greifswald, telling about the agitations in Dresden in September 1830, is conspicuous for its detached, ironic tone. This is no longer Friedrich's revolution. He watches skeptically: "If such an excited nation lets itself be led with so few words, one cannot refuse it one's respect, can one?"

Only his paintings maintained his convictions, in the earnest, dark-costumed figures, until he put down his brush.

18 *Garden Terrace*

There is a strange calm in this painting of 1811/12 (Plate 6), a calm emanating from the palpable, virtually exposed orderliness of the pictorial construction. Two powerful verticals — the trunks of the chestnut trees — and a horizontal — the road running below, parallel to the edge of the canvas — form an internal rectangle in the painting. From the side edges to the trunks, from below up to the wall (unmistakably closing off the bottom third of the surface and the foremost pictorial space), the pictorial surface consists of superimposed strips, two fields of structured emptiness. The two perpendiculars (trees) and the many horizontals (road — lawn — road — lawn — road — wall) determine the order, which is symmetrical. There are mild shifts within this symmetry — an emphasis on a short horizontal at the center of the picture, directly next to the middle axis, in the stone figure on the pedestal. The approximately symmetrical treetops are a graphic pattern against the bright sky.

Inside this picture within a picture, the objects are assembled: the red cloth covering the basket, the reading woman, the stone figure, the gateway with the lions. This gate, with the cross in the middle, is the key form to the whole painting. It determines the dominants of the front layer of space. It seems somewhat shifted to the left in the ground and turned into space in the red cloth, which lies like a gable over the basket. The gate is also hinted at in the leafwork of the two chestnut trees: their foliage opens downward in two triangles, which are centrally roofed by an overall gable form. This form also appears in the second layer of space: it is taken up in the two mountain ridges.

The pictorial structure distinctly pulls together in the internal rectangle and holds its breath, as it were. However, there is a movement urging rightward, almost yearningly, and driven by the chestnut branches pointing in that direction. It is as if this portrayal of orderly stillness had been lifted and held fast from the flight of all phenomena that are prey to time.

Inside and outside, the zone of contemplation in front and the remoteness — to be entered through the gate and summoning to the activity of departure, with the lions promising strength to whoever makes this decision — are the theme of this painting. It is so self-contained that one could only reluctantly infer any political meaning. Does the beautiful stillness of the tree-topped garden really symbolize the "world ordered according to the laws of reason," or "the numbing of a civilization that emphasizes reason"? Could the painting, in its two spatial strata, really be opposing the unacceptable "French spirit of rationalism to German religiosity" (Bösch-Supan)? The solemn silence in front and the bright, promising distance in the background are filled with a beautiful harmony that determines everything — the way the gable form of the gate with the cross in its latticework connects distance and nearness. The basket, which is covered in front, seems open in the background. A mysterious, taciturn fullness is engaged in a dialog with the blossoming, slightly hazy distance.

The chestnut trees must have been based on studies from nature. Two studies of 1812, done immediately after the completion of the *Garden Terrace,* offer an idea of the artist's intense, patient, detailed perusal of natural reality. These studies are *Maple Trees,* dated "the 20th and 21st of March 1812" (Figure 29), and *Firs at the Forest Edge,* dated "the 14th of June 1812" (Figure 30).

19 Travel

We always define and measure banality and boredom by the things that closely surround us, while things to delight us are always sought far away. From the days of our youth, it has been our studious goal to make all foreign things — customs, language, clothing, etc. — ordinary; for once, we should try to make ordinary things foreign, and we would be astonished at how close some instruction, some delight is to us, things that we seek in a remote, arduous distance. The wonderful Utopia often lies right before our feet, but we look beyond it with our telescopes.

From: Ludwig Tieck: *Peter Lebrecht, 1795*

Aside from his attendance at the Art Academy of Copenhagen (1794-1798) and his two journeys to northern Bohemia (1807 and 1808), Friedrich never left the boundaries of Germany. In fact, it must be added that he never even got to know southern or western Germany.

The painting of *The Watzmann,* near Berchtesgaden (Figure 31), was done in 1824/25, after a water color by Friedrich's pupil August Heinrich. Friedrich's Swiss landscapes were based on graphic works by his friend Carl Gustav Carus. The *Temple of Juno at Agrigento,* 1828/30 (Figure 32), used an aquatint etching by F. Hegi, derived in turn from a water color by C. L. Frommel. The early *Wreck in the Polar Sea* of 1798 (Figure 14) is still fully in the tradition of seventeenth-century Dutch seascapes. *Polar Sea* of 1823/24 (Plate 22) employs studies that Friedrich did in January 1821 of the ice drift on the Elbe (cf. Chapter 26). Friedrich never experienced the dialectics of near and far. This means that his distances, the quality of his background spaces, have no earthly relationships. They transcend space and time; they are visions of the universe, absent, yet separated from earthly tangibility.

Despite his usually straitened circumstances, the painter did not lack opportunities to leave Germany. In 1816, his Danish painter friend Lund invited him to come along to Italy. Friedrich begged off:

Thank you for the friendly invitation to travel to Rome, but I freely confess that I have never felt an urge to go there. Now, however, after leafing through a few of Herr Faber's drawing books [the Hamburg painter

Johann Joachim Faber, 1778-1846, a friend of Ludwig Richter, in Rome from 1806 to 1808], *I have almost changed my mind. I can now think of it as quite fine to go to Rome and live there. But the thought of coming back from there to the north fills me with horror; to my mind, that would be tantamount to burying myself alive. I am perfectly willing to stand still, without grumbling, if that is the will of destiny; but going backwards is repugnant to my nature, my entire being rebels against it.*

Friedrich's argument is remarkable. He would rather "stand still" than experience a wealth beyond his control and capable of punishing him with everlasting yearning after his return. Just as he rigorously limited the subjects in his paintings, so too he kept his personal world deliberately narrow. Those lines from his letter also expressed a truth that became disastrous for many northern artists who visited Rome: Upon their return home, their art grew lifeless. The more strenuously they tried to capture the experience of Italy, the emptier and wearier their works became. Ludwig Richter's artistic development is a good example of this.

In 1816, Friedrich's objections to travel were still confined to subjective emotions. Later on, travelers to and venerators of Italy became more and more suspect to him: "The creator of these three paintings must have been looking through tinted glass . . . Perhaps he might some day hit upon the dangerous notion of painting just once without spectacles, whereby the objects would then appear to him as they do to other honest folk who have not been to Rome and have sound eyes . . . "

Doesn't this verdict of a painting by an artist colleague ca. 1830 sound a bit dangerous? Aren't artists who have worked in Rome "honest folk"? Isn't a German chauvinism operating here, tied — as so often — to a scorn of anything foreign? A few things point to that, for Friedrich also assailed depictions of Italian landscapes. "The art referees are no longer satisfied with our German sun, moon, and stars, our rocks, trees, and grass, our plains, lakes, and rivers. Everything has to be Italian to make any claim to greatness and beauty."

Around 1830, Friedrich obviously felt that a stay in Italy could have only corruptive effects on a German painter. The following lines are directed against the art of Ludwig Richter, who had returned to Dresden in 1826 after studying in Rome, Naples, and

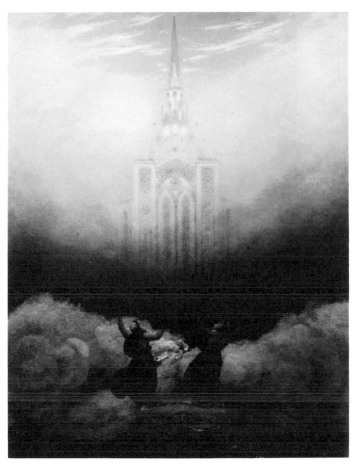

47 *Vision of the Christian Church.* 1812

Florence: "If X had not traveled to Rome, he would still be in art now. Since returning from there, he has greatly improved. He too followed the fashion in Rome and became a devotee of Koch [Joseph Anton Koch, 1768-1839, a great landscapist and teacher of the Nazarene landscape artists, had been living in Rome, aside from a three-year interruption, since 1795], and no longer a pupil of nature. . . ." It seems as if after 1830, Friedrich's voluntary restriction grew into an aggressive rejection of anything foreign, anything un-German.

In 1821 Friedrich turned down a suggestion by Vasily Andreyevich Zhukovsky to travel to Switzerland with him. The Russian writer reported the painter's explanation:

> *You want to have me along . . . but the "I" that you like will not be with you! I have to stay alone and know that I am alone in order to fully contemplate and feel nature; I have to surrender to what surrounds me, unite with my clouds and rocks, in order to be what I am. I need solitude for a dialog with nature. Once I spent an entire week in the Uttewald Abyss [cf. Figure 8] amid rocks and firs, and throughout this time I did not meet a single living soul; it is true, I do not recommend this method to anyone — it was too much even for me: involuntarily, gloom enters the soul. But this very fact must prove to you that my company cannot be agreeable to anyone.*

The sentence "I have to stay alone" is the kernel of Friedrich's refusal: alone in familiar nature, in order to "fully contemplate and feel" it. The painter fears great, exotic impressions because he might run the risk of no longer being "what I am."

Friedrich's self-restriction to his home sphere (Dresden, Pomerania, Neubrandenburg), his few travels to other, albeit nearby, areas (Bohemia, Giant Mountains, Harz Mountains), were originally due not to a philistine provincialism, but to a strong desire for concentration. Like a miner, he kept working the same parts of the landscape over and over again in order to penetrate more deeply into the mystery of nature. It was only around 1830 that "gloom entered his soul," leading to a drastic resistance to anything foreign.

Nearly all sources on the painter speak of a plan for a trip to Iceland, a possibility that Friedrich supposedly weighed in 1811. This information comes not from Friedrich himself, but from Karl

Ludwig von Knebel, whom the painter met when visiting Goethe in Jena on July 9/10, 1811. Von Knebel writes: "He remained here for only two days and we became very good friends. He even has something shy about him, which makes him even more into an old-time German. Goethe praises his talent, but laments that he is on the wrong track with it. The man is decent. He wants to go to Iceland soon." In my opinion, the chronicler fell victim to Friedrich's irony, for nothing else is known of this bold plan. It seems even more off target than the trip to Italy, which, after all, was earnestly considered. One should be cautious about citing this Iceland plan in order to definitively stamp the painter a man of the north. Just imagine the conversation:

Von Knebel: "Wouldn't you like to go to Italy at some point? I hear that the best German painters are gathering there, and Goethe — "

Friedrich: "Always this Italy! I just can't stand hearing about it anymore. I want to go to Iceland!"

If we list Friedrich's travels and connect them to the works reproduced here, we get the following overview:

1801 — March to April in Neubrandenburg, the home town of his parents and grandparents; May in Greifswald; first visit to Rügen in June and August. — Drawing of the Eldena ruin, 1801 (Figure 7), lost study of the Eldena ruin, used in the painting *Eldena Ruin,* ca. 1825 (Figure 37). Studies made during the Rügen sojourn are used in the painting *Woman by the Sea,* ca. 1818 (Figure 34), and the sepia *Beach with Rising Moon,* 1835/37 (Figure 40).

1802 — May in Rügen; returns to Dresden with a friend of P. O. Runge, the painter Friedrich August von Klinkowström. — Study of the dolmen in Gützkow, used for the painting *Dolmen in the Snow,* ca. 1807 (Figure 24).

1806 — May in Neubrandenburg; June in Greifswald; June /July in Rügen. — Sketchbook drawing, July 11, 1806 (Figure 9); Drawing *Rock Formations at Nobbin* in Rügen (Figure 12). Study from the Rügen visit used for painting *Woman by the Sea,* ca. 1818 (Figure 34), and water color *Eldena Ruin,* 1825-28 (Figure 38).

1807 — Trip to northern Bohemia in late summer.

1808 — Assumed trip to northern Bohemia.

1809 — April in Greifswald; May to July in Neubrandenburg. — Tree studies, June 2, 1809 (Figure 20); study of the Eldena ruin used in *Abbey in the Oak Forest*, 1809/10 (Plate 4); study of the dolmen in Gützkow, Rügen, used in painting *Dolmen in Autumn*, ca. 1820 (Plate 10).

1810 — May to July in Neubrandenburg. July in the Giant Mountains with the painter Georg Friedrich Kersting. — Studies from the wanderings through the Giant Mountains used in the painting *Morning in the Giant Mountains*, 1811 (Plate 7); painting *Village Landscape in Morning Light (Solitary Tree)*, 1822 (Plate 18); study of the cloister church on the Oybin in the Zittauer Mountains, used in the painting *Ulrich von Hutten's Grave*, 1823/24 (Plate 20); studies from wanderings through the Giant Mountains, used in the painting *Cross in the Forest*, ca. 1835 (Figure 19).

1811 — June, travels through the Harz Mountains with the sculptor Gottlieb Christian Kühn; visit to Ballenstädt; 9/10 July in Jena with Goethe. — Studies of the marble quarry near Hartenberg in the Harz Mountains, used in the painting *Cave with Tomb*, 1813, 1813-14 (Figure 25); studies from the Harz travels, used in the painting *Drifting Clouds in the Mountains*, 1821 (Plate 15).

1815 — August and September in Greifswald. — Drawing *Brigantine in the Harbor* (Figure 3); studies, used in the paintings *View of a Harbor*, 1815 (Plate 8), *Greifswald in the Moonlight*, 1816/17 (Figure 33), *Woman by the Sea*, ca. 1818 (Figure 34), *Chalk Cliffs in Rügen*, ca. 1818 (Plate 9).

1818 — June and July in Greifswald and Wolgast; August in Stralsund and Rügen, then back in Greifswald. — Sketchbook drawing *Six Sailships and Skipper*, August 18, 1818 (Figure 35); drawing *View over the Prow of a Sailing Ship;* this study was used in the painting *On the Sail Ship*, 1818/1819 (Figure 18; the silhouette of the town recalls Stralsund); water color *View of Greifswald*, ca. 1818 (Figure 36); studies used in the paintings *Chalk Cliffs in*

Rügen, ca. 1818 (Plate 9), *The Stages of Life,* ca. 1835 (Plate 24), situation near Wick in the vicinity of Greifswald.

1824 — October in Meissen. — Sepia *Front Entrance of the Princely School in Meissen, after 1835 (Figure 39).*

1826 — May and June, convalescence in Rügen after serious illness.

1828 — May 5, convalescent trip to Teplitz in Bohemia.

1835 — August and September, convalescence in Teplitz after a stroke.

This survey is indicative of how rationally Friedrich proceeded in his work. The greater number of his trips were to the same places; aside from the numerous trips to Bohemia, he went on only one excursion (Giant Mountains, Harz Mountains). All the material he worked out on these travels, the sketches and studies, were completed. These works formed an archive that was always available to the painter and that he used without giving it a second thought. Drawings of 1801, 1802, 1806, etc., were employed for paintings, sometimes worked into them literally — paintings that were done much later, namely in 1835/37, or 1807 or 1818 or 1825/28. This is true even for the paintings going back to studies of the environs of Saxony: Elbe Sandstone Mountains and Saxon Switzerland:

Paintings: *Wanderer over the Sea of Fog,* ca. 1818 (Figure 41); *Woman before the Setting Sun,* ca. 1818 (Figure 42); *Rocky Chasm,* 1822/23 (Plate 17). Paintings: *Morning Fog in the Mountains,* 1808 (Plate 2); *Mountain Landscape with Rainbow,* ca. 1810 (Plate 5).

This holds true not only for landscape studies, but for every sketch or drawing that Friedrich ever did.

Conclusion: Friedrich must have had certain basic visions that indelibly impressed his mind from 1799 until ca. 1810, for instance: ruins, churches, dolmens, shores, harbors, mountains, mountain ranges, cliffs, towns, forests, chasms, caves. Individual objects are also part of this foundation of Friedrich's art; for instance, the fir and the oak, the cross, a ship, a gate, a bridge, a figure viewed from the back. They assume the character of basic symbols.

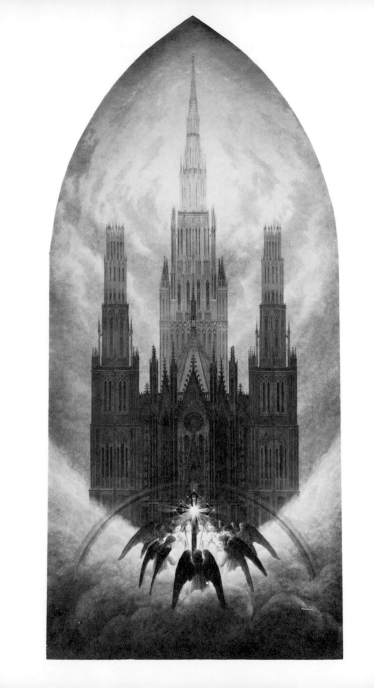

Once Friedrich was sure of his pictorial language, his work, his wanderings and travels, served almost exclusively to deepen and enrich this language, broaden its instrumentation, and explore new variations. His goal was to discover and reveal the whole from its details. Hence one can explain his "immobility" by his work — and vice versa. The painter's life was so much a part of his art that they formed a unit.

The 1811 painting *Drifting Clouds in the Mountains* (Plate 15) shows a view from Mount Brocken. Ten years after his travels through the Harz range, Friedrich was able to take a landscape study he had done from nature on June 29, 1811, and draw the color force of this small-format painting from it. The pond, embedded like an eye in the green of the meadow, reflects the drifting clouds. In back of it is an immense abyss. The old theme of menace and balance in a conflicting world becomes unaffectedly simple here, delivered like a folksong whose meaning one grasps only after long scrutiny.

20 *Woman at the Window*

Friedrich did this painting (Plate 16) in 1822, four years after his marriage. It shows a woman gazing from the window of her home over the Elbe River at the shore with its row of poplars. It has already been pointed out that the sepia *View from the Artist's Studio,* 1805/06 (Figure 2), was important for this painting (cf. Chapter 3), since it contains the seed of this depiction.

The emptiness, from the wide floor boards to the bare walls and window jambs to the portion of the wall under the window sill, must have repelled contemporary viewers. Aside from the two bottles and the glass standing on the tray which is on the windowsill to the right, the space contains nothing. And the woman is not looking at us. She has her back to us, for she feels she is all alone in the room.

This position indicates concentration. The woman is so absorbed in her thoughts and feelings that she has forgotten everything else. She is gazing. After all, this bare room is the painter's studio, his place for working and meditating. All forms, all lines intensify this impression of total concentration. The three slanting grooves in the floor (the central groove ends exactly on the central axis, which is designated by the vertical bar of the window) generate the impression of depth, which leaves a narrow space free for the woman. The vertical corner lines of the walls at the left and right emphasize the lateral frame-limits of the painting and narrow the woman's space for existing. As in a work of architecture, these verticals are braced by horizontals: the groove between the floor and the wall, the molding halfway up the wall, the windowsill, the lower beam of the window framework. Then, narrowed once again

by the actual frame, there is the green window frame: below, the middle of the open shutter; over it, the window with its thin cross, a cutting, terminating form. We do not see the upper limit of the window. This would make the entire painting sweep upward and outward, if it weren't for the window cross, which gives the window a boundary and places a stopping-point in front of the blue transparency of the sky. Thus the bare, strict closure of this room is maintained. No aperture brings any vastness into the room, which has the character of a monastic cell.

Through the open shutter we look out upon a row of poplars on the far bank of the Elbe. The narrow blue strip and especially the two masts make this clear: one mast is close by; it is visible below through the open window, then in the large upper window opening, into which it looms emphatically. Its tip ends below the horizontal arm of the cross. Its rigging, with thin lines, forms an upright, almost isosceles triangle in the lower right rectangle of the transom window. The second mast must be on a ship anchored behind the first, for we see a mast and rigging behind it (it is also presumably as large as the front ship) in the small space of the window hatch: the mast is directly under the vertical line of the thin window cross; and with its ropes, it repeats the triangle of the apparently large front mast, although to the left and on a smaller scale. Within this system of verticals and horizontals, in this design which consists of a precise architectural structure of rectangles, these triangles are the only geometrical forms to deviate from the construction of rectangles. The woman is the sole living thing in this rigorously constructed composition. The calm outline, approximately symmetrical, appears rich and dynamic here.

The colors of her dress add muted green stripes over a brown background to the dark browns and grays of the room and the window frame. This too brings something organic, something living, into this cool environment. From the darkness of the room, we see through the window opening into the bright outdoors, from where the room receives all its light. Below is the flickering yellow-green of the poplars; above, in watery blue, clouds drift leftward in three columns. This is why the viewer instantly looks outward, past the figure. The room seems secondary to the eyes, like a wide, grayish-brown framework. One has the impression that

the brightness in the apertures is what constitutes the actual painting. Involuntarily, we take part in the woman's gazing outdoors and share her thoughts.

The meaning of the picture comes from the notation of its overall construction. From the internal confinement, sober and gray, altogether bleak, the woman gazes into the rich distance: the river, the ships, the trees. She gazes into the uncertain, transparent blue of the sky, whose immensity is emphasized by the window. This is an image of human longing for permanence in the unstoppable flow of time. This room has something of a prison cell, from which the woman would like to get out into freedom. It is certainly no coincidence that the figure is a woman rather than a man: the bondage of woman, dependent on her man, at the mercy of her bodily functions, tied to the home, unequipped for a free life in the world, a role not tolerated by society — could Friedrich have been thinking of all that when he painted his picture, or did it flow in unintended?

The painting confronts inside and outside, darkness and light, barred confinement and spreading vastness, perhaps even despair and hope, fear and confidence. The chasm between these opposite poles can be bridged only in thoughts, in feelings, in prayers. Hence the work has also been given Christian interpretations, with the window cross symbolizing Christ, who gives the limitation of earthly existence the prospect of eternal life. The other bank would then symbolize the afterlife, the river death, the poplars on that bank — illogically — death (Börsch-Supan). Embedded in the almost boundless wealth of meanings that the painting allows, this exegesis has its place too; but if made absolute, it remains imprisoned in the narrowness of the room.

The confrontation of two utterly opposite spatial entities never had a more radical expression in Friedrich than in this interior painting, the only one he ever did.

21 Marriage

Everything is stillness — stillness — stillness all around me; this stillness is beneficial, but I would not always care to have it around me to such a high degree. I enjoy my breakfast alone, I take my lunch alone, my supper alone. I go from one room, from one chamber into the other, alone and always alone; it is beneficial, but I would not always care to have it like this.

Caspar David Friedrich
in a letter to his wife, July 10, 1822

To the amazement of his friends and acquaintances, on January 21, 1818, Friedrich married Caroline Bommer (1793-1847), the daughter of a Dresden manager and elder sister of the painter Christoph Wilhelm Bommer (b. 1801), who later became Friedrich's pupil. Three children were born to the couple: two daughters, Emma Johanna (1819-1845) and Agnes Adelheid (1823-1889), and a son, Gustav Adolf (1824-1889), who became a fairly successful animal painter.

Friedrich's economic situation had greatly improved since 1810 when he had sold two paintings to the Prussian royal house, *Monk by the Sea* (Plate 4) and *Abbey in the Oak Forest* (Plate 3). He had become a member of the Berlin and Dresden academies, and his art was welcomed by the public and understood within limits. Thus he could finally start a household.

Caroline Bommer must have meant a great deal to him, even though she is scarcely mentioned in accounts by friends and visitors. For Friedrich, this marriage was certainly a turning point, for we hear next to nothing about any earlier women in his life. The chatty anonymous writer of 1843, whom we have already quoted once (cf. Chapter 15), tells the following story about the painter's courtship, which is quite informative about his relationship to women. Friedrich meets a young man on the street, and the young man doffs his hat courteously; it is the merchant from whom he usually buys his pencils:

This memory is joined by another one, of the salesman's sister sitting and working at the window of the shop, a rather sweet, charming, homey girl. If this friendly child, he muses, were to live in his dwelling, he would

certainly not lack fire when coming home in the evening. Since then, he has exchanged few words with her, and quite insignificant ones at that. But he makes up his mind on the spot to purchase a pencil as early as possible the next day and, on this occasion, to sound out the pretty maiden and see whether a more substantial conversation might be started with her. And lo and behold, the artist, who was so fed up with his domestic seclusion, succeeded so well in everything that the following evening had already made a happy fiancé of him. His rejoicing heart had to air itself by spreading the news everywhere. An unexpected question was the first disturbance of his happy intoxication. It seems that a friend wanted to know the name of his betrothed and it turned out that the fiancé himself could not give the information. But Friedrich's initial flush of embarassment soon gave way to hearty laughter at a circumstance that surely occurred seldom in life.

This anecdote is so well devised that it could be true. Yet Caroline's role in Friedrich's life should not be underrated. She eased his life with a friendly home and with children, attaching him to existence with the weight of the family. His paintings lighten up conspicuously after his marriage. Women now enter his pictures, bringing in a new and friendly element. Around 1818, he painted *Woman before the Setting Sun* (Figure 42) and *Woman by the Sea* (Figure 34). The former shows the woman as a large silhouette in front of the reddish-yellow evening sky (Figure 42). The gesture of her spreading hands expresses humility, confidence, devotion. A flat stage lifts the figure out of the evening-green meadows toward the sun. The rocks to the left and right are like protective, reliable forces. The landscape space is not harshly divided into strata; it unfolds in stages all the way to the outlines of the mountains.

The other painting fascinates with its particularly daring and yet harmonious composition (Figure 34). The woman is the pivot of the structure. Her warm red dress determines the gentle coloring of the picture, into which a reflection of redness is woven. The woman leans against the rock as though holding the lines and helm in the stern of a sailboat. And indeed, she is the formal counterweight to the four or five ships sailing by in a row. The woman and the vessels make up a wedge, supported on the left by four parallel horizontal lines — the lower edge of the canvas, the nets, the shoreline of the steep coast of Cape Arcona in Rügen, and the horizon. The nearby ships, emblems of passing time, are probably not what captures the

woman's gaze. She is gazing at the distance, at the faraway white, majestic sailships on the horizon, at the heavens. Beyond the ships, which are rushing ineluctably toward the ephemeral, the woman has entrusted herself to timeless rapture.

In 1818/19, Friedrich portrayed his wife in the painting *On the Sailship* (Figure 18), which so penetratingly expressed the notion of this life and the afterlife, of nearness and farness, of time and eternity. The couple are sitting in the prow of the ship, which we see foreshortened as though we viewers were riding along. The man and woman are holding hands and gazing toward the shore, toward the remote town, whose churches and houses loom out of the foggy mist. They are going home. Once again, the meaning of the work exists on many levels. Everyone feels the expectation of the two people, the far gaze, and the distant aparition of the town, which is the goal of this voyage. The upright prow and the billowing sails transmit the feeling of wind and strength, which drive the ship forward. The town is a celestial vision: from the captivity of narrow earthly space comes the longing for freedom (the man is wearing the German costume of the Wars of Liberation), the longing for infinity, for coming home to God's eternal kingdom.

Caroline Friedrich is also the model for the female figure in *Chalk Cliffs in Rügen,* ca. 1818 (Plate 9). This painting, one of Friedrich's most beautiful, shows the breakthrough to a new relationship to life and to other people that Friedrich gained through his marriage.

In conclusion, we might read the letter in which the painter informed his relatives in Greifswald about his marriage:

Dresden, January 28, 1818

Let it be known herewith to my brothers, relatives, and acquaintances that at the sixth hour of January 21, in the local Church of the Cross, I was wed to Caroline Bommer; hence, I have been a married man for one week already. A few hours after the nuptials, I went home with the intention of writing to you, but I was hindered. And thus a whole seven days have passed, and still nothing has happened. If I have felt obligated since the day of my nuptials to write to you and inform you of my marriage, then we too have been expecting your letters for a long time, and my wife is already beginning to worry and has repeatedly reminded me to write; for she too wants to write in order to become better acquainted with her new brothers.

It is indeed a droll thing having a wife; it is droll having a household, be it ever so small; it is droll, I find, when my wife bids me to come to table at noon. And finally, it is droll when I now remain properly at home in the evenings rather than running around outside. I also find it droll that everything I now undertake always happens and has to happen with consideration for my wife. If I merely hammer a nail into the wall, it mustn't be as high as I can reach, but as high as my wife can comfortably reach. In short, ever since the I turned into We, quite a number of things have changed. There is more eating, more drinking, more sleeping, more laughing, more bantering, more fooling around. Also, more money is being spent, and perhaps in the future too we will have no lack of cares; but however it please God, the will of the Lord be done. Many things and different things have changed since I have a wife. My old simple domestic furnishings are in some ways beyond recognition, and I am glad that my place now looks cleaner and nicer. It is only in the room I used for my occupation that everything remains as it was. Incidentally, curtains have become necessary for the windows. Also necessary are: a coffee roaster, a coffee grinder, a coffee funnel, a coffee sack, a coffee pot, a coffee cup; everything, everything has become necessary. Pots, big and little; bowls, big and little; jars, big and little; everything, but everything has become necessary. Everything has changed; once my spitoon was all over the room; now, I have been instructed to spit into small dishes set out for that purpose; my love of cleanliness and neatness acquiesces with joy. The desk, ordered long ago, is finished, and it was worked with utmost trimness, it cost fifty-six talers, and on the very same day and at the very same hour that I received it, I sold two paintings — of which I showed one to the buyer as a failed, hence spoiled painting — for nineteen gold louis. A sum that delighted me all the more inasmuch as the expenditure of fifty-six talers seemed somewhat unnecessary to me; for I had ordered the desk earlier, when thinking of my present wife.

God be with you, dear brothers, and your wives and children, and the entire family and all acquaintances.

Your brother,
C.D. Friedrich

22 Gothic

Just as the eternal, the infinite draped themselves in love . . . so too has love entered the method in a similar way . . . wherever the eye looks and where it moves, it encounters this tender humor and swaying in waves, roses, buds, pictures, arches, in order to dissolve the hard stone and rock as in music and harmony. Hence, the inexplicable way we stand here as before a miracle, before a dream, when this loftiest giant work hovers before us like a delicate, celestially airy joke. In stones, we see the inklings of heaven's glory, and the rock too has had to break its rigid nature in order to sing "Hosanna!" and "Holy! Holy!"

From: Ludwig Tieck: *Franz Sternbald's Wanderings*, 1798
(On the Cathedral of Strasbourg)

The central theme of Caspar David Friedrich's landscape art is the visionary contemplation of the divine in nature. Objects of natural reality are placed as emblems in the picture. They become symbols or, as Philipp Otto Runge put it, hieroglyphs, for making the ungraspable comprehensible. The image of nature becomes an allegory of the "retransformation of the world into God" (Sumowski). And one cannot fully understand Friedrich's works if one fails to decipher his allegories. The difficulty of an adequate reading lies in the painter's failure to develop his symbolism systematically and apply it logically, as it were. Instead, it is subjective; its intensity keeps changing, and its meanings keep varying continually.

On the basis of Friedrich's description of the Tetschen Altar (Plate 1), we can interpret the setting sun in any of his works containing an evening sun "as the image of the eternal, all-animating Father." We would then have the satisfaction of possessing a solid key to these evening suns; but we would be sadly mistaken. For everything goes to show that this interpretation is off the mark for paintings done around 1830, e.g., *The Great Pasture* (Plate 23). If the interpretation actually goes into particulars—i.e., a towering mountain is always God, a ship or boat always the ship of life, a wheatfield mature life threatened by death, the waxing moon Christ — that would be forcing Friedrich's pictorial language into an overly confining scheme that fails to grasp the totality of his art. Friedrich himself would object as follows to such attempts at positivistic and systematic exegesis: "People of this sort would like

to have a law for anything and everything in both science and art in order to be exempt from all independent thinking, feeling, perceiving."

The ambiguity of Friedrich's pictorial language is probably due to his efforts to maintain the integrity of his painting. For the symbols appear in a certain order, which we call their pictorial arrangement, and in a medium that can be experienced with the senses, drawing or painting. The integrity of the picture derives from a sensory present and from a meaning that can be mentally reconstructed. But there is no validity to what the Hanover chamberlain Von Ramdohr maintained in his polemical essay against the Tetschen Altar, namely that the allegorical charging of the landscape "demotes the self-contained work of art to a mere symbol." Friedrich's landscape painting remains a "self-sufficient" work of art, for Friedrich was a great painter, and, as in every significant work of art, the meaning cannot be detached from the phenomenonality, nor the making from the idea, nor the symbol from the form. This is what causes Friedrich's art to fascinate so many people today. For the presence of his art in the picture is so compelling that a viewer may be struck by it even if he knows nothing of its allegorical meaning.

However, if we wish to go beyond this compelling effect and penetrate the meaning, we have to become acquainted with Friedrich's hieroglyphs. But we must not make the mistake of presuming that such decipherings can explain any of the artist's works once and for all. Perhaps his most unequivocal symbol is that of Gothic architecture, which appears unscathed or ruinous.

The ruin of the Cistercian abbey of Eldena near Greifswald was first drawn by Friedrich around 1801 (cf. Figure 7). It was here that his intense interest in the medieval Gothic style commenced, becoming extremely important for his entire work. After all, the Gothic churches in Greifswald, Stralsund, and Neubrandenburg had been part of Friedrich's environment since his childhood.

This Gothic focus was not peculiar to Friedrich. Its pre-history in Germany began with Goethe's essay on the Cathedral of Strasbourg (*On German Architecture,* 1773). And its effects lasted for more than a century. The completion of the Cathedral of Cologne, which was made into a cause for all Germans and came about between 1842 and 1880, was the highpoint in this rediscovery of

49 *Design for the Altar of St. Mary's Church in Stralsund.* 1817/18

the medieval building style. This interest was stoked by English literature, horticulture, and illustrations. More than anything, it was the poetic epic *Ossian* that excited all German minds about the Teutonic. The Gothic period was *the* German style. In contrast to the plastic Baroque and rational Classicism, it was regarded as plantlike, natural, unpredictable like nature itself, and spiritual and unmaterial like the divine. The Gothic church combined mind and matter, God and nature, in a mighty form. The painter and architect Friedrich Schinkel (1781-1841), whose neo-Gothic designs and buildings were trend-setting, and whose early paintings of Gothic churches were presumably known to Friedrich, celebrated the Gothic style as the victory of mind over matter.

Furthermore, the Romantics looked back on the German Middle Ages, declaring them the ideal epoch. Here they found the idea of a comprehensive synthesis coming true in history, a time when state and church, art and life, faith and deed, order and movement, supposedly formed a marvelous exemplary whole.

We have shown that Friedrich grew familiar with this notion thanks to Quistorp and Kosegarten (cf. Chapter 5). It is typical of him that he appropriated the Gothic in a place where it appeared concretely: his homeland. While others theorized, mentally reconstructed, speculated, and philosophized — he made drawings.

For him, the Eldena ruin signified the Gothic ruin per se. Hence this image runs through his entire *oeuvre*. Yet — indicative of the painter's basic stance — he approached the Gothic by seeking it in its destruction. It was not until 1810 that he painted his first intact Gothic structure in a gloomy picture of burning.

Winter with the solitary monk, 1808 (Figure 16), places the Eldena ruin in surroundings that we know from the painting *Dolmen in the Snow,* ca. 1807 (Figure 24). The dead oak and the tree stump symbolize death and persistence. The ruin belongs to the second strata of space, the one in back. We do not see its walls and their footings; the ruin floats in front of the fog-gray wall. To the left, a graveyard is fenced in by low walls. Monk and oak, Christianity and German paganism, confront each other, whereby the oak stands defiantly upright and the monk trudges through the snow, humbly bowed. The ruin envelops the two semantic fields in an overall emblem, which, in ephemeralness, points to the eternal.

50 *Design for a Chalice for St. Mary's Church in Stralsund.* 1817/18

The pendant of this painting is *Summer,* which was done somewhat earlier (Figure 15).

In *Abbey in the Oak Forest,* 1809/10 (Plate 3), the ruin, in a variation of the Eldena motif, is an emblem of the Church as an institution, which, like the heathen oaks, is waning before the morning of Resurrection. Around 1830, in regard to another

painting, the one showing the Cathedral of Meissen as a ruin, Friedrich explained: "The time of the splendor of the temple and its servants is gone, and from the demolition of the whole thing, another age and another longing for clarity and truth have emerged. (Concerning *Abbey in the Oak Forest;* cf. also Chapter 14.)

Monastery Graveyard in the Snow, 1817/19 (Figure 43), one of the largest paintings that Friedrich ever did, expands the pictorial idea of *Abbey in the Oak Forest* in terms of an architectural picture (Carus criticized this). The terraced ruin in front, with the line of monks passing through the pointed arch, uses Eldena motifs. The chancel in back, towering tremendously over the ruin and looming up, with its pillars and barrel vaults, like an intact manifestation, transcends the chancel of Greifswald's Church of St. James. The death landscape with the cemetery, the German pagan oaks, and the ruinous medieval church are absorbed by a new vision of the Church, on which everything focuses. That is where the monks are going, that is where the preacher is standing: the promise of the Holy Scriptures triumphs over death, and the spiritual architecture of the chancel is subordinated to that promise.

A prosaic rendition is the water-colored pencil drawing of the Eldena ruin, 1825/28 (Figure 38). As in the painting of ca. 1825 (Figure 37), realistic tendencies now operate in Friedrich's work. They were promoted around 1825 by his new, intense relationship to nature. This effort to incorporate "modern" realism into his works is also visible in the unusually dramatic painting *Rocky Chasm* of 1822/23 (Plate 17). It reveals the influence of Johan Christian Clausen Dahl, a close friend who had been living in the same house as Friedrich since 1823.

The painting of the Eldena ruin, in its setting of green shrubbery (Figure 37), can scarcely have an allegorical meaning. Perhaps, for all our qualms, the canvas may have a critical relationship to contemporary history; the wretched present, bereft of any grandeur, contrasts with the tremendous German past, which, even in a state of destruction, towers over the fragile house. It has been established that such a house did exist near the ruin at that time.

The late cycle of the seasons includes the sepia of winter, which shows the Eldena ruin around 1834 (Figure 44), a portrayal of ephemeralness: the old couple sit at the open grave, apparently

preparing for death. On the one hand, the ruin is an emblem of transitoriness; on the other hand, the bright radiance of the moon, promising life, flows through the pointed-arch window.

The intact architecture of the Gothic church is presumably the vision of the Beyond, the heavenly city. But we must not forget that the reading of this symbol should not be exclusively Christian. It also contains a vision of "German art and spiritual sublimity . . . the perfection of symmetry, the most daring allegorical creation of the human spirit, this expansion on all sides and beyond itself into the heavens; endlessness and self-contained orderliness . . . so that everything exists here for the sake of everything else, and everything in order to express German greatness and splendor." Thus did Tieck's Sternbald wax enthusiastic over the Cathedral of Strasbourg.

In *Winter Landscape with Church,* 1811 (Figure 45), the Gothic church appears in Friedrich's work for the first time as a celestial vision. The church looms out of the fog like a manifestation that is not of this world. The man in this icy landscape has lost his crutches. He leans on a rock and gazes devotedly up at the crucifix. The group of firs in front is a prelude to the architecture in the imaginary background. Death in this landscape is virtually canceled by the Gothic church, which is a promise of eternal life. This canvas is the last of three paintings, one of which is likewise a winter landscape (Figure 46). Here everything is bleak — the row of tree stumps, the dead trees in the foreground, all express an inescapable certainty of death. The plain with the stumps melts into nowhere. The bent man, hobbling along on a cane, peers helplessly into the endless vastness of death.

The cathedral, in contrast, rises triumphantly against the pagan priests who are making their sacrifice on the altar (Figure 47). Avoiding the *Vision of the Christian Church* (the title of this 1812 painting), the sacrificial smoke shifts off to the sides and creeps along the ground. Terrified, the druids lift their arms against the shining vision. This painting no doubt demonstrates the limits of Friedrich's artistry. Its meaning is too obvious: the fulfillment of the pagan religion by the Christian evangelism, which transcends the faith of the fathers. There may also be a Germanic overtone here: the strength of Teutonism is overgrown by the timeless apotheosis of Germanism; the sacrificial stone and the priests

virtually form the pedestal for the architecture. The figures, going back to drawings from around 1800, actually seem comical in their theatrical gestures. The earnest meaning of the canvas finds no corresponding pictorial construction. The two-layered structure remains in the bathos of a confrontation of two different worlds; and the result is really an embarrassing unequivocality.

The perhaps unfinished *Cathedral,* ca. 1818 (Figure 48), reworks St. Mary's Church in Stralsund, transcending its architecture and transforming it into an alien floating vision. Furthermore, there is the rainbow as the sign of reconciliation and there are the angels grouped around the radiant cross. The instruments of the Passion refer to Christ's sacrificial death. The moons on the arms of the cross and the sun in the middle suggest the apocalyptic return of the Son of God. The cathedral, in an almost diffuse composition (we see it only as if through a pointed-arch window) rises from the lap of the clouds into the flamelike cloudy sky, which melts like a funnel into a light-filled depth behind the upper stories of the central tower. Thus the painting really has three dimensions: in front, the space with the angelic choir and the rainbow radiating overhead; then the flat filigree disk of the cathedral; above, the view of the depth. The painting operates almost like a visual interpretation of the Tieck quotation at the beginning of this chapter. This painting, likewise, can scarcely be regarded as successful. The accumulation of the symbolic figures betrays the artist's uncertainty. Their summation yields an unartistic conglomerate. The unspeakable remains unspoken.

Friedrich's architectural interests are especially obvious in *Cathedral.* In fact, he also did some architectural designs (his monument designs have already been mentioned in Chapter 17). In 1817 and 1818, on commission to the town council of Stralsund, and together with his brother Christian, he did designs for the interior architecture of St. Mary's Church. Since the church had served as a hay storeroom during the French occupation, all the interior furnishings had been destroyed. Friedrich drew several versions of suggestions for the gallery and for the principal pieces (the altar, the chancel, and the font). From the group of extant works, an altar design (Figure 49) and the drawing for a chalice (Figure 50) are reproduced here. One may conclude that in Pomerania the painter was regarded as a specialist in Gothic

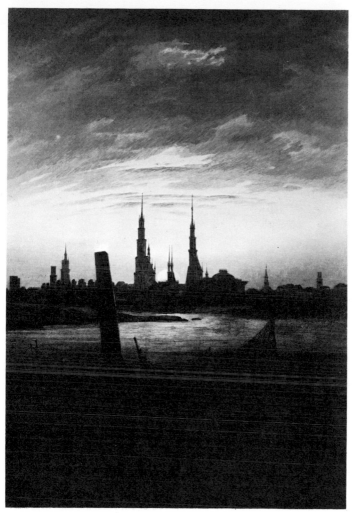

51 *Town under Rising Moon.* Ca. 1817

52 *Hill and Boggy Field near Dresden.* Ca. 1824

architecture. Personal relationships with pastors in Stralsund also
did their share. One of the clerics, Dr. Furchau, a friend of Ernst
Moritz Arndt, was supposed to write the text for a book of views of
the island of Rügen, for which Friedrich was to do the illustrations.

In some paintings, such as *Winter Landscape with Church,* 1811
(Figure 45), we notice that Friedrich treated the group of firs as
Gothic architecture. Natural form and architecture are inter-
changeable or interpenetrate in many of his works. In *Cross in the
Forest,* ca. 1835 (figure 19), the firs behind the cross recall a Gothic
façade with pinnacle turrets. Similarly, the woods in *Chausseur in
the Forest,* 1814 (Figure 27), have an architectural structure. And in
Early Snow, ca. 1828 (Figure 23), the pines are arranged in a
semicircle, like the pillar groups of a church gallery. (This canvas,
incidentally, is a Passion painting: the path vanishes into the forest,
which symbolizes death and resurrection.) For this assimilation of
natural forms to Gothic architecture, we may once again quote
from Tieck's Sternbald novel: ". . . I kneel mentally to the mind

that designed and executed this all-powerful structure [the Cathedral of Strasbourg]. Verily, it was a rare mind that dared to place this tree with branches, twigs, and leaves in this way, going ever higher toward the clouds with its rocky masses, and spiriting up a work that is virtually an image of infinity."

Normally, Gothic architecture also rules the town backdrops in Friedrich's works. They mostly contain distinct reminiscences of his hometown of Greifswald or of Stralsund, for instance *Greifswald in Moonlight,* 1816/17 (Figure 33), or *Town under Rising Moon,* ca. 1817 (Figure 51), where the Greifswald churches are powerfully transformed by being exaggerated (St. Nikolai!). If the town here is a vision of the Beyond, a heavenly Jerusalem (Sumowski), then this symbolism is also hinted at in the Greifswald moonscape (Figure 33), but remains within the framework of an atmospheric view with a more profound meaning.

The splendid, rigorously constructed painting *Hill and Boggy Field near Dresden,* ca. 1824 (Figure 52), depicts the towers of the Church of the Cross, the Church of our Lady, the castle, and the royal church. But it seems dubious to give the "remote city" a general religious significance, for instance: behind the zone of death — bare field, autumn trees, and crows — the celestial city surfaces from the chasm as a sign of the promise of eternal life. The city could also sink behind the hill and would then be an image of bottomless ephemeralness. The painting remains tied to the reality of the place. The daring composition does prompt such readings (because one suspects more), but does not really suggest them very strongly. In Friedrich, the purely visual can often take over, as demonstrated by the water color view of Greifswald, ca. 1818 (Figure 36). Recording reality, it has worked in the probably universal significance of homecoming: the crowded boat is heading toward the town on the river, which starts out broad.

In the painting *On the Sail Ship,* 1818/19 (Figure 18), the meaning is now quite unequivocal. Here, the city is certainly a symbol of the Beyond: the journey of life is coming to its final goal of death and resurrection.

This brief portrayal of Friedrich's kinship with the Gothic period and its meaning for his *oeuvre* can only hint at a complex and intricate problem. The ambivalence of all proposed interpretations, even in this relatively uncomplicated motif of Gothic architecture,

becomes quite clear. We cannot wrest out the secret of Friedrich's works if we try to seek only denominator for the comprehensive whole of his art.

23 Nazarenes

The Schlossers have sent me stupendous things by Cornelius and Overbeck. This is the first case in art history of important talents having to form themselves backwards, to return to the mother's womb, and thus find a new artistic era. This was reserved for honest Germans and, of course, effected by the spirit that seized not only individuals but the entire mass at once.

Goethe, 1814

On April 19, 1820, Friedrich received a noteworthy visitor. His vain, self-assured guest did not immediately introduce himself, in order to leave the painter in the dark about his identity. Finally, he gave his name: Peter Cornelius, the spokesman of a group of German painters in Rome who were called "Nazarenes" because of their long hair. Nazarenes — this term has stuck until the present for these artists, who tried to meet a different Romantic demand in their works, a demand opposed to Friedrich. They wanted to create a new school of religious painting and a depiction of national history, not by charging an available genre with allegory or by achieving a new pictorial form, but by deliberately reaching back to tradition. Nazarene art oriented its pictorial form by the panel and fresco painting of Dürer's time and of the artists around Raphael. Using their model, they wanted to convey the Christian gospel in the old symbolic language. They thereby hoped to reach a broad public, educating their audience both morally and ethically. On the basis of this tried and tested old pictorial language, they had a second goal: to show Germans their national history in huge figure compositions. The chief works of the Nazarene spirit are: Alfred Rethel's (1816-1859) frescoes in Aachen, glorifying the deeds of Charlemagne; Julius Schnorr von Carolsfeld's (1794-1872) Nibelungen frescoes in the Munich Residence; the decorations of the Cathedrals of Speyer and Mainz by Nazarene artists; and the fresco of the *Last Judgment* in Munich's Ludwig Church by Peter Cornelius (1783-1867).

However the Nazarenes also tried to propagate an "art for the people" by doing vast series of graphic illustrations that were distributed in large editions, entering almost every middle-class

161

German home. These include Julius Schnorr von Carolsfeld's illustrated Bible, Friedrich Overbeck's (1789-1869) illustrations for the Gospels, and Ludwig Richter's (1803-1884) pictures "For the Home," as well as Moritz von Schwind's (1804-1871) painting cycles of popular fairy tales, all of which were known everywhere in reproductions.

These artists belonged to a different, a younger generation than Friedrich. In this new generation, the all-embracing Romantic claim was virtually drying up — the claim of restoring, in a more and more disoriented world, a new unity of the human spirit to all areas of life, based on a universalism of all religions and all nations. Unity of the human spirit — for the younger Romantics, that meant a return to tradition, religion of nations and races — narrowed down to propagating Christianity, especially Catholicism (to which many Nazarene artists converted) and a leadership claim for Europe. Political unity for the world — that led to recollecting national history and domestically, to recognizing principles of restoration.

Art had lost its dream of a new type of devotional painting that would be open to the religious feelings and yearnings of every human being. Runge's and Friedrich's attempt was abortive and unfulfilled. For the Nazarenes, the new religious painting came out of the tradition of old church art. The old pictorial forms had to be reawakened; then the timeless substance of the Christian gospel could come alive again for the present age. Artists had only to reconstruct history, study the costumes and outfits of the Middle Ages, and do their paintings in the rigorous linear style of old panel art. In this way, along with the old and true pictorial form, they would also capture the truth of the historical event.

Friedrich could not understand that the design of Romanticism could not be carried out, and that the times legitimized the *philosophy* of the younger Romantics. He passionately opposed the art of the Nazarenes, whose traditionalism he could only grasp as a backward flight. Around 1830, he wrote:

> . . . If in our time, another Raphael or an excellent artist like those of earlier days were to rise up with natural talents and faculties as fine as those of his predecessors, he would nevertheless not paint as they did. His works would and must bear the stamp of his time, and the second Raphael would therefore have to be very different from the first one in his depictions,

even if both treated one and the same subject. Hence, you gentlemen, you Mr. A to Z, who constantly imitate Raphael and Michelangelo and goodness knows whom else, people will no more recognize your works as being by any of these masters than they would take a monkey for a human being, no matter how much the monkey imitates the human; one might be more tempted to take you gentlemen for nothing much more than apes. So come to your senses and taste and know yourselves and your time.

Friedrich's words are valid when he points out that the emulation of masterpieces does not produce masterpieces. On the other hand, he failed to realize that the Nazarenes were in keeping with their time. The Napoleonic rule and the Wars of Liberation had aroused the national consciousness of the Germans. All European nations became enthusiastically aware of their own independence and their distinct qualities, which had grown through the centuries. The political restoration in Germany after 1819, the dogmatic and pietistic reform movements in the Catholic and Protestant churches, the attempt to suppress the urgent social problems with undemocratic political structures, determined the decades until the Revolution of 1848/49. None of the Nazarenes stood on the barricades in Dresden, Berlin or Vienna. Only a few relatively insignificant realistic painters joined the Revolution. In this way, Nazarenism was part of the contemporary tendencies.

Friedrich's Romantic subjectivity, which had created an independent vocabulary of allegorical meanings, was alien to the desire of the younger Romantics to join their art to objective and — they hoped — universally accessible pictorial formulas. The verities of salvation, as the Church taught them, were, after all, of an objective nature, independent of the condition of the individual soul. Hence the younger Romantics demanded a clear, intelligible pictorial language that already existed in tradition. Romantic universalism, which had regarded the human soul as a mirror of the universe, was reduced to a simple formula by the Nazarenes: art could be true only if the artist believed what he painted; the conversions of many Nazarenes express the feeling of throwing oneself from the unbounded universe, from the inconstant world into the arms of an objective authority. This authority, for many, was the Catholic Church; for others, it was scholarship, which unearthed the sources of historical or literary deeds.

When Cornelius visited Friedrich in Dresden, he was about to begin his triumphant career. Bavarian Crown Prince Ludwig had summoned him from Rome and commissioned him to paint the interior of a room in Munich's Glyptothek. Cornelius was already in Munich when he received a message from Berlin, offering him the directorship of the Düsseldorf Academy of Art. He stayed in Berlin in January of 1820, where he discussed details of his directorship. The artist, whom both Prussia and Bavaria were trying so hard to win, traveled back to Munich in April, by way of Dresden, in order to continue working on his cycle of frescoes. Cornelius was the celebrated leader of the Nazarenes, a hothead with aquiline features in his "wonderful, mind-scintillating countenance," energetic, with an organizational talent and a brilliant — one would really have to say monumental — graphic artist, for he was not an important colorist. In 1825, when he became director of the Academy in Munich, he robustly compelled acceptance for his Nazarene goals. In a letter to King Ludwig I of Bavaria containing his suggestions for new professors at the Munich Academy, he declared: "I regard a chair for genre and landscape painting as superfluous. True art knows no isolated compartments: it embraces the whole of visible nature. Genre painting is a kind of moss or lichen on the great trunk of art."

The Romantic striving for a synthesis of all phenomena had degenerated into rigid principles here. For Cornelius, there are no special compartments in art, for art is a single "trunk." "True art," however, as in earlier centuries, is the portrayal of man, figure composition. Landscape, like the realistic depiction of everyday incidents, is merely a side path, a "moss," for only figure painting has powerful contents, such as Raphael and Michelangelo so exemplarily created.

This scorner of specialization now visited a specialist, the landscape painter Caspar David Friedrich. This visit was described by Karl Förster, whose account, printed in 1846, does not indicate whether Cornelius understood anything of the total impact of Friedrich's landscape art. He probably considered Friedrich merely a particularly capable specialist, for he never mentioned this visit in writing or conversation.

However Friedrich's conduct was informative:

> *When he [Cornelius] finally told him his name, the other [i.e. Friedrich] stated that he could never have had such lofty hopes. The dear, excellent man was very charming in his simple, childlike way, all joy and humility. He showed him several things with a timidity honoring the capable artist. He sat down with us on the floor and could not be persuaded to take another seat: "Just gotta show my devotion a little," he said in his true-hearted Pomeranian dialect. He made fun of himself for painting nothing but moonlight and said that if human beings went to a different world after dying, then he would be sure to land on the moon.*

Thus Friedrich made absolutely no attempt to explain his art to his famous guest. His exaggerated humility was steeped in irony — and so the visitors regarded him as a true-hearted Pomeranian *naïf*. One has the impression that Friedrich behaved as he believed Cornelius expected him to. He himself ridiculed his art, thus underscoring its peculiarity. The landscape specialist acts like a slightly silly eccentric. But then he flashes up when commenting on his painting *Swans in the Reeds:* "The divine is everywhere, even in a grain of sand; so I depicted it in reeds."

Hence this encounter between the two utterly opposite men had no aftereffects. In 1840, the year Friedrich died, Cornelius bitterly left Munich and the Academy, whose reputation he had founded. The fate he suffered was different from and yet similar to Friedrich's: until his death, he lived in seclusion in Berlin, honored and yet forgotten, working until the very end on his monumental figure paintings, in which almost no one was interested anymore. He was a monument to himself that time had pushed off to an out of the way site.

Friedrich traveled to his homeland in 1818 with his wife, in order to introduce her to his kin, speed up plans for the book of views of Rügen, and visit Stralsund to discuss his designs for the interior decoration of St. Marien. The two newlyweds also went to Rügen. The idea of this painting (Plate 9) probably evolved during their stay on the island. At any rate, Friedrich presumably painted it soon after returning to Dresden. For the composition, he used studies of chalk cliffs he had done in Rügen in August 1815, and sketches of sail ships he had made in 1818. (The drawing of the sail ships and the fisherman Johann Daniel, Figure 34, is also in the sketchbook from this trip.) The motif of the picture has been ferreted out: it is the so-called "cubby hole" with the "fire rain rock," not lifelike in detail, but altogether recognizable, so that the place can be found again today. Above all, the rocks are steeper and more rugged on the canvas than in their natural reality, in which the wind and the weather have given the rock a soft, polished contour.

The spatial stratification of the painting, which appears simple at first glance, is basically rich and therefore complicated. The impressive two-layer structure — foreground and chalk cliffs, then the sea — begins twice: the dangerously narrow, grassy foreground with the two trees left and right gives the picture a framework recalling a view through a window. The incision into this "stage ramp" leads the eyes into a depth whose bottomlessness cannot be discerned. From this abyss, the rocks climb brusquely, expanding left and right, heedless of the foreground framework. One has the feeling that they continue beyond the limits of the canvas. The pictorial structure breaks off abruptly and definitively behind this

53 *Chalk Cliffs in Rügen.* After 1837

first abyss. From an even deeper depth, the sea comes up all the way to the horizon, which lies very high, a stretched-out plane on which two ships are floating, very far apart, yet of the same size. This ocean plane, changing from below to above, from green-blue to pink-blue, in strips, has no elementary natural force. It is an immaterial skin that hints at incomprehensible things, like the bright, reddish sky that extends this ocean plane, in a different coloring and smoother pigments, up to the top of the canvas. The very precision in the depiction of the figures and vegetation in the immediate foreground clarifies the different laws pertaining to the sea and the sky. The white rocks, a bare, almost ghostly zone between here and there, cannot mediate between incompatibles because they really belong to the foreground. They mirror the life of the humans and plants with a virtually abstract formal vocabulary in a different time of deadness and erosion. Anything green and growing and breathing in front is devastated and dead in the rocks. The life and mortality of earthliness are confronted by the blue-reddish wall of sea and sky as a symbol of eternity.

Nevertheless, this is an unusually festive painting. The triad of green/white/blue is so heightened by the red in the woman's dress — which is reflected in the sea and the sky — that we can hardly tell whether the fascination of this work is due to its formal daring or its contrasting coloring. The two form an indivisible whole.

Some interpreters have sought a religious meaning here. They have viewed the figures as representing the Christian virtues: the red dress of the woman=love; the blue (?) coat of the kneeling man=faith; the green (?) coat of the standing man=hope. In contrast, however, I see the painting as an allegory of Friedrich's love for his wife. It belongs to the tradition of Romantic friendship painting. One is particularly reminded of Philipp Otto Runge's triple portrait of 1805, showing Runge with his wife and his brother (*We Three,* formerly in Hamburg's Kunsthalle, destroyed by fire in 1931). For the woman of the *Chalk Cliffs* must be Friedrich's Caroline. Friedrich himself has been identified as the man on the ground; the man standing on the right is believed by some critics to be his brother Christian. I believe that the painter can only be the standing man in the German costume. One has to consider that the artist's self-depictions in his paintings always remain general: in *Monk by the Sea* (Plate 4), the thirty-five-year-old

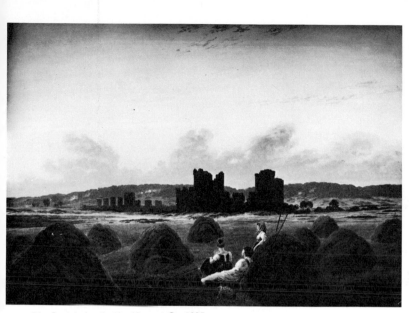

54 *Rest during the Hay Harvest.* Ca. 1835

painter portrayed himself as an elderly man, as he also did in *Mountain Landscape with Rainbow* (Plate 5). I feel that in *On the Sailship* (Figure 18), which was done at approximately the same time as *Chalk Cliffs in Rügen,* he painted himself together with his wife. However, he presented himself as a younger man, for he was forty-five at the time of his marriage, nineteen years older than Caroline. Friedrich was timid about doing precise portraits of himself — or his wife — in his paintings. In 1817, he wrote to his brother Christian: "And take care not to show your heart to this cold, heartless human race, ensheathe your heart in a rind of ice against human beings, but only against them." Here, presumably, lies one of the reasons for the encoding of his allegorical pictorial language. But we most likely have to reckon that the painter concealed himself with special caution when introducing his personal life into his art.

Crucial to my interpretation is the previously unnoticed fact that the framework of the grassy stage and the trees in the painting is in the shape of a heart. The tip of the heart is designated by the cut into the grassy ground between the woman and the kneeling man. The curves of the two heart swellings are marked by the branches of the two trees. Husband and wife, separated by a chasm, are joined in these branches. The narrow tree rooted in the rock over the woman and visually prolonging the trunk in front of which the woman is sitting, and the powerful tree coming from the man's side stretch their tops into the center of the painting. The man, who is Friedrich, keeps a fascinated gaze on infinity. He also sees the two sail ships, which might signify his and his spouse's ships of life. The man's task is to view eternity in the semblance of natural reality. He and the woman are subject to ephemeralness; the man leans on the tree stump, the woman holds fast to the parched shrubbery.

One might be inclined to think that mortality concerns only the physical. The souls are united in the resurrection of the spirit, which gives meaning to the intertwining green treetops. The woman is bound to earthliness. Her gaze is not attached to the vastness of eternity; instead, she gazes down into the chasm. One might almost assume that the woman was speaking the words that Friedrich wrote to his brother Christian on March 26, 1818, after setting the plan for a honeymoon in his homeland: "But when I tell her about traveling from Greifswald to Rügen, she shudders all over; then she snuggles a bit under my coat and declares softly and fearfully: Whither thou goest, I shall go, and if you sink into the sea, then I shall sink with you."

But what about the man in the middle, groping along the brink of the chasm? He mediates between husband and wife. He might have a concrete function in this — shall we say? — wedding picture; he may have contributed to bringing the two people together. Could he perhaps be Caroline's older brother, Bommer the shopkeeper? Or — less probably — he might be Friedrich's brother Christian, who, together with his wife, accompanied the newlyweds on their trip to Rügen. These conjectures are not all that cogent.

In 1820, Friedrich talked to Fouqué about a painting of a woman at a window (perhaps *Woman at the Window,* 1822, Plate

16, treated in Chapter 20). The artist said he wanted to paint the same woman on the opposite river bank as an old crone peering from the window of a house. This fact encourages me to speculate that in the Rügen canvas, Friedrich portrayed no relative, no friend, but himself, to wit as a man of his own real age, forty-five. Perhaps the standing man in German garb shows Friedrich as an artist, devoted to the political ideas of freedom (Friedrich in 1818 to Christian: "For I wouldn't trust any government further than you could throw it"), pledged to the eternal as his mission in art. If that is so, then the man boldly yet cautiously creeping over to the brink of the abyss, middle-aged, fashionably sporting a tophat, cane, light-brown trousers, and Prussian blue overcoat, is meant to be integrated into social restraints, dependent on them and subject to their anxieties. His adventurous act of peering down into the chasm, where the woman is pointing, simultaneously expresses doubt: can he, the lone man, really trust this woman's gesture? Can he believe that the younger beauty will go with him, ready to keep her promise: "If you sink into the sea, then I shall sink with you"?

Carl Gustav Carus has left an account of the jealousy with which Friedrich tormented his wife and his family after 1830 (cf. Chapter 1). But the odd line in the painter's letter of September 23, 1821, to his brother Heinrich doesn't seem to indicate disappointment and jealousy: "Then we'll go on a nice trip, but with no females, that's paltry stuff." At any rate, the anonymous obituary for Friedrich (in *Blätter für literarische Unterhaltung,* 1843) says: "However, according to general avouchment, after Friedrich recovered from the groundless jealousy that at first took control of him, the future totally confirmed the good fortune of his choice." Hence, is the crawling man's gaze into the chasm also an allusion to jealousy?

Let us leave these conjectures and establish that this painting is to be regarded as a manifestation of the painter's love for his wife. This reading explains not only the composition but the festive tone of the entire work.

The artist's late period, a time of deepening gloom, produced the water color that repeated the composition of the chalk cliff painting (Figure 53). It is attributed to after 1837. However, this is supposedly a different landscape, an abyss southeast of the so-called King's Throne in Rügen. The water color belatedly clarifies that Friedrich had already worked this situation into his

1818 painting (Plate 9): the twin rocks at the foot of the steep rock needle come from the local context, held fast by the water color. (Friedrich had drawn these rocks from nature as early as 1815.)

Comparing the painting and the water color, we discover something that fairly shocks us. The water color landscape is utterly deserted. On the left, where the woman was sitting, there are dead roots; to the right, where the man in German garb was standing, there is a sawed-off tree stump. The trees with interpenetrating tops of the 1818 painting have degenerated into shrubs here, and their foliage can no longer join across the chasm. Hence, the heart shape, which is unmistakably formed in the water color by the inner framework of the foreground, is no longer closed on top. The heart has broken asunder. The narrow stage in front of the chasm is overgrown by long grass. The whole thing creates a deserted, muddled impression. Also, the four ships on the sea are arranged with no cogent links to one another. In this water color, the festive wedding picture has frozen into a cipher that speaks of deathly abandonment and despair.

Let us once again quote the painter and physician Carus, whose lines, written after Friedrich's death, virtually describe the road that brought Friedrich from the chalk cliff painting of 1818 to the water color of the mid-1830s:

> *In his peculiar, always obscure and often harsh mentality, certain fixed ideas developed – evidently as forerunners of a cerebral complaint, to which he later succumbed – and began totally undermining his domestic existence. Distrustful as he was, he tormented himself and those near to him with fancies of his wife's faithlessness – fancies that were manufactured out of thin air, but that nevertheless sufficed to absorb him fully. Attacks of gruff harshness towards his loved ones did not fail to come; I made earnest remonstrances to him and tried to have some effect on him as a physician, but all in vain . . .*

25 The Figure Viewed from the Back

However, the art of quiet contemplation, of a creative observation of the world, is difficult; its execution requires serious meditation and severe sobriety; and the reward is no applause by contemporaries who are sparing of their efforts, but rather just a joy of knowing and waking, a more intimate contact with the universe.

From: Novalis: *The Apprentices of Sais, 1794/97*

The figure viewed from the back has a central position in Friedrich's pictorial world. Its importance for the composition and symbolism of his works gradually increases. It first appeared only after he started painting in oils (1807). The paintings *Winter,* 1808 (Figure 16) and *Monk by the Sea,* 1808/10 (Plate 4) are the first to give this figure a weight that rules the picture. At first, these figures are small, so that they are not always perceived at first glance, for example in *Winter Landscape with Church,* 1811 (Figure 45).

From the very beginning, however, they are crucial to the meaning of the picture, as shown convincingly in *Monk by the Sea.* It is only around 1817/18 that their size makes them the ruling object in the depiction. The early paintings of this sort include *Woman before the Setting Sun,* ca. 1818 (Figure 42) and *Wanderer over the Sea of Fog,* ca. 1818 (Figure 41). From this point on, these back-view figures became a fixed component in Friedrich's art. However, it is noteworthy that after the painter's stroke (1835), these figures are no longer so frequent in his paintings, water colors, and sepias. Still, their semantic function remains until the very end.

This may have an external reason, which simultaneously touches a critical point. Friedrich was clumsy and shaky in his drawings of figures, as demonstrated by his early figure studies. In a letter of May 28, 1816, to his brother Christian, he freely admitted his weakness: "Since you prefer having figures and that is not really my affair. . . " We know that his friend Georg Friedrich Kersting painted the figures in *Morning in the Giant Mountains,* 1811 (Plate 7). He was probably responsible for many figures in Friedrich's

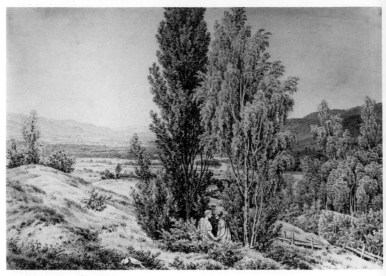

55 *Summer*. Ca. 1826

canvases. It has been conjectured, no doubt correctly, that Kersting prepared them as outline drawings for his friend (Geismeier). Friedrich then anxiously copied these figures and used them for other paintings as well. That is why many of his figures are strikingly similar. Toward the end of his life, the painter evidently stopped adding to the small supply of figures that he had gathered and practiced. His interest shifted from the human figure, a sign of increasing misanthropy.

The importance of these back-view figures is greater than has been generally assumed. They have a long tradition in art history, going all the way back to Greek antiquity. The Baroque employed them almost stereotypically as *repoussoirs* — foreground objects leading the eye into the depth of the picture. It has been pointed out that in illustrations for Dutch emblem literature, the individual figure appears in front of a landscape, which, to be sure, is depicted for moral, theological reflections. The collection of Professor Carl Schildener (1767-1843) in Greifswald, a man who

shared many of Friedrich's opinions and acquired a number of his works, includes such graphic illustrations. Altogether, one may say, however, that in older art, the back-view figure served as a yardstick or had a compositional function. Far more seldom, it indicated a specific device to lead the viewer's eye. But if this was the case, it personified a didactic indication as to how the meaning of the depiction was to be construed.

The isolation of Friedrich's back-view figures underscores their importance. They are alone, solitary, in pairs or in a small group, in a natural setting. They are aliens in the elementary coordinate system of nature. One always feels that they have only just now entered the painting, to pause for a long moment and then go on.

Sometimes, like the *Woman before the Setting Sun* (Figure 42), they stand in the landscape, humble and ready, as though sanctified by the spectacle of nature. It has also been pointed out that a kind of eucharist is being depicted; the divine manifests itself in nature. The experience of nature and the experience of the sacrament contain the same substance. That was part of the thinking of the theologian Theodor Adolph Philipp Schwarz, a pastor in Altenkirchen, Rügen, whom Friedrich knew (Sumowski).

These figures are always portrayed in utter calm. They are absorbed in contemplation, like the trio in the painting *Moon Rising on the Sea* (Plate 19). These people let the tableau of nature work its effect on them: the women embrace as though unable to bear their emotions alone. Men lean on one another as in the painting *Two Men Gazing at the Moon* (Figure 28), and the couple in the prow of the ship (Figure 18) are holding hands. They gaze reverently, or they meditate under the impact of nature, bent over, buried in themselves, as in *Moon on the Sea* (Plate 4). Only very rarely do the figures take part, almost directly and terrified, in the natural events, for instance the parents in the painting *Graveyard Entrance* (Plate 21).

These figures do not so much stand in front of the picture, they are part of the picture. Man and nature meet: the divine universe unfolds in the tableau of nature, it manifests itself in transcendental infinity, to which Friedrich, for this very reason, has given a non-perspective and immeasurable spatial quality. Man, the figure in this picture, responds with the stance of someone who has concentrated all his spiritual energy on this phenomenon. The

individual's solitude is replaced by the fusion of picture and contemplation, visibility and thought, the arrival of the godly in the infinite and the entrance of man into this unearthly realm. One might generally say that Friedrich's back-view figures fulfilled a demand which he himself called perhaps the greatest demand put on the artist: "Thus it is the artist's great, and possibly greatest, merit to stimulate the viewer spiritually and arouse thoughts, feelings, and sensations . . ."

These back-view figures, and Friedrich's figures in general, become sentimental and banal only when he exaggerates the meaning to be placed on them. Characteristically, these are usually moving figures, like the pair in *Morning in the Giant Mountains* (Plate 7) or the ancient priests in *Vision of the Christian Church* (Figure 47). Here Friedrich is overtaxed as a figure painter.

The meaningful *Wanderer over the Sea of Fog,* ca. 1818 (Figure 41) must also be viewed as an artistic failure. The painting is presumably a memorial for a deceased person. The wanderer stands like a monument on the high cliff, in front of the foggy mountain landscape; he has, according to some assumptions, arrived at the end of his life. The large realistic figure is strangely incongruent in this immense natural setting. Because of the overemphasis on the contrast of light and dark (on the one hand, the fashionable suit, the cane, and the hair lit up by the back lighting; on the other hand, the withdrawing, unreal landscape, which has put incommensurable mountain forms together), the figure actually remains in front of the picture, apparently displaced, exaggerated, and somewhat inappropriate. The "concordance of the whole," which Friedrich regarded as the most important criterion in judging a work of art, has not been achieved here. But this very straining and taxing shows the grand density of his other pictorial formulations.

Friedrich experienced what his figures personify, as he told the writer Zhukovski: "I need solitude for conversing with nature" (cf. Chapter 19). He wrote to his wife in 1822: "In the evenings, I walk across the fields and meadows, the sky above me, green crops, green trees around me and near me, and I am not alone; He who created heaven and earth is around me, and His love protecteth me. . ."

Carus summed up the painter's vital bond with nature: "The twilight was his element, a lonesome early stroll at the first light of

dawn, and a second one in the evening, during or after sundown, when he liked having a friend along; these were his only diversions."

Thus, in this respect, Friedrich's back-view figures are not merely artistic figures. They draw the balance of the incessant "conversations with nature" that the painter engaged in throughout his life.

When this painting (Plate 22) was shown in Prague in 1824, the following critical remarks appeared in *Archive for History, Statistics, Literature, and Art:*

> *A ship wrecked under the towering masses of ice. These are in the foreground; a fragment of the wreck peeps out only here and there, its proportions intelligible only from the iceberg. As unsuitable as death may strike us as a subject of fine art, so do we refrain from recommending such an utterly lifeless, uniform, bleak natural view to a painter. Having no yardstick for such subjects, we cannot pass any judgment on the truth; concluding, however, from the analogy of our experience, we find the ice floes not transparent enough here and there, nor could we fully recognize foamy white settling on and between the floes. Likewise, the perspective, in which the remote icebergs are standing, did not strike us properly motivated. The snowy sky is excellent . . .*

The reviewer judged this painting by standards he had taken from realistic painting of the time, and he thus had no understanding of the true content of the picture. An investigation of whether this canvas resembles a North Pole landscape is not a useful approach. Nor did Friedrich even try to reproduce a real ice landscape. We have already mentioned that he utilized 1821 studies of ice floes on the Elbe in this painting.

Furthermore, the critic denies that death and bleakness can be "subjects of fine art," and he thus ignores the uninterrupted series of portrayals of death and suffering that have been themes in art since antiquity. (Nevertheless, even today, the normally polemical opinion that art should uplift and make happy, rather than terrify

or pillory, is still widespread — an opinion characteristic of a society that seeks to block death from its mind.)

Another reviewer (1824) expressed a similar judgment in the *Literary Conversation Gazette*: "I confess that I regard such subjects as being outside the area of painting; what can the colors, what can the soul spirit into such lumps of ice?"

The third, Carl Töpfer in *Originals from the Area of Truth, Art, Whimsy, and Imagination* (1826) rebuked the painter for confusing the dimensions in this painting: "A ship as the main content of the painting, crushed by ice, struggling vainly against the enormous floes, might at best have been a possible subject; but never the ice floes as the chief subject, and the smashed ship, in the middle ground, virtually as a symbolic yardstick for the physical length and breadth of those blocks of ice, which weary and repel our eyes."

And a fourth critic ironically observed: "If only the ice painting of the North Pole would finally melt."

At the time, no one properly understood the painting. It was done during a period when Friedrich's artistic conception was being more and more rejected, especially when, with his former radicalism, he treated a theme that held this conception up to his contemporaries with particular purity, i.e. — for the times — dreadful harshness.

Fedor: Do not overlook the other work of this brilliant Friedrich, the *Polar Sea,* exactly as we know it from doughty Parry's descriptions; it is beautiful in its rigid, hostile grandeur.

Rosa: Yes indeed, but I would not care to have it in front of my eyes all the time.

Sir William Edward Parry had gone on an expedition to the North Pole, and Friedrich might possibly have heard or read about it. He might also have been familiar with an account of a sailing trip through the Northwest Passage, which was published in 1821. Be that as it may, a direct source for this painting has not been demonstrated; it derives from the painter's free imagination.

The composition — this word is fully justified since the painting is clearly put together — has a certain vehemence that makes it run the risk of becoming theatrical. The dramatic

culmination of the ice floes in the center of the canvas brings the picture to the verge of overclarity. It turns into an obtrusively didactic statement on the ephemeralness of all human effort and on the elemental violence of nature.

In another, now lost painting done in 1822, a year prior to *Polar Sea,* and showing a similar theme, the word "Hope" (*Hoffnung*) could be read on the shattered vessel. The meaning of the picture was thus overly blatant there too. Nevertheless, *Polar Sea* is extraordinary, especially when seen in the context of contemporary paintings of catastrophes. Thus Friedrich's canvases have often been compared to Théodore Géricault's (1791-1824) famous wall-sized work *The Raft of the Medusa* (Louvre, Paris). But precisely in those points in which the French artist's power comes to the fore, in gripping drama, in empathy with an extreme human situation, Friedrich's icy landscape is stiff and a bit dry. "This is a man who has discovered the tragedy of landscape," exclaimed the Frenchman David d'Angers in 1834 upon viewing Friedrich's paintings at his Dresden studio. Friedrich did not paint the *human* tragedy, and when he did try to depict it, he reached the limits of his capabilities.

The solemnity of the portrayal, its architectural construction (the ice floes in front are tremendous steps recalling those of a temple ruin — cf. *Temple of Juno at Agrigento,* 1828/30, Figure 32) have led Börsch-Supan to a most likely valid interpretation: "The pure blue of the sky with the sun in the central axis is an allegory of transcendence and eternity, since the rhythm of the times of day is absent at the North Pole. In contrast, the wreckage of the ship, whose embedment in the ice floes recalls a grave, signifies the ephemeralness of man . . ."

Friedrich's political stance must also be brought up in regard to this painting. *Polar Sea* was done at the same time as *Ulrich von Hutten's Grave* (Plate 20), during 1823/24 — that is, at a time when the painter was deeply affected by the political situation in Germany, the three or four years of drastic persecutions of freedom-loving Germans. *Polar Sea* might also symbolize the general numbing in Germany, which buries the ship, the notion of liberty.

The immediate impact for me, in contrast to other readings, is as follows: the gesture of the icy ruins, pointing obliquely upward

56 *Skeletons in the Stalactite Cavern.* Ca. 1834

in the center of the picture, rules the entire composition with an almost monotonous exclusivity. This shape is echoed by the icebergs in the blue background on the white surface. The ship is dragged along by this movement. The whole mass sweeps up to a climax and could sink at any moment: the steps of this natural temple lead into the void.

27 The Artist in His Time

*My friends know best how isolated I am and how greatly I wish that I had
someone at hand with common ideas in some art or science. All the artists
here have to work for their living, and in addition, Hamburg is a bad place
for making pictures.*

Philipp Otto Runge, 1808

By around 1800, the artist's relationship to society had fundamentally changed. Until the end of the Baroque, the Rococo — if we take the outbreak of the French Revolution, 1789, as a key year — the artist was more linked to society. The distinction between craft and art did exist, but it was not an insuperable wall. The artist was faced with patrons (the state, court, nobility, church), who knew what they wanted and made precise demands. Usually, not only the content of the work of art, its so-called program, was laid out by the patron, but also the format, and often the choice of colors and material. Since art had genuine functions — representation, political or class propaganda, the visual rendering of elements of faith, and so on — it could reckon with the immediate understanding of a broad public. There was no conflict between the artist and society. Even the outstanding masters were generally recognized in their era, and usually highly respected and honored. Nor was art ahead of its time in the modern sense; it articulated the wishes, aims, and thoughts of its time.

With the upswing of the bourgeoisie, with rationalism and emotionalism and, politically, the withering of aristocratic and ecclesiastical influence, with the first revolutionary claims of the people for social and democratic equality and participation in the political decision-making process, society became pluralistic, as we would put it today. There were no more universally recognized truths or principles to be imparted through visual art.

From now on, artist stood against artist, picture against picture, and artists together against a society that made only private demands on art (portraits, sofa paintings) or that was served styles and artistic contents for political reasons (Napoleon and his Empire

Style, King Ludwig I of Bavaria and his Classicism and Romanticism), and for which moral, educational, or ideological purposes still had to be invented. A gap broke open between art and society — and it still exists in our present age.

In this situation, the artist retreated into himself and into a circle of congenial minds. He had his "community." Despite all the strenuous efforts to reintegrate artists into society today, this situation, which has lasted for almost two centuries, has not essentially changed. It has merely sharpened and concentrated. From proclaiming his attitudes in order to reach the largest audience possible, it was only a small step for the artist to provoking this audience.

Hence Friedrich's subjectivism has a history dating back to the mid-eighteenth century. It is the expression of his generation and determines the artist's relationship to his work and his milieu even today. If the artist, as Friedrich demanded, is supposed to "consider his every emotion sacred" because it is "art is us"; if he avows: "The artist's feeling is his law . . . But never should another man's feeling be burdened upon us. Spiritual kinship produces similar works"; then he was thereby necessarily rejecting a dialog with the public. "Necessarily" because fulfilling the more and more rapidly changing demands of the society or — usually — of certain groups could mean just spinelessly going along with the fashion.

Even today, it is part of the artist's character that he — who cannot work for himself alone, after all, but whose painting needs a viewer as a book needs a reader — is torn between an often exaggerated ego and profound depressions. Only great human qualities, steadfastness, and the courage of deprivation could (and can?) help him to hold out. From the nineteenth century until today, committed friends, admirers, collectors, or generous and understanding family members have played an often crucial role in the history of art. Just recall the relationship between Philipp Otto Runge and his brother Daniel, or between Vincent Van Gogh and his brother Theo. The more radically the artist made his artistic stance come true despite the demands of his day, the more harshly he was and is exposed to a confrontation with society.

In 1814, when Friedrich was still in intellectual harmony with a large, educated group, he had to ask his brother Heinrich to take over his debts: "Fortune must have altogether abandoned me, or

57 *Angels Worshipping.* 1834

should I merely blame my straitened circumstances on the times? I've got good reason and a desire to believe it; for many more people like me are no better off than I . . ."

Friedrich was over forty years old when he finally became a member of Dresden's Academy of Art in 1816, with a yearly salary of one hundred fifty talers. And in 1824, when a chair became free after the death of the landscapist Johann Christian Klengel, Friedrich was given only a meager associate professorship. The Academy didn't want the outsider to exert influence as a teacher. By 1820, Friedrich's financial condition had changed, so that he could live somewhat securely for a full decade. But the first critical voices were already beginning to be heard.

Each success brought the painter to the brink of his physical and mental powers because he was basically convinced that no one realized his true importance. In 1816, he was in a profound crisis. "I was lazy for a while and felt quite incapable of doing anything.

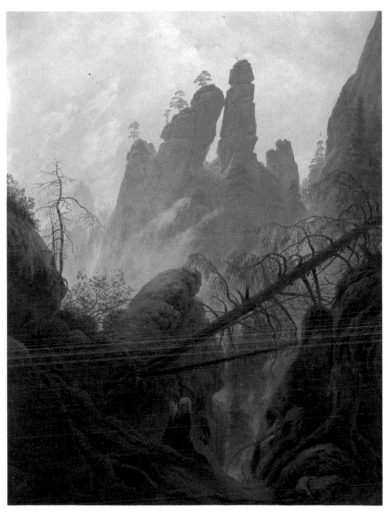

17 *Rocky Chasm.* 1822/23

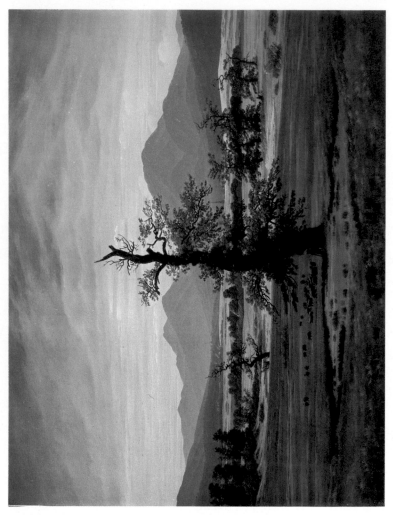

18 *Village Landscape in Morning Light (Solitary Tree).* 1822

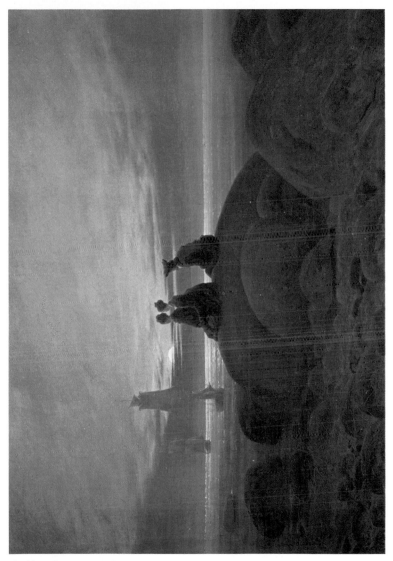

19 *Moon Rising on the Sea.* 1822

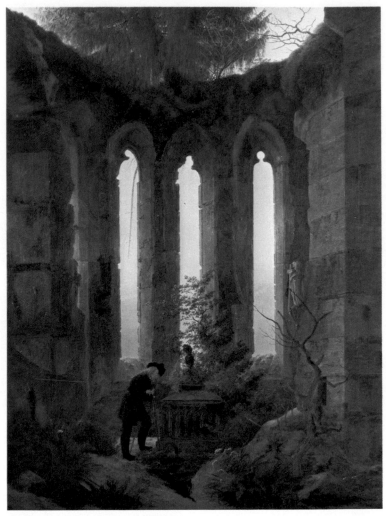

20 *Ulrich von Hutten's Grave.* 1823/24

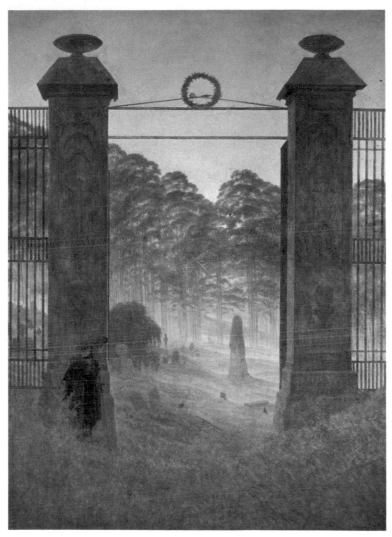

21 *Graveyard Entrance* (unfinished). 1825

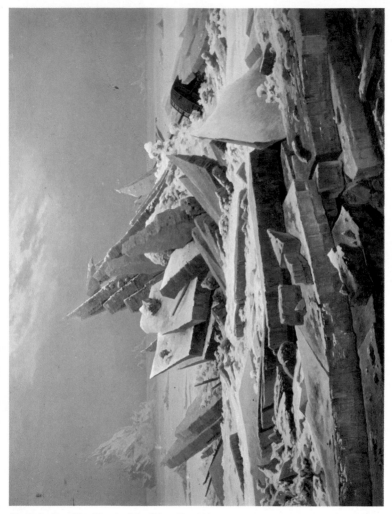

22 *Polar Sea* (The Wreck of the "Hope"). 1823/24

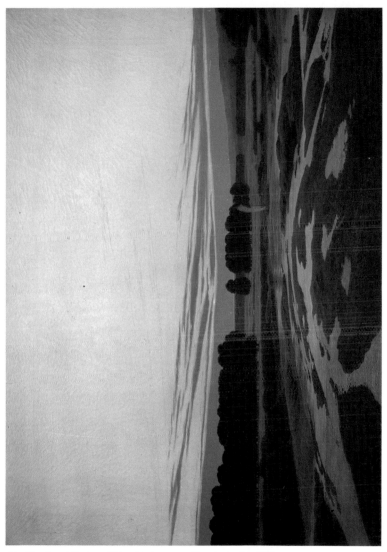

23 *The Great Pasture* (Ostra Pasture near Dresden). Ca. 1832

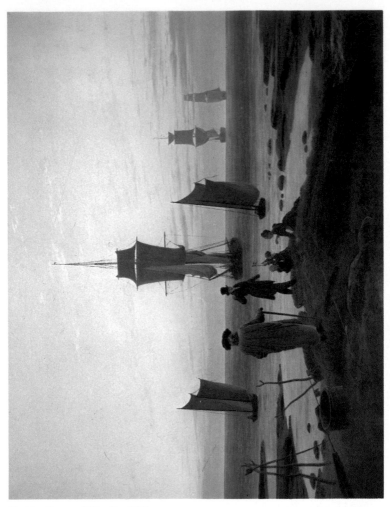

24 *The Stages of Life.* Ca. 1835

Nothing would flow from inside; the well was dry, I was empty; nothing would appeal to me from the outside either, I was dull-witted, and so I thought it would be best to do nothing. What use is work ultimately if nothing is accomplished with it . . ." (Letter of July 11, 1816 to J. L. G. Lund). But then, on December 4, the nomination reached him. In 1824, he became critically ill — but at least he had been finally half-permanently employed since January.

On the one hand, he was self-assured and confident of his cause: "Keep devising rules! The crowd will praise you for the crutches you offer, but the man who feels his own strength will laugh you to scorn." On the other hand, also around 1830, he wrote several statements concerning his total isolation, which was already marked almost by paranoia: "Do what you will, your achievements will never gain recognition, and to the same extent that your works were once lauded, perhaps exaggeratedly, everything will now be rebuked and scorned, for you have insulted these honorable men and bluntly and loudly called them rascals . . . But this frankness of yours will break your neck, and no one will ever, ever forgive you. Poor devil, I pity you. . ."

Thus Friedrich stood up to his time with the prophetic self-awareness of a man who feels he is ahead of his time. "Finally, I would like to ask the following question: does man make his age or does the age make the man? Contemplating a series of older and recent art works, I am compelled to reflect that each age has its set limit and even the most brilliant man cannot get beyond the goal of his time; or, if a man ever did manage to cross the frontier, he was utterly misunderstood by his contemporaries or most likely even declared insane, only to be first recognized by posterity." The failure to recognize new, progressive art works, a failure that Friedrich attributed to the past, came only with the yawning abyss between art and the public, that is, in Friedrich's lifetime. This misunderstanding haunted the nineteenth century and belongs to the history of modern art in an incredibly dramatic, tragic way.

In this situation, all that remained and still remains for the artist are self-affirmation and the faith in being recognized in another time: "How often does it not happen that outstanding men remain ignored throughout their lifetimes, finding their deserved attention only after death. . ."

When Friedrich was paralyzed by a stroke, vegetating after 1835, distrustful and despairing, a crushing burden on himself and his family, it was a foreigner, the Russian writer Zhukovsky whom we have often quoted, who took up his cause: "The poor wretch has been paralyzed for four years now, he cannot paint, and he is suffering want. . . Friedrich is the best and worthiest man, but unfortunately he has outlived his talent. . . Please help him. . ." Zhukovsky wrote in 1838 to Alexander, the successor to the tsarist throne (who gave this aid at least to Friedrich's widow).

It was only at the end of the century, in 1893, that the first evaluation to do justice to Friedrich's art came out. It was written in Norwegian by Andreas Aubert, who had done a monograph on his compatriot J. C. C. Dahl and who, in the years following, repeatedly pointed out Friedrich's significance.

After the Berlin exhibit of 1906, which offered an initial survey of paintings and sculptures from 1775 to 1875 (including thirty-two works by Friedrich), the rediscovery of the painter began. It is still going on today and has confirmed Friedrich's self-awareness.

Friedrich compensated for the contemporary misunderstanding of his art by isolating himself and offering a defiant resistance. He wrote, most likely even before 1830:

> *Having universal appeal*
> *Means appealing to the common,*
> *Only the common is universal.*

Only later did he come to terms with the fact that very few people understood him. These few could only be part of the intellectual elite of the nation — here too he compensated for the lack of a widespread popularity: "It may be a great honor to have a great public. But surely the honor is greater when one has a small, select public."

Friedrich resigned himself to his "community" of friends and admirers — and his isolation became almost total. But was it not due to his art itself that he was simply forgotten during his lifetime?

Johan Christian Clausen Dahl described, without illusions, Friedrich's situation in his time and the effect of his art upon the public:

58 *Churchyard Entrance.* 1822

Friedrich often seems to have crossed the boundary between painting and poetry. In his views and needs, he tolerated no overstress, indeed he actually avoided all the strains that now oppress the world. That was why he acted, to an extent, in opposition in these matters, and, so it strikes me, he went a bit too far in every respect. C. D. Friedrich was in no wise a minion of fortune, and his life was like that of many of the deepest natures: they are properly understood by few men and misunderstood by most. In his paintings, his age saw ideas that were utterly unnatural. Hence many

> *bought his paintings only as curiosities or, especially during the time of the Wars of Liberation, because they sought and found in them a specific, I might say, political prophetic interpretation. . . Artists and art connoisseurs saw only a kind of mystic in Friedrich, because they themselves sought only the mystical. . . They failed to see Friedrich's faithful and conscientious study of nature in everything he depicted; for Friedrich truly knew and felt that one does not and cannot paint nature itself, but rather one's own feelings — which, however, have to be natural. Friedrich saw this in his own tragic manner, which was not exactly labored, but exaggerated in regard to what can in fact be portrayed in painting.*

We cannot permit ourselves to merely pity this great artist and shake our heads at the blindness of his era, particularly since we cannot be certain, in our present time, of truly recognizing the artist for what he was. But it must be said that Friedrich's art was clearly too demanding for his contemporaries. It was an art for the educated bourgeoisie, and even this class was only very conditionally capable of deciphering his symbolic language. No doubt, from the very start, Friedrich was uninterested in a popular appeal. He never thought of the people or of his responsibility to society (here he might have learned from the Nazarenes). Self-realization was more important for him than anything else in the world. Hence from the very start his art was not meant to be understood. The poets of the Wars of Liberation, the writers and thinkers of the revolution of 1848, expressed themselves more decisively and formulated their ideas more lucidly than the painter in his political canvases. One must actually admit that his work can not be clearly explained even today. Helmut Börsch-Supan's far-reaching efforts do not signify an end to these decipherings, but, as may be feared, only their start.

Nor is it enough to stress Friedrich's genius and brand his age as backward and view his work, in contrast, as being ahead of its time. The monomaniacal, almost mystical concealment of the pictorial meaning in a daring composition that turned the tradition of painting upside down yet simultaneously conformed to convention in painting style and linear structure — all that could only arouse misunderstanding. If someone saw a familiar painting style, he assumed it would have familiar contents. If someone grasped the new composition, he would be repelled by the traditional concep-

tion. Yet it was precisely this field of tension between tradition and the projection into the future that produced Friedrich's powerful paintings — and their mystery.

Philipp Otto Runge made a comprehensive, perhaps necessarily fragmentary effort to overcome this tension in a new unity of painting, composition, form, and making. He was ahead of Friedrich in this respect, as well as in the clarity of his symbolism and his thinking. Runge saw the gap between art and the public, between the artist and the mass, with an aloof precision that is still valid today:

> *Art must first be properly scorned and regarded as totally useless before anything can become of it again, or else it has to be applied to anything quite unilaterally. It is futile to wish that the public should properly understand us; an individual comprehension is the only thing that can be achieved and the only thing that can truly preserve us; in the great body of water, however, we will ultimately drown with our entire individuality, so that we shall only see a big, clear, green mass, for cooling us and leaving us cold, and we shall pass out of the world, so that not a soul will care two hoots about it.*

Friedrich may have felt this way too, and he would thus be justified, within limits, in the mystery of his hieroglyphs, in his time — and in ours.

Friedrich most likely did this painting (Plate 24) shortly before his stroke, ca. 1835, at roughly the same time as *Rest during the Hay Harvest* (Figure 54). Perhaps he managed to complete a few things in the unfinished painting after his stroke.

Seldom did the painter show more than two or three people in a picture. But here there are five: two children, on the tip of the tongue of land, are meaningfully holding up the Swedish flag; to their right, somewhat in the foreground, is the figure of a girl; to the left, fairly on her level, is a man in a tophat and brown frock coat; his left hand points at the group of children, and he gazes out of the picture, toward the figure looming out of the foreground and striding toward the group. This is a middle-aged man, whom we see from the back. Wearing the wide black cap of the Wars of Liberation and a brown-gray coat with a fur collar, he carries a cane in his right hand. The man in the top hat appears to be beckoning to him.

One is tempted to connect the five ships to the figures: the two boats to the two children, the large sailing vessel to the back-view figure, the second sailing vessel to the young man, and the ship coming in from far away to the young girl. Each of the ships would then symbolize the life or lifetime of the people. But strangely enough, all the ships are approaching the shore. In terms of form, the group of children seems virtually surmounted by the large sailing vessel in front and the small boats, two pyramids, canopying one another. One also sees (and senses?) that the sailing vessel in front, which is already taking in its sails, belongs to the middle-aged man as the dominant figure of the group.

Altogether, two movements rule the painting: the back-view figure is moving away from us, toward the children — who are turned away from him — and approaching the man. All the lines of the group head toward the shore and touch the water. But the ships are coming from the water. They are sailing toward the bay, whose two arms embrace the peninsula and surge out of the painting further back, to the left and right, in two vast wing motions. In the middle of this bay, in the yellowish strip that reflects the yellow evening sky rising over the violet strip, we seem to make out the point toward which everything is striving, an imaginary border of encounter.

The back-view figure has been — in my opinion, correctly — identified as Friedrich himself. The children could represent the painter's nine-year-old son (Gustav Adolf, b. 1824) and his daughter Agnes Adelheid (b. 1823); the girl would be Friedrich's eldest daughter Emma Johanna (b. 1819). Strangely and revealingly, the painter's wife Caroline is not in the picture. The man mediating between the back-view figure and the children could be one of the painter's nephews: Karl Heinrich Wilhelm (1811-1896), whose father, Johann Heinrich, owned this canvas; or Gustav Adolf (1809-1888), who took over the family home in Greifswald from his father Johann Christian Adolf; or Caspar Heinrich (b. 1810) the son of Johann Samuel Friedrich. (The painter was godfather to all of his brothers' sons.) It has been correctly pointed out that this fashionably garbed man is almost shielding the children.

This painting should be read as a picture of homecoming. Just as the ships sail toward the shore in order to cast anchor, so too the older man trudges toward his final resting place. The Swedish flag in the children's hands is probably a reference to the Swedish-Pomeranian homeland where Friedrich spent his childhood. Given the restrained, quietly flowing earnestness of the portrayal, it does not seem hazardous to think of the eternal home. Friedrich is trudging along on his cane (after his stroke, the painter had trouble walking) toward death. The overturned boat and the long beflagged poles for marking the nets that have been laid on the shore symbolize this final situation. The nets have been hauled in, the boat has been pulled up on dry land; life is concluded.

All this takes place in a beach landscape, which, on the one hand, is solidly constructed, and on the other hand dematerializes

into unreality or transcendence. To the left of the big sailing vessel, which draws a horizontal line through the entire painting, the sickle of the waxing moon appears in the yellow reflection of the setting sun, right over the violet bank of clouds. Time is ending, it is being canceled out; just as the horizon sharply divides the sea and the sky and yet draws them together, with the cloud bank and the ultramarine of the ocean strip, into a zone of dissolving boundaries.

29 Times of the Day — Seasons of the Year

Natural beauty is more divine, artistic beauty is more human, and that explains why it is art that first truly opens our sense of nature. It is as though the endless wealth of nature were written in a language that man first had to master. . .

From: Carl Gustav Carus
Nine Letters on Landscape Painting, 1831

"The twilight was his element." Thus wrote Carl Gustav Carus in his obituary for Friedrich. And he thus pointed out the painter's intimate link with nature, and even more, the all-embracing theme of his art: morning twilight and gathering evening. Or: rise and decline. Or: growth and waning. Or: birth and death. The painter's thinking moved in terms of these pairs. All the other themes of his art have their midpoint here. In this, he has an affinity with Philipp Otto Runge, who drew the four graphics of his cycle of the times of day in Dresden, and within the sphere of the poet Ludwig Tieck, in 1802 and 1803. This theme of the times of day never stopped haunting him until the end of his life.

It cannot be coincidental that Friedrich too did his first cycle of the seasons in 1803, in a now vanished sequence of four sepias. This cycle makes clear the allegorical, hieroglyphic significance of his landscape art. Runge indicated the comprehensive meaning of his depictions of the times and seasons in a letter to Tieck (December 1, 1802): "By all flowers and trees, it becomes extremely obvious to me and more and more certain that everything has a certain human spirit and concept or sensation, and it becomes so clear to me that this must have been so since Paradise; it is simply the purest thing that still exists in the world and in which we can recognize God or His likeness — namely what God called man at the time that He created man. But man must not make any other image of God, nor can he."

Nature, according to Runge, was "the purest thing that still exists in the world," because it "must have been so from Paradise," i.e., it is still immediately related to God, becoming a contemplation of a higher order for man. By integrating himself into nature,

by adjusting his lifeline to the phenomena of nature, man purifies himself, becoming one again with Paradise, in which the divine operates intact. The landscape mirrors the subjective experience of the individual; man's yearning for salvation is fulfilled in the landscape.

This area of thought, which repeatedly nourished the art, music, and literature of Romanticism, also gave rise to Friedrich's cycles of the times of the day and the seasons of the year. The period from 1820 to 1822 brought forth his painting cycle of the times of the day: *Morning* (Plate 11), *Noon* (Plate 12), *Afternoon* (Plate 13), and *Evening* (Plate 14). Perhaps the meaning of these times of the day is so clear because it is depicted in four nature pictures that do not permit any far-fetched readings of details.

First, *Morning,* a fog-draped mountain landscape, a lake, a fisherman, unreal and real, "since Paradise." The fisherman is pushing his boat into deeper waters.

From the mountains, we step into the plain. It is *Noon.* A broad path opens up the picture for us, a figure on the path is moving away from us, there is a shepherd on the right. A group of trees — no longer the firs of the mountains, but the pine forests of the plain — give the painting stability. Actually the portrayal does not have a noonday brightness; the countryside is overcast, under a grayish-blue sky.

Afternoon — the light is more shadowy. Fields of high stalks have replaced the meadows of the noon painting. Everything rushes towards ripeness. The farmer with the wagon recalls harvest time. The group of pines is now on the right side of the canvas and is connected to a large section of forest that begins at the right. The colors are autumnally varied.

Then we enter *Evening,* following the two men, and find ourselves in the bright pine forest, with the evening sky peeping between the trunks. Twilight is rising up from the dark ground. With the end of the day, the shadow of night keeps growing; sleep, that preexistence of death, will receive us.

This sequence maintains the primal thought in special purity: the lucid picture of nature in the time-bound course of the day becomes a symbol of awaking, acting, end, and rest, to the extent that man entrusts himself to this picture of nature.

202

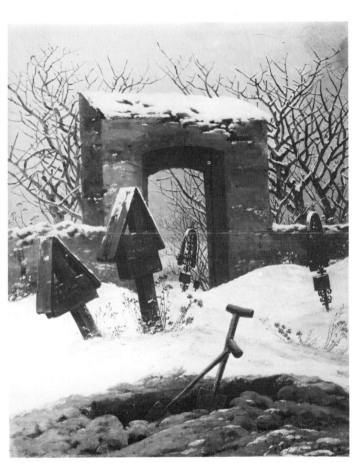

59 *Graveyard in the Snow.* 1826

In two other paintings, more demanding and more important, Friedrich offered a more concentrated and more profound portrayal of this idea. These two works are: *Village Landscape in Morning Light,* known under the title *Solitary Tree* (Plate 18), and the evening picture *Moon Rising on the Sea* (Plate 19). The paintings, of equal size, are conceived as pendants (Börsch-Supan). The morning picture shows the civilized landscape that men have reshaped through the centuries. The oak may symbolize history, as an emblem of the past that looms into the present. Yet the oak is more probably a sign of permanence, and not of isolation and solitude: the shepherd entrusts himself to this tree. The zone of dissolving boundaries lies beyond this vast, inhabited domain. This zone consists of the bare mountains that do not harmonize with the green and yellow of the meadows. Perhaps the earthly, immediate path is depicted "in the morning," i.e., at the start of its consciousness of the manifestation of God in the picture of a reality that can be seen and experienced by the senses.

What has been hinted in the morning is fulfilled in the evening light (Plate 19). The transcendent has now fully appeared in nature. Thus evening here means keeping a promise. Three human beings (the figures were probably devised by Kersting) devotedly await the arrival of the divine: the ships are sailing quietly and steadily toward the group, the moon emerges from the bank of clouds. Now, paradise appears directly before the eyes of man: water, ships, moon, heaven — a realm in which the earthly yardsticks have no validity in the face of the irruption of infinity.

The cycles of the seasons are more evidently linked to man. In the unfolding of the year, man recurrently comprehends the law under which his own lifetime stands. Friedrich often dealt very intensively with this allegory. The early cycle of 1803 has already been mentioned; Friedrich presumably repeated it in a variant in 1807/08. The *Summer* of these sequences led to the early painting *Summer,* 1807 (Figure 15), which has a pendant *Winter,* 1808 (Figure 16). The wealth of nature and human life is confronted with the bleakness of winter, the ruin, and the solitary monk.

Gotthilf Heinrich von Schubert analyzed Friedrich's sepia cycle of 1807/08 in the summing-up of his lectures, which appeared in 1808 under the title *Views of the Nocturnal Side of Natural Science.* One has to take this interpretation with a grain of salt, because the

speculative philosopher quite obviously projected his "views" into Friedrich's pictures.

However, let us quote the basic idea, since it could indeed have inspired Friedrich. Schubert writes:

> In the following pages, permit me to say a few words about the connection between a future higher existence and a previous lower existence. . . For the human mind, the contemplation of such a connection between the various stages of existence is of utmost interest, since nowhere does a future world, with its profound and still unrevealed forces, show itself as a mere striving, and a present world as a radiant, blossoming enjoyment — nowhere does a blend of the two show itself so clearly and intimately as in man's nature. We can discern this heterogeneous blend all too clearly in the formative history of our nature. . .

He then launches into a detailed interpretation of the sepias of the four seasons, from the "dawn of an enduring spring day," to the "dazzling noon" of summer that "does not as yet satisfy a profound yearning," to the evening, the "time of maturing," in which man realizes "what that deep striving, that yearning within us desires," to the winter night, the coast, the "final resting place," where the "eternal spring" appears in the light of the moon.

With the seasons, Friedrich thus not only set up the parallel of the human lifetime, he also depicted the idea of a process. From spring to winter, from childhood to old age, the power of understanding increases with the years of one's life. Understanding develops like a bud — it grows, blossoms, ripens, and is finally exposed in dying, during winter. Hence, the idea fundamental to these seasonal cycles is not that of "death and the grave," but resurrection and everlasting life.

In 1826, and once again in 1833/34 (as Börsch-Supan posits), Friedrich repeated this cycle in two further sepia versions, expanding it. Each sequence begins with a depiction of a *Sea with a Rising Sun,* in which the painter formulated the idea of infinity. Then come *Spring* and *Summer,* ca. 1826 (Figure 55), *Autumn* and *Winter,* ca. 1834 (Figure 44), a portrayal of death, *Skeletons in the Stalactite Cavern,* ca. 1834 (Figure 56), and the concluding piece *Angels Worshipping,* 1834 (Figure 57).

The whole thing sums up the entire sequence of stages in the seasons and in the three subsequent works, a natural history of

man, beginning in infinity, running through the time of life, restoring all the physical to the earth in the cavern tomb, and taken up again as a spirit-body by infinity. From the inkling of God in the natural picture of the sea, the artist passes all the way to the manifestation of the divine in the brightly illuminated cloudy sky of God's eternity. The different variations on the theme indicate Friedrich's intimate participation and the importance he attributed to this idea of birth, death, and resurrection, which he understood as a cosmic circulation.

However, the picture of nature's reality is not twisted around until it becomes a symbol. Instead, the symbol is sought in the image of nature. This seven-part cycle of the seasons struck the artist as not making a sufficiently powerful statement. And so he introduced figures: the human couple appears in this sequence of the seasons of the year and the phases of life, from the two children in the spring to the skeletons in the cavern (which recall the macabre depictions of death in the Baroque); and the two angels are their spiritually reborn bodies. By refusing to limit himself to nature, Friedrich once again fairly verges on banality. One could imagine this cycle without the couple too; the embarrassment of the naively and drastically obvious elements would be avoided. Nevertheless, the figures demonstrate Friedrich's thought and faith; he himself could not do without them.

Friedrich was well aware that his conception of nature, which he saw as a mirror of human feelings, was opposite to realism, which seeks to reproduce reality, not to charge it with significance. He tried to deal with this artistic trend around 1830. In regard to a realistic work, he wrote:

> Well, supposedly, only what the artist has seen with his physical eyes and aped rigorously and faithfully is the task and demand of our time, of art. I confess freely and openly that I shall never ever agree with this opinion. To be sure, I readily admit that these paintings by XX, which supposedly fulfill the demands of our time, have many and great merits, and I enjoyed the faithful imitation of details. But the whole thing has little attraction for me, precisely because I miss the intimate, spiritual permeation of the artist by nature. Hence, despite their excellent qualities, these paintings, like so many others, are without an animating soul, at least for me.

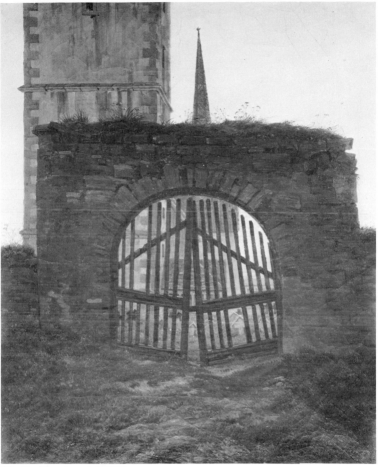

60 *The Churchyard.* 1825/30

30 Graveyard

From the very outset of his career, the theme of "death, ephemeral-ness, and the grave" — to use Friedrich's words — were part of the artist's thinking. This theme entered his pictorial world very early. Around 1800, he drew the Eldena ruin with a funeral. Likewise, *Winter* from the early cycle of seasons, 1803, links a ruin and a grave (cf. the later version, ca. 1834, Figure 44). And only a short time later came the sepia *My Funeral,* which has since vanished.

1806 and 1807 brought the dolmen portrayals (Figure 24); 1808, the *Winter* with the monk (Figure 16); 1809/10, *Abbey in the Oak Forest* (Plate 3); and 1817/19, *Monastery Graveyard in the Snow* (Figure 43); then in 1813 and 1814, the memorial paintings for the men who had fallen in the Wars of Liberation, with monuments (Figure 25). In all these depictions, the cemetery and the grave are the most important secondary theme, but not — aside from the military monuments — the only subject.

It was only in the memorial picture for his murdered friend Gerhard von Kügelgen that Friedrich, in 1821/22, did his first real graveyard painting. He gave *Kügelgen's Grave* to his widow when she left Dresden in 1822. That same year also brought *Churchyard Entrance* (Figure 58), which may be a variation of a view of the Plauen Cemetery in Dresden. If *Kügelgen's Grave* confronts the audience with the cemetery itself, with the stacked-up crosses and graves, then the other formulation (Figure 58) puts us in front of the cemetery. The path simply climbs relentlessly from the lower edge of the canvas, through the gate, to the crosses, thereby opening up the layout of the painting in a mesmerizing way. The foreground lies in shadow, but the graveyard itself is in full light.

One recalls the old saying: "Death is the gateway to life." The bright inner space with the crosses links the idea of death to the idea of hope.

While *Churchyard Entrance* has something of a "view" about it, which only reluctantly hints at a dominant symbolism, *Graveyard Entrance* (Plate 21) is emphatically earnest about presenting the notion of death in a monumental way. Friedrich began with a real situation (the tremendous gate derives from the entrance to Trinitatis Cemetery in Dresden). But he alters this by intensifying and thus alienating it, i.e., shifting it from reality to symbolism.

Vasily Andreyevitch Zhukovsky saw the picture in Friedrich's studio in 1826:

> *A large iron gate, which leads into a cemetery, stands open; by this gate, one sees a man and a woman, leaning against one of the pillars and concealed by the shadow. It is a married couple that has just buried its child and now, in the night, is peering at a grave that one can make out inside the cemetery; it is only a small grassy mound, next to which one sees the shovel; not far from this grave one sees another one, overtowered by an urn; here lie the ashes of the child's forebears! The graveyard is densely filled with fir trees; it is night, one does not see the moon, but it must be somewhere. Patches of fog hover over the graveyard; they conceal the tree trunks, which seem detached from the earth; through this veil, one hazily discerns the other graves, and, above all, primeval monuments, a huge erect rock appears like a gray ghost; everything together forms a charming landscape. But the painter was after more: he wanted to focus our thoughts on the next world. The poor parents have stopped at the gate of the cemetery. Their eyes, fixed on the grave of their child, are struck by a mysterious manifestation. Truly, the drifting fog around the grave is animated; they think they can see their child rising from its grave, the shades of its ancestors moving towards it, stretching out their arms to the child, and an angel of peace with an olive branch floating over them and uniting them. None of these airy forms is precise; one sees nothing but fog, yet the imagination completes the painter's hints, and the manifestation, without adding anything, fully subordinates itself to the effect of nature. . .*

This description is accurate, for the figures that the writer mentions exist as thin outlines in the painting. Floating, stretching figures (angels to bear the child up?) are over the open grave with the wooden bier lying next to it. Over these figures, an angel with

spreading wings and arms floats directly in the middle of the gate. This canvas was never finished, perhaps because of the painter's illness (1824) and its aftereffects; but perhaps also because he might have noticed that any completion of the figures would have degraded the picture. Now, in its brownish-gray emptiness, it has an impressive monumentality. The bare foreground, the pillars, the severe architecture of the iron grating, and the cemetery's rich, hazy space, which falls away to the right, give the painting an almost impalpable mood of grief and hope, a mood due precisely to its state of incompletion. Thus the painting lightens gradually from the brown tone of the underpainting, to the white of the fog, the brown of the pines, and the light blue of the sky, in which the iron wreath of the crowning piece of the gate looms out. The two figures at the pillar participate directly in a process in nature, the manifestation of the angels. This has almost no parallel in the painter's *oeuvre*. But because the outlines of the angels are barely visible, the figures have their innocence restored to them. They turn back into the devoted, contemplating back-view figures, fully integrated into the structure of the painting.

In 1826, Friedrich painted *Graveyard in the Snow* (Figure 59) and, at roughly the same time, *Churchyard* (Figure 60). The winter picture was probably commissioned as a memorial painting. There is no other way to explain the inscription (the only date to be found in Friedrich's paintings). The client and owner was a Baron von Speck, who, we know, prepared a grave for himself and his wife during his lifetime. However, we are in the dark about whom or what the date refers to.

Graveyard in the Snow (Figure 59) reverses the perspective. From the cemetery, our eyes move across the gaping grave and the crosses to the open gate. There, this stratum of space comes to an end. Bare shrubbery fences off this zone; behind it, empty sky. An image of bleak certainty of death? A depiction viewing the freedom of hope beyond the graves? One might think that Friedrich painted *vanitas,* ephemeralness, here by adding up tokens of mortality: graves and spades, crosses, snow, bare shrubbery, wilted flowers.

Churchyard, 1825/30 (Figure 60) formulates the theme of the gate and the cemetery almost by way of conclusion. The gate of the Priesnitz cemetery (for that is what is portrayed here) is shut. Death and the promise of resurrection, the bright space of the graveyard

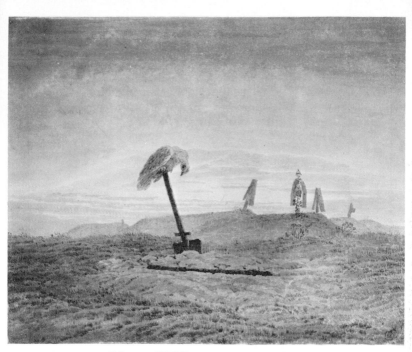

61 *Landscape with Graves.* 1835/37

and of the church, are solemn, as though definitively shifted into the background layer of the picture. The bare foreground leads all the way to the gate and the wall; the actual subject of the painting is barred up and walled up.

Toward the end of his life, death and the grave became a leitmotif in Friedrich's works. These are normally sepias, water colors, and drawings, because he hardly ever used oils after his stroke. The gloomiest of these grave paintings is *Landscape with Graves* (Figure 61) with the vulture sitting on the spade handle and gazing into the open grave. The moon is a ghostly element. I do not agree with Börsch-Supan, who interprets the stars as "the symbol of Christ's overcoming of death." Nothing of this, I feel, is in the depiction. The painting is filled with desperate emptiness and a hostility to life.

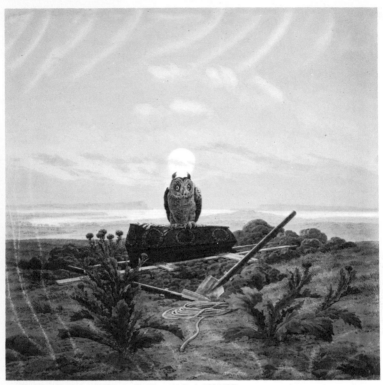

62 *Landscape with Grave, Coffin, and Owl.* 1836/37

The period around 1837 also produced one of the largest sepias of the painter's late period, *Landscape with Grave, Coffin, and Owl,* (Figure 62). The owl perches gigantically on the closed coffin. The death bird, the coffin, the open grave, the spade, the ropes for letting down the coffin, the thistle, the sea in back, the precipitous coast (a reminiscence of Rügen's Cape Arcona), the sky with the moon: the symbols of the certainty of death are heaped up with monomaniacal absoluteness. Here too, I cannot detect any symbol of eternity in the moon, which simply makes the sparkling evil eyes

of the bird more visible and hovers like a nimbus directly over the head of the owl. The landscape is an almost insane wasteland.

Zhukovsky visited Caspar David Friedrich once more on March 19, 1840. He entered in his journal: "At Friedrich's. Dismal ruin. He wept like a child."

A few weeks later, on May 7, the painter died.

31 Influences

It is certainly very difficult to be severely just towards others and not overestimate oneself, which applies to both the period and the individual human being. Every period has its own stamp. Every man has his own ways. But the more a man goes along with the doings of nature or mankind, the more he deserves respect and emulation. With the advance of time, there is an eternal war; for wherever something new is to be created in the world, no matter how resolutely true and beautiful, it is nevertheless fought by the old and existing; the new can make and maintain a place for itself only by fighting and struggling, until it too must finally yield when replaced by the new. But not all replacements of what has existed by what now exists can be regarded as an advance in knowledge by time.

Caspar David Friedrich, ca. 1830

Caspar David Friedrich's effect on the art of his time can be demonstrated. His greatest impact was on the paintings of Carl Gustav Carus. Settling in Dresden in 1814, Carus met Friedrich in 1817, becoming his friend and something of a disciple. Friedrich's pictorial approach made such a deep impression on him that for a long time outsiders confused works by the two painters. A clarification emerged only in the final years. We have shown that Carus, however, following the contemporary trend of realism during the 1820's, criticized Friedrich's art after 1830.

Johan Christian Clausen Dahl, who was far more independent as an artist than Carus, was convinced of Friedrich's importance and closely attached to him from 1818 on. But in the course of the years, his painting simply grew into the opposite pole of Friedrich's: realistic, dramatic portrayals of landscapes. It was Dahl who became Klengel's successor in 1824, obtaining the chair for landscape painting at the Academy. There he gathered a large circle of pupils, developing a fruitful activity as a teacher.

Although Friedrich became an associate professor, he did not have to teach at the Academy. So he had only private pupils or he affected artists only indirectly. August Heinrich (1794-1822) began his career under Friedrich, only to have it cut short prematurely by death. His few works show great talent, but he developed Friedrich's formal language in terms of realism. Dahl's disciple Ernst Ferdinand Oehme (1797-1855) was strongly under

Friedrich's influence in works he did after 1820. In the mid-1830s, however, Oehme followed Ludwig Richter's conception instead. It was the same with Julius von Leypold (1806-1874), Gustav Friedrich Papperitz (1813-1861), Robert Kummer (1810-1889), and Adolf Kunkler (1792-1866). They were mostly disciples of Dahl, conforming their work so greatly to Friedrich's pictorial approach that some of their canvases have been attributed to Friedrich. And it was they who copied a few of his paintings. A self-willed pupil of Dahl's was Georg Heinrich Crola (1805-1879), whom Friedrich also tutored. Also, the work of Christian Friedrich Gille (1805-1899) shows traces of Friedrich's notions. In Greifswald and Stralsund, Friedrich's paintings had an impact on Pomeranian artists: Gottlieb Giese, Anton Heinrich Gladrow, and, the most important, Johann Wilhelm Brüggemann (1785-after 1859).

Characteristic of Friedrich's special position, however, is the fact that the artistic essence of his work, namely its hieroglyphic element, was only rudimentarily understood by his friends and pupils. Or else, by followers like Dahl and Carus, it was rejected as too overwrought and peculiar. Hence in a narrower and more specific sense, his art had no followers. All the painters on whom he had an impact walked virtually one step behind him. Only Carl Blechen (1798-1840) realized Friedrich's importance and submitted to his influence after visiting Dresden in 1823. His landscape similarly became a remembrance of subjective experiences and sufferings. In his late work, the landscape becomes an allegory of ephemeralness in an intenser and more desperate sense than for Friedrich. Nature is no longer the stuff of reality, transcended to the divine and revealing the universe. It is a mirror of the artist's own endangerment. Blechen was not up to these tensions.

Like Friedrich, he fell ill of a nervous complaint in 1836, and died insane in Berlin, two months after the Dresden master. Bettina von Arnim (1785-1859), that restless and passionate woman in Romanticism, took up Blechen's cause. On July 11, 1838, she wrote something that could be applied to Friedrich in the final years of his life:

> *Cold misunderstanding, stupid judgments, envious distortions of his gigantic efforts made him rage, and no little drop of the dew of sympathy*

was to refresh him. A dichotomy with himself, a confusion of his instinct, were the results! Was it an optical illusion that he saw the world in that way, was it to him alone that the bold masses he planted on the rocks and mountains seemed so grand and noble? And the light that poured from his brush, was that meant to be a mere fiction and no truth? These controversial issues wore him out more violently than probably anyone else, for his all was at stake, for he was completely imbued with the spirit of his art; no other, secondary purpose had any room in his soul.

Until now, Friedrich scholars have overlooked the fact that certain French painters also treated a few of the themes in the Caspar David Friedrich circle. Theirs was a thin painting and a clear, rigorous composition, which, if we didn't know who had done them, would be scarcely distinguishable from paintings by, say, Kersting. The themes of the woman at the window, a room interior, and a studio were current in these painters. Such themes can also be found within the radius of the David school and among the pupils of Guillaume Lethière (1760-1832), as well as around Achille Devéria (1800-1857) and Louis Boulander (1807-1867). We would have to think especially of the painters Pierre Duval Le Camus (1790-1854) and Jean François Dunant (1780-1858). Their paintings were normally circulated in the form of etchings. Scholars still have to investigate whether there were any direct links between Paris and Dresden.

It was part of Friedrich's subjective conception of art that his symbolism was as little understood as Philipp Otto Runge's. In their art, both of them came to a border where their codes were to be spelled out by a broad public. The refashioning of thought by Romantic philosophy and literature stayed rudimentary because, on the one hand, it was too intellectual and difficult, and on the other hand, its revolutionary essence was overwhelmed by the Restoration of 1815 and so thoroughly adulterated that only concrete and superficial things had any further effect: national consciousness and historical scholarship, museums and the preservation of monuments, awareness of the homeland, anthropology of one's own and other nations, and — with restrictions — the concept of a different, better social structure.

Thus, after 1818/20, there was no audience left to face Friedrich's art as a partner. The artist was forgotten. This oblivion

now turns out to have been an almost necessary process. His rediscovery began, characteristically, at a time when new understanding for his art was made possible by Symbolism in France and the attempt of *Jugendstil* to create a new art for reshaping all areas of life. The importance of Friedrich's work has been more clearly recognized from decade to decade since about 1900. Indeed, he has become popular because of some of his paintings. And of course, now as then, he is usually misunderstood as a daring and thrilling painter of powerful moods of nature.

It strikes me as off target to reproach the public for this misunderstanding, because, as I have tried to show, it lies in Friedrich's art itself. His paintings do, however, have one level that everyone understands. This level may be shallow, the sensory manifestation of color, form and subject. But the compelling power of his work comes precisely from these usually hidden sources of elementary knowledge and a comprehensive desire by the artist; the power comes from their artistic substance, which, even when unrecognized, makes for their tremendous effect. Hence, everyone ought to be encouraged to penetrate into this pictorial world without always promptly seeking a deeper meaning. After all, the understanding of a work of art emerges gradually. Its mystery is to be comprehended layer by layer. One cannot play one level against another without losing sight of the work of art as a whole.

Critics have pointed out Friedrich's importance for twentieth-century non-objective painting, which he not only aspired to in his thinking and doing, but which was also theoretically formulated in the philosophy of Romanticism. The Romantics yearned for a work of art that was a pure arrangement of forms and colors, that, like music, was not overshadowed by its subject, and directly rendered moods and emotions. The conviction that the human soul mirrors the universe led to the "inward gaze" into one's own soul. And when the Surrealist Max Ernst maintained that "It is the role of the painter to husk out and depict what he sees in himself," he was simply repeating a Romantic insight, which Friedrich too had once formulated.

This is not the place to discuss the details of how Friedrich's work pointed into the future, especially since there are excellent studies of this connection (cf. for example, Otto Stelzer: *Die Vorgeschichte der abstrakten Kunst — The Development of Abstract Art*

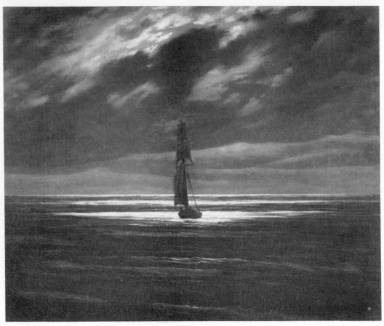

63 *Seascape in the Moonlight.* 1830/35

— Munich, 1964). Equally indisputable are the parallels between Romanticism and Surrealism. But we must not forget that it was Philipp Otto Runge as a theoretician of art, the writers Wackenroder, Novalis, and Tieck, and the philosophers, cultural critics, and writers Schelling and the two Schlegel brothers, plus the far-reaching thoughts of Goethe, that formulated the views of Romanticism. It was not Friedrich, who was outstanding as a painter, but not as a writer.

Nevertheless, the modern realists in America and Europe will have to let Friedrich ask them about the contents of their views and works. Friedrich looms out of nineteenth-century art because he tried to say more and deeper things in his work than could be gleaned from the mere reproduction of reality. As far as I can see,

modern realism has made no attempt (aside from the banal effects of alienation by magnifying the pictorial area, the use of photos, etc.) toward contents that would develop a new symbolic nomenclature for the present. We must ask in connection with Friedrich's work too whether a reproducive realism might be at all capable of developing such a thing. The condemnation of abstract (or concrete) art as subjectivistic and individualistic (true, in a way, of Friedrich's *oeuvre*) overlooks an important achievement: the vast effort to find valid symbols, whose point of departure could only be the self. After all, the "imitation of nature" (the term for reproducing reality in Friedrich's times) is only the lowest level of artistic creativity. Furthermore, this is done far better and more impressively today by documentary photography. To this extent, Friedrich's existential striving for a new symbolism is as topical today as it was in his time.

In his works, Friedrich created pictorial figures that will remain in art forever. The vertical line in front of a low horizon, such as he created in *Monk by the Sea* (Plate 4), cannot be wiped out today or tomorrow from the memory of artists and viewers. The transitory motion of clouds, the single object in a bare, bleak space, attracting interpretations by its very isolation, his rigorous two-layered composition — all these things will point to Friedrich wherever they appear in objective or non-objective works.

In conclusion, the small *Seascape in Moonlight* (Figure 63) from after 1830 shows how lucid Friedrich's pictorial language is, despite all problems of interpretation. In the horizontals of the sea, the horizon, the sky, in the light figures on the water, the clouds melting away diagonally to the right, with moonlight breaking out of them, the ship sails along, the sole vertical, from the center of the canvas towards us. No twentieth-century Constructivist could construct a picture more logically. No Expressionist could intensify the tableau of nature into an emotional experience more expressively. No modern realist could render reality more severely. Without having to decipher Friedrich's allegorical meaning, we feel the statement directly: isolation in immensity, the threat of the confined individual by utter vastness, the defiant and confident self-assertion of the individual in a world that offers no stability. And: the ship sails along, safe in the light of the moon. One has the impression that Friedrich painted a "mental self-portrait" here.

In relating my attempts at interpretation to those of the Friedrich specialists, I wonder whether more is gained for understanding his art if one tries, in any case, to express deeper and more accurate things about the statement of such a painting, if that statement is discernible without difficulties.

Afterword

There are short-lived fads that suddenly make a painter's name popular for a while. Three years after this book first appeared in May 1974, it has turned out that Caspar David Friedrich's person and *oeuvre* are not to be counted among such fashionable but brief successes. On the contrary, this artist obviously fulfills a visual and — dare we say it? — an emotional yearning. This yearning for a reality that is concentrated and interiorized in a painting is deeper than certain cynical commentaries would care to admit. I mean the remarks about the mass visit to the Jubilee Exhibition in Hamburg three years ago.

Friedrich is perhaps the only German painter of the nineteenth century who deliberately arranged the ambivalence of his paintings in such a way that viewers of all levels, all classes, all ages and educational backgrounds, are fascinated. Do we not all feel profoundly stunned when gazing at a painting by Friedrich?

Yet this response develops on various levels:

1. We see Friedrich's work as rendering a certain natural reality, and we are astonished at how accurately our visual sensation of a sunrise, sunset, of a winter day or moonlight night, is reproduced.

2. We recognize symbols in Friedrich's pictorial subjects, symbols that carry and transmit his message: the cross in the forest, for instance, the green fir on a bare rock, the church ruin in winter, the ship in the harbor, the men and women in German costume.

3. We understand the overall *Gestalt* as the painter's confession. On the one hand, it evokes, in meditative absorption, the

221

utopia of a world resting in God; and, on the other hand, it offers a commentary on a historical situation, interpreting historical events with prophetic Protestant zeal.

4. These three levels of understanding are inseparable from one another. Together, they form the whole of the painting.

Wherever one begins, one eventually comes to the essence of this art.

Upon contemplating Friedrich's works, the art historian once again realizes how presumptuous it is to try and name the mystery of the art work. Thus this book is an attempt to close in on something. I am grateful to my many readers for understanding this intention of mine.

Jens Christian Jensen

Catalog of Pictures

After the publication of the catalog by H. Börsch-Supan/K. W. Jähnig, it makes sense not only to indicate the works by the numbers of that catalog, but also to take over the titles used in it, even if one does not always agree with them. Likewise, the dates given in the catalog have been adopted, with a few exceptions.

In the dimensions indicated for the pictures, height goes before width.

Color Plates

1 The Cross on the Mountain (The Tetschen Altar). 1807/08
 Oil on canvas. 115 x 110.5 cm.
 Unsigned.
 Dresden, State Art Collections, Painting Gallery of New Masters
 (The frame was made by the sculptor Karl Gottlob Kühn from a design by C. D. Friedrich.)
 Catalog no. 167

2 Morning Fog in the Mountains. 1808
 Oil on canvas. 71 x 104 cm.
 Unsigned.
 Rudolstadt, State Museums at Heidecksburg Castle
 Catalog no. 166

3 Abbey in the Oak Forest. 1809/10
 Oil on canvas. 110 x 171 cm.
 Unsigned.
 Berlin (West), State Castles and Gardens, Charlottenburg Castle
 Catalog no. 169

4 Monk by the Sea. 1808/10
 Oil on canvas. 110 x 171.5 cm.
 Unsigned.
 Berlin (West), State Castles and Gardens. Charlottenburg Castle
 Catalog no. 168

5 Mountain Landscape with Rainbow. Ca. 1810
 Oil on canvas. 70 x 102 cm.
 Unsigned.
 Essen, Folkwang Museum
 Catalog no. 183

6 Garden Terrace. 1811/12
 Oil on canvas. 53.5 x 70 cm.
 Unsigned.
 Potsdam — Sanssouci, State Castles and Gardens
 Catalog no. 199

7 Morning in the Giant Mountains. 1811
 Oil on canvas. 108 x 170 cm.
 Unsigned.
 Berlin (West), State Castles and Gardens, Charlottenburg Castle
 Catalog no. 190

8 View of a Harbor (Greifswald Harbor). 1815
 Oil on canvas. 90 x 71 cm.
 Unsigned.
 Potsdam — Sanssouci, State Castles and Gardens
 Catalog no. 220

9 Chalk Cliffs in Rügen. Ca. 1818
 Oil on canvas. 90.5 x 71 cm.
 Unsigned.
 Winterthur, Oskar Reinhart Foundation
 Catalog no. 257

10 Dolmen in Autumn. Ca. 1820
 Oil on canvas. 55 x 71 cm.
 Unsigned.
 Dresden, State Art Collections, Painting Gallery of New Masters
 Catalog no. 271

11 Morning. 1820/21
 Oil on canvas. 22 x 30.5 cm.
 Unsigned.
 Hanover, Museum of Lower Saxony
 Catalog no. 274

12 Noon. 1822
 Oil on canvas. 22 x 30 cm.
 Unsigned.
 Hanover, Museum of Lower Saxony
 Catalog no. 296

13 Afternoon. 1822
 Oil on canvas. 22 x 31 cm.
 Unsigned.
 Hanover, Museum of Lower Saxony
 Catalog no. 297·

14 Evening. 1820/21
 Oil on canvas. 22.3 x 31 cm.
 Unsigned.
 Hanover, Museum of Lower Saxony
 Catalog no. 275

15 Drifting Clouds in the Mountains. 1821
 Oil on canvas. 18.3 x 24.5 cm.
 Unsigned.
 Hamburg, Kunsthalle
 Catalog no. 276

16 Woman at the Window. 1822
 Oil on canvas. 44 x 37 cm.
 Unsigned.
 Berlin (West), National Gallery
 Catalog no. 293

17 Rocky Chasm. 1822/23
 Oil on canvas. 91 x 72 cm.

Unsigned.
Vienna, Art Historical Museum
Catalog no. 301

18 Village Landscape in Morning Light (Solitary Tree). 1822
Oil on canvas. 55 x 71 cm.
Unsigned.
Berlin (West), National Gallery
Catalog no. 298

19 Moon Rising on the Sea. 1822
Oil on canvas. 55 x 71 cm.
Unsigned.
Berlin (West), National Gallery
Catalog no. 299

20 Ulrich von Hutten's Grave. 1823/24
Oil on canvas. 93.5 x 73 cm.
The name "Hutten" appears on the pedestal of the armor; "Jahn
1813," "Arndt 1813," "Stein 1813," "Görres 1821,"
"D. . . 1821," and "F. Scharnhorst" on the fields of the front of the
coffin.
Weimar, State Art Collections
Catalog no. 316

21 Graveyard Entrance (unfinished). 1825
Oil on canvas. 143 x 110 cm.
Unsigned.
Dresden, State Art Collections
Painting Gallery of New Masters
Catalog no. 335

22 Polar Sea (The Wreck of the "Hope"). 1823/24
Oil on canvas. 96.7 x 126.9 cm.
Unsigned.
Hamburg, Kunsthalle
Catalog no. 311

23 The Great Pasture (Ostra Pasture near Dresden). Ca. 1832
Oil on canvas. 73.5 x 102.5 cm.
Unsigned.
Dresden, State Art Collections
Painting Gallery of New Masters
Catalog no. 399

24 The Stages of Life. Ca. 1835

Oil on canvas. 72.5 x 94 cm.
Unsigned.
Leipzig, Museum of the Fine Arts
Catalog no. 411

Black and White Reproductions

Frontispiece
Georg Friedrich Kersting:
Caspar David Friedrich in his Studio. 1811
Oil on canvas. 54 x 42 cm.
Signed and dated at lower left: GK 1811
Hamburg, Kunsthalle

1 Christian Friedrich, the Painter's Brother. Ca. 1798
 Black chalk on slightly yellowed paper. 23.7 x 18.6 cm.
 Unsigned.
 Munich, Alfred Winterstein Collection
 Catalog no. 67 (dated 1801/02)

2 View from the Artist's Studio, right-hand window. 1805/06
 Brush/sepia over pencil. 31 x 24 cm.
 Unsigned.
 Vienna, Art Historical Museum
 Catalog no. 132

3 Brigantine in the Harbor. 1815
 Pencil, brush/water-color washes on brownish paper. 35.8 x 25.3 cm.
 The words "chukergilger/Schalubgilger" appear at the top right,
 barely legible: "Meer (?) Swodling"
 Mannheim, Städtische Kunsthalle
 Not in Catalog

4 Self-Portrait. Ca. 1810
 Black chalk; mounted on cardboard. 23 x 18.2 cm.
 Unsigned.
 Berlin (East), National Gallery
 Catalog no. 170

5 Self-Portrait. Ca. 1800
 Black chalk. 42 x 27.6 cm.
 Bottom left in I. L. G. Lund's (?) handwriting:
 "Friedrich/by himself/drawn":
 And, in the artist's own hand:
 "If you were serious about having my portrait,/
 then I believe that I have not acted unjustly/
 with this exchange — drawn by myself."
 Copenhagen, Royal Print Room
 Catalog no. 56

6 Self-Portrait with Cap and Visor. 1802
 Brush/sepia over pencil. 17.5 x 10.5 cm.
 Dated top left: "the 8th of March 1802"
 Hamburg, Kunsthalle
 Catalog no. 72

7 Ruin of the Eldena Abbey. 1801
 Pen/ink, brush/water-color washes in gray over pencil; back of paper
 shaded by pencil. 17.6 x 33.4 cm.
 The words "Eldena Abbey" bottom left; date at lower right: "the 5th
 of May 1801"
 Stuttgart, State Gallery
 Not in Catalog

8 Uttewald Abyss. Ca. 1801
 Brush/sepia over pencil; mounted on brown cardboard 70.5 x 50.3
 cm.
 Unsigned.
 Essen, Folkwang Museum
 Catalog no. 77

9 Sketchbook page: Landscape with Meadows and Forest. 1806
 Pencil. 11.6 x 18.2 cm.
 Dated, bottom, left of center: "the 11th of July 1806"
 Oslo, National Gallery
 Not in Catalog

10 Sketchbook page: Moon and Clouds, 1806
 Brush/sepia over pencil. 11.6 x 18.2 cm.
 Unsigned.
 Oslo, National Gallery
 Not in Catalog

11 Sketchbook page: Landscape with Two Poplars. 1806
 Pencil, brush/sepia. 11.6 x 18.2 cm.
 Unsigned.
 Oslo, National Gallery
 Not in Catalog

12 Rock Formation at Nobbin. Ca. 1806
 Pencil; the paper is squared off. 12.2 x 34.6 cm.
 Words written by an unknown hand on the back, bottom left:
 "Caspar David Friedrich f/† in Dresden, 7th of May 1840"
 Munich, Alfred Winterstein Collection
 Not in Catalog

13 Farmyard with Draw Well. 1806
 Pencil, brush/sepia. 24.3 x 35.1 cm.
 Date at bottom right with pen/ink: "the 21 and 22 of May 1806"
 Schweinfurt, Georg Schäfer Collection
 Catalog no. 140

14 Wreck in the Polar Sea. 1798
 Oil on canvas. 29.6 x 21.9 cm.
 Dated at the bottom center: "the 12 of Dec. 1798"
 Hamburg, Kunsthalle
 In Catalog under "dubious and erroneously attributed works," no.
 XV

15 Summer. 1807
 Oil on canvas. 71.4 x 103.6 cm.
 Unsigned.
 Munich, Bavarian State Painting Collections,
 Neue Pinakothek
 Catalog no. 164

16 Winter. 1808
 Oil on canvas. 73 x 106 cm.
 Unsigned.
 Munich, Bavarian State Painting Collections,
 Neue Pinakothek (destroyed by fire in 1931)
 Catalog no. 165

17 View over the Prow of a Sailing Ship. 1818
 Pencil, brush/sepia. 36 x 26 cm.
 Unsigned.
 Oslo, National Gallery
 Not in Catalog

18 On the Sail Ship. 1818/19
 Oil on canvas. 71 x 56 cm.
 Unsigned.
 Leningrad, State Hermitage
 Catalog no. 256

19 Cross in the Forest. Ca. 1835
 Oil on canvas. 42 x 32 cm.
 Unsigned.
 Stuttgart, State Gallery
 Catalog no. 450

20 Tree Studies. 1809
 Pencil. 36.1 x 26 cm.
 Top left: "Oak/the 1st of May/1809"
 Bottom left: "Oaks/Neubrandenburg/the 2nd of June 1809"
 Underneath in pen/ink: "C. D. Friedrich"
 Bottom center: "In shade"
 Stuttgart, State Gallery, Graphics Collection
 Not in Catalog

21 Woman with Cobweb between Bare Trees (Melancholy). 1801/17
 Woodcut. Paper: 24.5 x 19.2 cm.
 Depiction: 17.1 x 12 cm.
 Unsigned.
 Munich, State Graphics Collection
 (Cut in wood by his brother Christian in 1817 after a Caspar David
 Friedrich drawing of 1801/02.)
 Catalog no. 60

22 Woman with Raven at the Abyss. 1801/1817
 Woodcut. Paper: 24.5 x 19.2 cm.
 Depiction: 17 x 12 cm.
 Unsigned.
 Munich, State Graphics Collection
 (Cut in wood by his brother Christian in 1817 after a Caspar David
 Friedrich drawing of 1801/02.)
 Catalog no. 61

23 Early Snow. Ca. 1828
 Oil on canvas. 43.8 x 34.5 cm.
 Unsigned.
 Hamburg, Kunsthalle
 Catalog no. 363

24 Dolmen in the Snow. Ca. 1807
 Oil on canvas. 61.5 x 80 cm.
 Unsigned.
 Dresden, State Art Collections,
 Painting Gallery of New Masters
 Catalog no. 162

25 Cave with Tomb. 1813/14
 Oil on canvas. 49 x 70 cm.
 The coffin had the following inscription before it was damaged: "May
 your loyalty and invincibility as warriors always set an example for us"
 Bremen, Kunsthalle
 (badly damaged in 1949, torn apart twice, one fifth restored — top
 left)
 Catalog no. 206

26 Design for Warrior Monument with Multicolored Flags. 1814/15
 Pen/India ink and ink, brush/water color over pencil; corners torn on
 bottom. 55.2 x 43.3 cm.
 At lower left, bottom center, and at the left edge, dimension figures
 and calculation notes in pencil and pen.
 On the back, by an unknown hand: ". . .iedrich f/. . . n 1840"
 Mannheim Städtische Kunsthalle
 Not in Catalog

27 Chausseur in the Forest. 1814
 Oil on canvas. 65.7 x 46.7 cm.
 Unsigned.
 Bielefeld, private collection
 Catalog no. 207

28 Two Men Gazing at the Moon. 1819
 Oil on canvas. 35 x 44 cm.
 Unsigned.
 Dresden, State Art Collections,
 Painting Gallery of New Masters
 Catalog no. 261

29 Maple Trees. 1812
 Pencil, brush/water colors. 27.6 x 23.4 cm.
 Signed bottom left: "the 20 and 21 of March 1812/maple tree"
 Bremen, Kunsthalle
 Not in Catalog

30 Firs at the Forest Edge. 1812
Pencil. 35.5 x 25.8 cm.
Dated bottom left: "the 14th of June 1812"
Oslo, National Gallery
Not in Catalog

31 The Watzmann. 1824/25
Oil on canvas. 133 x 170 cm.
Unsigned.
Berlin (West), National Gallery
(The painting is based on a water color by August Heinrich of 1821.)
Catalog no. 330

32 Temple of Juno at Agrigento. 1828/30
Oil on canvas. 54 x 72 cm.
Unsigned.
Cappenberg Castle, Museum of Art and Cultural History of the City
of Dortmund
(The painting is based on an aquatint view by F. Hegi.)
Catalog no. 381

33 Greifswald in the Moonlight. 1816/17
Oil on canvas. 22.5 x 30.5 cm.
Unsigned.
Oslo, National Gallery
Catalog no. 224

34 Woman by the Sea. Ca. 1818
Oil on canvas. 21 x 29 cm.
Unsigned.
Winterthur, Oskar Reinhart Foundation
Catalog no. 245

35 Sketchbook page: Six Sail Ships and Skipper. 1818
Pencil. 20.3 x 12.7 cm.
Signed top right: "Stralsund the 12th of August 1818";
top left: "Eldena 15 Aug 1818";
below at the edge of the picture: "Johann Daniel Lemyk in Wieck by
Greifswald/the 18th of August 1818"
Oslo, National Gallery
Not in Catalog

36 View of Greifswald. Ca. 1818
Brush/water colors, pen/India ink over pencil. 23.9 x 35.5 cm.
Signed at bottom right: "C. D. Friedrich"

Schweinfurt, Georg Schäfer Collection
Catalog no. 252

37 Eldena Ruin. Ca. 1825
Oil on canvas. 35 x 49 cm.
Unsigned.
Berlin (West) National Gallery
Catalog no. 328

38 Eldena Ruin. 1825/28
Pencil, brush/India ink and water colors. 17.8 x 22.9 cm.
Signed bottom left in pencil: "C. D. Friedrich"; on the back, bottom
left, the words: "Eldena Abbey in Pomerania"
Schweinfurt, Georg Schäfer Collection
Catalog no. 376

39 Front Entrance of the Princely School in Meissen. After 1835
Brush/sepia over pencil. 22.8 x 19.3 cm.
Unsigned.
Munich, Alfred Winterstein Collection
Catalog no. 458

40 Beach with Rising Moon. 1835/37
Brush/sepia and pencil. 23.2 x 35.7 cm.
Unsigned.
Dresden, State Art Collections, Print Cabinet
Catalog no. 484

41 Wanderer over the Sea of Fog. Ca. 1818
Oil on canvas. 74.8 x 94.8 cm.
Unsigned.
Hamburg, Kunsthalle
Catalog no. 250

42 Woman before the Setting Sun. Ca. 1818
Oil on canvas. 22 x 30 cm.
Unsigned.
Essen, Folkwang Museum
Catalog no. 249

43 Monastery Graveyard in the Snow. 1817/19
Oil on canvas. 121 x 170 cm.
Unsigned.
Berlin (West), National Gallery (lost in the war)
Catalog no. 254

44 Winter (Monastery Ruin and Graveyard by the Sea). Ca. 1834
 Brush/sepia over pencil. 19.2 x 17.5 cm.
 Unsigned.
 Hamburg, Kunsthalle
 Catalog no. 432

45 Winter Landscape with Church. 1811
 Oil on canvas. 33 x 45 cm.
 Unsigned.
 Cappenberg Castle. Museum of Art and Cultural History of the City
 of Dortmund
 Catalog no. 194

46 Winter Landscape. 1811
 Oil on canvas. 33 x 46 cm.
 Unsigned.
 Schwerin, State Museum
 Catalog no. 193

47 Vision of the Christian Church. 1812
 Oil on canvas. 66.5 x 51.5 cm.
 Unsigned.
 Schweinfurt, Georg Schäfer Collection
 Catalog no. 202

48 The Cathedral. Ca. 1818
 Oil on canvas. 15.5 x 70.5 cm.
 Unsigned.
 Schweinfurt, Georg Schäfer Collection
 Catalog no. 231

49 Design for the Altar of St. Mary's Church in Stralsund. 1817/18
 Pen/ink, brush/India ink. 76.5 x 59.3 (top 45 cm.)
 Unsigned.
 Nürnberg, Germanic National Museum
 Not in Catalog

50 Design for a Chalice for St. Mary's Church in Stralsund. 1817/18
 Pen/ink, brush/India ink. 43.5 x 35.9 cm.
 Unsigned.
 Nürnberg, Germanic National Museum
 Not in Catalog

51 Town under Rising Moon. Ca. 1817
 Oil on canvas. 45.8 x 33 cm.

Unsigned.
Winterthur, Oskar Reinhart Foundation
Catalog no. 227

52 Hill and Boggy Field near Dresden. Ca. 1824
 Oil on canvas. 22.2 x 30.5 cm.
 Unsigned.
 Hamburg, Kunsthalle
 Catalog no. 321

53 Chalk Cliffs in Rügen. After 1837
 Pencil, brush/water color. 31.7 x 25.2 cm.
 Unsigned.
 Leipzig, Fine Arts Museum
 Catalog no. 490

54 Rest during the Hay Harvest. Ca. 1835
 Oil on canvas. 72.5 x 102 cm.
 Unsigned.
 Dresden, State Art Collections, Painting Gallery of New Masters (lost
 in the war)
 Catalog no. 426

55 Summer. Ca. 1826
 Brush/sepia over pencil. 19 x 27.1 cm.
 Unsigned.
 Hamburg, Kunsthalle
 Catalog no. 340

56 Skeletons in the Stalactite Cavern. Ca. 1834
 Brush/sepia over pencil. 18.8 x 27.5 cm.
 Unsigned.
 Hamburg, Kunsthalle
 Catalog no. 433

57 Angels Worshipping. 1834
 Brush/sepia over pencil. 18.5 x 26.7 cm.
 Unsigned.
 Hamburg, Kunsthalle
 Catalog no. 434

58 Churchyard Entrance. 1822
 Oil on canvas. 38 x 33.5 cm.
 Unsigned.

Karlsruhe, Staatliche Kunsthalle
Catalog no. 291

59 Graveyard in the Snow. 1826
Oil on canvas. 30 x 26 cm.
Date on the grave cross on the left, in front of the entrance: "1826"
Leipzig, Fine Arts Museum
Catalog no. 353

60 The Churchyard. 1825/30
Oil on canvas. 31 x 25.2 cm.
Unsigned.
Bremen, Kunsthalle
Catalog no. 357

61 Landscape with Graves. 1835/37
Pen/ink, brush/sepia over pencil. 23.8 x 28.7 cm.
Unsigned.
Vienna, Graphics Collection of the Albertina
Catalog no. 464

62 Landscape with Grave, Coffin, and Owl. 1836/37
Brush/sepia and pencil. 48.5 x 38.5 cm.
Unsigned.
Hamburg, Kunsthalle
Catalog no. 460

63 Seascape in the Moonlight. 1830/35
Oil on canvas. 25 x 31 cm.
Unsigned.
Leipzig, Fine Arts Museum
Catalog no. 393

Chronological List
of the works of Caspar David Friedrich reproduced in this volume

1825/28 — Drawing: Eldena Ruin (Figure 38)
1825/30 — Painting: The Churchyard (Figure 60)
1826 — Painting: Graveyard in the Snow (Figure 59)
Drawing: Summer (Figure 55)
1828 — Painting: Early Snow (Figure 23)
1828/30 — Painting: Temple of Juno at Agrigento (Figure 32)
1830/35 — Painting: Seascape in the Moonlight (Figure 63)
1832 — Painting: The Great Pasture (Plate 23)
1834 — Drawing: Winter (Figure 44)
Drawing: Skeletons in the Stalactite Cavern (Figure 56)
Drawing: Angels Worshipping (Figure 57)
1835 — Painting: The Stages of Life (Plate 24)
Painting: Rest during the Hay Harvest (Figure 54)
Painting: Cross in the Forest (Figure 19)
Drawing: Front Entrance of the Princely School in Meissen
(Figure 39)
1835/37 — Drawing: Beach with Rising Moon (Figure 40)
Drawing: Landscape with Graves (Figure 61)
1836/37 — Drawing: Landscape with Grave, Coffin, and Owl (Figure 62)
1837 — Drawing: Chalk Cliffs in Rügen (Figure 53)

Bibliography

This list contains literature that deals directly with the artist, as well as the now available monographic studies. A complete bibliography can be found in the H. Borsch-Supan/K. W. Jahnig catalog.

Sources

Caspar David Friedrich in Briefen und Bekenntnissen. Edited by Sigrid Hinz. Munich, 1968.

Runge, Philipp Otto. *Hinterlassene Schriften.* 2 vols. Göttingen, 1965.

Articles, shorter works

Bang, M. "Two Alpine Landscapes by C. D. Friedrich." *The Burlington Magazine* 107 (1965):571 ff.

Berefelt, F. "The Regeneration Problem in German Neoclassicism and Romanticism." *Journal of Aesthetics and Art Criticism* 7 (1959):475 ff.

Eimer, Gerhard. *C. D. Friedrich und die Gotik.* Hamburg, 1963.

Einem, Herbert von. "Ein Vorlaufer C. D. Friedrich's?" *Zeitschrift des deutschen Vereins für Kunstwissenschaft* 7 (1940):156 ff.

Eitner, L. "The Open Window and the Stormtossed Boat. An Essay in the Iconography of Romanticism." *The Art Bulletin* 37 (1955):281 ff.

Geismeier, Willi. "Die Staffage bei C. D. Friedrich." *Staatliche Museen zu Berlin, Forschungen und Berichte* 7 (1965):54 ff.

Hartlaub, Georg Friedrich. "C. D. Friedrichs Melancholie." *Zeitschrift des deutschen Vereins für Kunstwissenschaft* 8 (1941):261 ff.

Hartlaub, George Friedrich. "C. D. Friedrich und die Denkmals-Romantik der Freiheitskriege." *Zeitschrift für Bildende Kunst* 51 (N.F. vol. 27) (1916):201 ff.

Lankheit, Klaus. "C. D. Friedrichs Entwürfe zur Ausstattung der Marien-kirche in Stralsund." *Anzeiger des Germanischen Nationalmuseums* (1969:150 ff.

Lankheit, Klaus. "C. D. Friedrich und der Neuprotestantismus." *Deutsche Vierteljahresschrift für Literaturgeschichte und Geisteswissenschaft* 24 (1950:129 ff.

Lankheit, Klaus. "Die Frühromantik und die Grundlagen der gegenstandslosen Malerei." *Neue Heidelberger Jahrbücher* (1950):55 ff.

Platte, Erika. *C. D. Friedrich: Die Jahreszeiten.* Stuttgart, 1961.

Reitharova, Eva, and Sumowski, Werner. "Beiträge zu Caspar David Friedrich." *Pantheon* 35 (1977):41 ff.

Schmitt, Otto. "Die Ruine Eldena im Werk von C. D. Friedrich." *Kunstbrief,* no. 25, Berlin, 1944.

Monographic studies

Börsch-Supan, Helmut. *C. D. Friedrich.* Translated from the German by Sarah Twohig. New York: G. Braziller, 1974.

Börsch-Supan, Helmut, and Jähnig, Karl Wilhelm. *C. D. Friedrich. Gemälde, Druckgraphik und bildmässige Zeichnungen.* Catalog of works. Munich, 1973.

Einem, Herbert von. *C. D. Friedrich.* 3d ed. Berlin, 1950.

Geismeier, Willi. *C. D. Friedrich.* Vienna and Munich, 1973.

Sumowski, Werner. *C. D. Friedrich-Studien.* Wiesbaden, 1970.

Vaughn, William. *Caspar David Friedrich, 1774–1840: Romantic Landscape Painting in Dresden.* Catalog of an exhibition held at the Tate Gallery, London, 6 September– 16 October, 1972. London: Tate Gallery, 1972.

Photo Credits

Berlin (East), State Museums, National Gallery, Print Cabinet and Collection of Drawings: Figure 4

Berlin (West), State Museums of the Prussian Cultural Property, National Gallery: Plates 16, 18, 19; Figure 31, 37, 43

Berlin (West), State Castles and Gardens, Charlottenburg Castle: Plates 3, 4, 7

Bielefeld, private collection: Figure 27

Bremen, Kunsthalle: Figure 25, 29, 60

Cappenberg Castle, Museum for Art and Cultural History of the City of Dortmund: Figure 32, 45

Copenhagen, The Royal Print Collection of the State Museum of Art: Figure 5

Dresden: German Fotothek (State Art Collections, Painting Gallery of New Masters): Plates 1, 10, 21, 23; Figure 24, 28, 54

Dresden, State Art Collections, Print Cabinet: Figure 40

Essen, Folkwang Museum: Plate 5; Figure 8, 42

Hamburg, Kunsthalle: Plates 15, 22; Frontispiece; Figure 6, 14, 23, 41, 44, 52, 55, 56, 57, 62

Hanover, State Museum of Lower Saxony: Plates 11, 12, 13, 14

Karlsruhe, Staatliche Kunsthalle: Figure 58

Leipzig, Museum of the Fine Arts: Plate 24; Figure 53, 59, 63

Leningrad, State Hermitage: Figure 18

Mannheim, Städtische Kunsthalle: Figure 3, 26

Munich, Bavarian State Painting Collections, Neue Pinakothek: Figure 15, 16

Munich, State Graphics Collection: Figure 21, 22

Munich, Collection of Dr. Alfred Winterstein: Figure 1, 12, 39

Nürnberg, Germanic National Museum: Figure 49, 50

Oslo, National Gallery: Figure 9, 10, 11, 17, 30, 33, 35

Potsdam, Sanssouci, State Castles and Gardens: Plates 6, 8

Rudolstadt, State Museums of Heidecksburg Castle: Plate 2
Schweinfurt, Georg Schäfer Collection: Figure 13, 36, 38, 47, 48
Schwerin, State Museum: Figure 46
Stuttgart, State Gallery: Figure 7, 19
Stuttgart, State Gallery, Graphics Collections: Figure 20
Vienna, Albertina Graphics Collection: Figure 61
Vienna, Art Historical Museum, New Gallery: Plate 17; Figure 2
Weimar: State Art Collections: Plate 20
Winterthur, Oskar Reinhart Foundation: Plate 9; Figure 34, 51

Index of Names

BARRON'S POCKET ART SERIES

These attractive low-priced books contain an average of 100 reproductions, many in full color. Each volume 4½" x 7⅛", softbound.

ART NOUVEAU,
Sterner. The exotic turn-of-the-century aesthetic movement. 93 ill. (19 color), $3.50

AUBREY BEARDSLEY,
Hofstatter. Fabulous collection of his elegantly decadent illustrations. 140 ill., $2.95

THE BLUE RIDER,
Vogt. Fascinating German-based Expressionist school. 87 ill. (20 color), $2.95

JOSEPH BEUYS,
Adriani, Konnertz & Thomas. The stormy career of Europe's most intriguing avant-garde artist. 100 ill., $4.95

MARC CHAGALL,
Keller. Includes many rarely-seen examples of his early work. 92 ill. (24 color), $3.75

DICTIONARY OF FANTASTIC ART,
Kirchbaum & Zondergeld. Comprehensive guide to an increasingly popular genre. 124 ill. (39 color), $5.95

CASPAR DAVID FRIEDRICH,
Jensen. The finest paperback study of Germany's greatest landscape painter. 87 ill. (24 color), $3.95

ANTONÍ GAUDÍ,
Sterner. Photo-filled study of Gaudí's landmark architectural creations in Barcelona. 95 ill. (30 color), $3.50

GEORGE GROSZ,
Schneede. Trenchant satirical drawings and paintings by a 20th century master. 100 ill. (8 color), $3.75

PAUL KLEE,
Geelhaar. Outstanding selection of works by the "thinking eye of modern art." 91 ill. (42 color), $3.50

RENÉ MAGRITTE,
Schneede. Surrealistic images both witty and terrifying. 76 ill. (16 color), $3.50

PICASSO, Photos 1951-72,
Quinn. Picasso's late career, documented in fascinating photos and text. 127 ill., $2.95

ART OF THE PRIMITIVES,
Bihalji-Merin. Thorough, colorful survey of "naive" artists around the world. 182 ill. (41 color), $5.50

REMBRANDT,
Haak. New perspective on one of the most profound of all painters. 82 ill. (16 color), $3.95

PETER PAUL RUBENS,
Warnke. The celebrated Flemish master and his dynamic composi-tions. 105 ill. (21 color), $3.95

THE BASIC LAW OF COLOR THEORY,
Kueppers. Innovative illustrated guide for art students and profes-sionals. 152 ill. (66 color), $6.95

COLOR ATLAS,
Kueppers. Screen tint grids show 5500 colors obtained through various combinations and saturations. 75 ill. (48 color), $9.95

BARRON'S, 113 Crossways Park Drive, Woodbury, New York 11797